P9-ARJ-594

ON FEATHERED WINGS

Birds in Flight

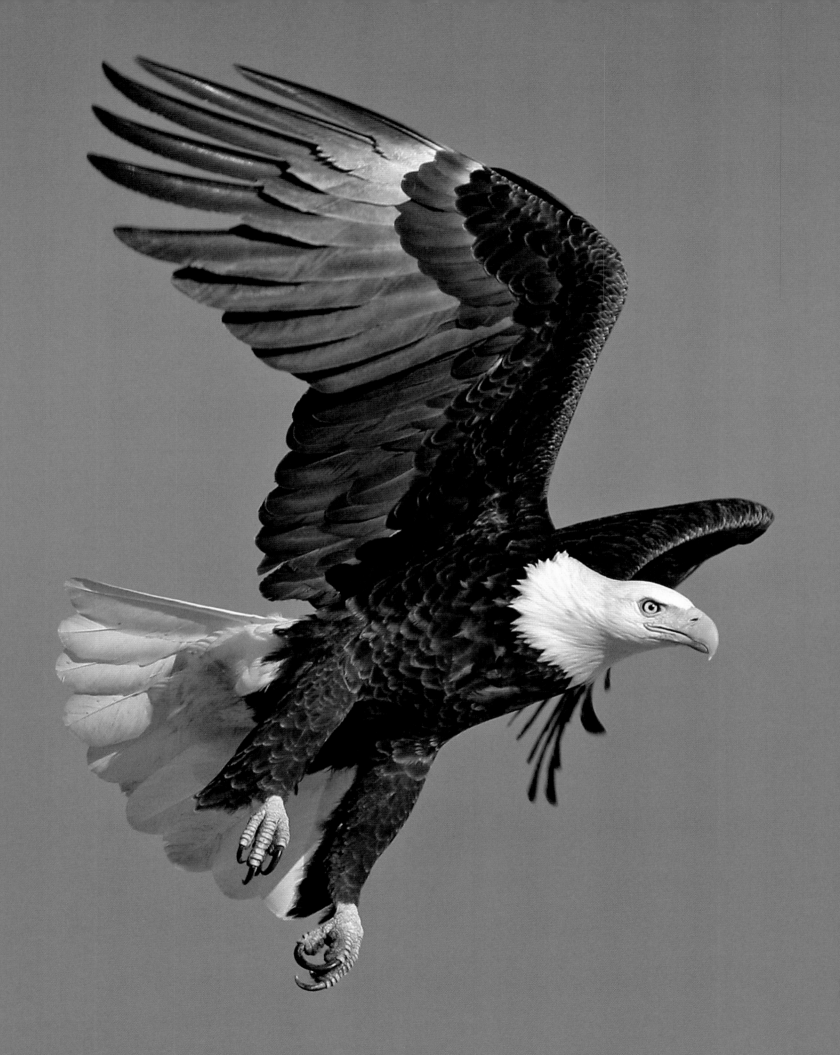

ON FEATHERED WINGS

Birds in Flight

RICHARD ETTLINGER

PHOTOGRAPHS BY RICHARD ETTLINGER, DAVID G. HEMMINGS,
K.K. HUI, MIGUEL LASA, OFER LEVY, JIM NEIGER, AND ROBERT PALMER

ABRAMS, NEW YORK

Editor: Aiah R. Wieder
Designer: Kris Tobiassen
Production Manager: Alison Gervais

Library of Congress Cataloging-in-Publication Data

Ettlinger, Richard.
 On feathered wings : birds in flight / by Richard Ettlinger ; photographs by Richard Ettlinger ... [et al.].
 p. cm.
 ISBN 978-0-8109-9525-3 (hardcover)
 1. Birds—Flight. 2. Birds—Flight—Pictorial works. 3. Photography of birds. I. Title.
 QL698.7.E88 2008
 598.157—dc22

 2007029407

Copyright © 2008 Abrams, New York

Published in 2008 by Abrams, an imprint of Harry N. Abrams, Inc.
All rights reserved. No portion of this book may be reproduced, stored in a retrieval system, or transmitted
in any form or by any means, mechanical, electronic, photocopying, recording, or otherwise, without written
permission from the publisher.

Printed and bound in China
10 9 8 7 6 5 4 3 2 1

harry n. abrams, inc.
a subsidiary of La Martinière Groupe

115 West 18th Street
New York, NY 10011
www.hnabooks.com

To my beautiful nestmate, Julie, and our five fledglings,
Jilian, Nicole, Alec, Matthew, and Morgan

Contents

INTRODUCTION ⅄ 1

HIGH FLIERS, WORLD TRAVELERS, AND FRIGHTFUL HUNTERS ⅄ 11

BEHIND THE CAMERA ⅄ 17

PLATES ⅄ 19

ACKNOWLEDGMENTS ⅄ 181

PHOTOGRAPH CREDITS ⅄ 183

Introduction

A PORTION OF GENIUS

Every so often, there's a moment when a wildlife photographer has a chance to take the "impossible" shot. You know it when you see it. It's the instant when everything inherently magnificent and unique about the animal in front of or above you can be captured with unforgettable impact. It's the crook of a limb, the sinewy knitting of muscles up and down its body, the look of purposeful, even frightening intensity in its eye. It's the "personality" of an animal so defined and so artful that it tells you something no dry academic prose in a manual or textbook can.

No one gets as many chances to make—or miss—that impossible shot as bird photographers. Such is life trying to freeze-frame creatures whose very survival rests on constant, unpredictable, now-you-see-me-now-you-don't movements that (hopefully) baffle and foil predators. Birds are the only vertebrates able to get away by flying and to live pretty much every part of their lives in the air. And they seem to take particularly devilish pride in flum-moxing those of us who want to slow them down. Most of us, in turn, tend to give up trying.

But some of us don't. We only get more determined to bring home the impossible shot of a bird in full, throttled-up flight, focused sharp as a tack and overflowing with character. For me, these opportunities typically manifest in the blink of an eye, when I least expect it. One day, I was walking along the trail in Jamaica Bay, near my home on the south shore of Long Island, when, out of nowhere, I saw a ferocious-looking hawk hurtling out of the sky and boring right down on me, faster than any bird I'd ever seen—it had to be going 90 miles (145 kilometers) per hour. The common instinct at a time like that is to duck and cover. But as it got ever closer, I was able to define—fleetingly, in a blur—the markings of a hawk I'd been studying but had previously seen only from afar. It had a black-hooded face, a bluish beak, a snow-white undercarriage, bright golden claws, and—chillingly—coal-black, hard, staring eyes. It could only have been a peregrine falcon, a bird whose reputation certainly precedes it.

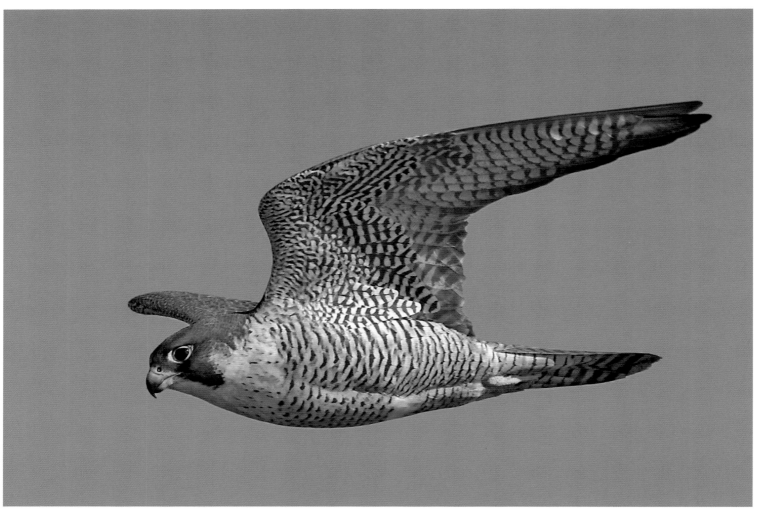

PEREGRINE FALCON *(FALCO PEREGRINUS)* AT FLOYD BENNETT FIELD IN BROOKLYN, NEW YORK.

Few photographers have taken pictures of this scowling ave that rise above the prosaic level, and for good reason: The peregrine is the fastest bird on this good earth. Flying in a straight line, it's been clocked at up to 100 miles (161 kilometers) per hour. But that's not even its top gear. The peregrine is a classic hunting bird that spears its choice of prey—small birds—right out of the air before they know what hit them, and it really turns on the burners when it spots its target. Peregrines have been known to fly in circles, gathering up energy and power before dive-bombing straight down at 200 miles (322 kilometers) per hour, skewering the victim in their beaks, and spiriting it off before the human eye has even seen the act!

This combination of raw speed and brute power is nonpareil in birdland. In fact, a peregrine tears through the air with such force on a typical sprint that, if not for the conelike buffer around its beak limiting inhalation, its lungs would burst like a water balloon.

Now, on that day I had no idea whether this peregrine had come from the air, or a tree, or, like Godzilla, from the sea. All I knew was that I was in its flight path; it was as if the bird didn't even know I was there. Everything happened so fast that I had no time to be terrified. In that moment, some instinct made me pull my camera to my face and try to squeeze off a shot or two.

Alas, it was a noble but failed attempt. Just as I tried to shoot, it whizzed past my head with a great whoosh, missing

me by inches before heading out over Jamaica Bay, probably with its prey in tow. I was empty-handed, but that brief skirmish with the world's fastest bird stayed in my head. Whenever I'd walk down that strip of trail, I wondered if there would be another encounter. For three years, there wasn't. Then one day I saw another peregrine perched on the branch of a tree, and I stopped in my tracks. I began to tip-toe closer; in a flash, it leaped off the tree and flew right at me! Having gone through this scenario before, I was either brave or dumb enough to stand my ground.

This time around, I was able to get my camera up quickly enough to focus and frame the incredible hawk through my lens. One, two, three times, I hit the shutter button. And just as with the previous encounter, the peregrine buzzed right past my head in a blinding whoosh and soared off. It had played with me, as though it knew that it had the power to make or break my impossible dream. And when I checked my camera, there it was! The impossible shot.

That particular peregrine made the cut for this book, and you can find it on page 20. The shot is a classic example of extreme action bird photography. Note the kinetic qualities, the angle of the peregrine as it twists through the air in full attack posture: belly up, talons high and, pincer-like, poised to grab, wings pinned back for aerodynamic propulsion. The eyes glare unyieldingly. Every muscle and tendon is tense, straining yet working smoothly in conjunction. All these elements combine in a feel of powerful flight—a precise mirror of the many biological processes that make the bird the perfect flying machine.

*T*his book is filled with nearly 175 other "impossible" shots of birds in flight, each one more breathtaking than the last, and each proving anew that a picture can be worth more than a thousand words, that text is an unnecessary embellishment.

However, given the enormous inspiration birds on the wing have provided writers of prose and poetry through the centuries, even a few words sometimes say it just right. For example, the great poet William Blake once wrote: "When thou seest an eagle, thou seest a portion of genius; lift up thy head!"

Those stirring words were penned in the early 1800s, so Blake didn't know the half of it; there were no cameras back then, much less zoom lenses, megapixels, and digital imaging. But he spoke the essential truth, not just of eagles but also of all birds in flight—and, by extension, the best photographs of birds in flight. They fly with grace, power, and resolve. And they fly with genius. It is a genius seen in their sense of purpose amid the randomness of the open sky; in their gravity-defying flips, twists, climbs, and dives; and in their chains of group formations, which open alleyways of eased passage for each trailing bird. Why—and how—can they do these things? In many ways, we still don't know.

Nor is it necessary that we do. As modern author Mitchell Burgess writes of cranes, they carry "heavy mystical baggage" on their wings. This is doubtless why, through the centuries, humans haven't tried to unravel these mysteries, but rather have simply lifted up their heads and become lost in the wonder of them. Even today, Burgess notes, "the Vietnamese believe cranes cart our souls up to the heaven on [their] wings."

This book was conceived and created in celebration of birds' mystical genius—a quality that can only be observed while they are off the ground. Their wings may be made of pretty feathers, but these appendages serve no other purpose than to get them into and through the air. How curious, then, that up until now, no collection of bird photographs has been confined strictly to flight shots, and certainly not in the number and with the vivid detail of the photographs between these covers. Indeed, for reasons that become clear with the turn of every page, this is a truly extraordinary collaborative effort, uniting in one venue the

finest work of seven of the best bird photographers in the world, who share a simple philosophy: Settle for no less than doing the impossible.

Thus, not a single photograph in this vast and exhilarating array finds a bird anywhere but on the wing. You will not find a bird on a limb, in a nest, or soaking up rays at the water's edge. In these shots, there is nothing but action. You see it, feel it, as the subjects spill and tumble and dart and do whatever else birds tend to do in the air up there—which is pretty much everything, including courting, mating, and feeding their fledglings. In fact, about the only things they don't do in the air are nest and hatch eggs. Neither do they have to be persuaded into showing off for those lifted heads down below. And who can blame them? Turn-of-the-twentieth-century naturalist John Burroughs wrote that a bird "is a symbol and a suggestion to the poet . . . so vehement and intense his life." One is tempted to believe that the birds know this full well.

Who among us, after all, has not yearned, as the song goes, to fly like an eagle? The very notion has led humans to create numerous mighty, winged pop culture icons. Mythology teems with them: the Mexican Cu Bird, the Native American firebird, the griffins of ancient Greece, the ho-o and fenghuang of the Far East—and the most famous of all, the Egyptian phoenix, which falls into the sun and rises from its own ashes. All these heroic, feathered symbols of the divine are imbued with mighty traits—steel wings that flap as loudly as thunder, with 90-foot (27-meter) wingspans, claws big enough to carry off whales or elephants, and beaks that draw water from rivers and regurgitate it as rain.

Then, too, literature would be unrecognizable without the magic and haunting metaphorical qualities of birds: Witness, most famously, Poe's raven, not to mention the menageries in the works of Aesop, Chaucer, Tolkien, Thornton Burgess, Japser Fforde, Beatrix Potter, and J. K. Rowling. Let us not forget, either, the biblical sprig-carrying dove that told Noah he could finally unload his ark. Of course, there are also those modern myths that weld birds and humans in ways we dream about—from Superman to the Flying Nun. All too real were the Wright brothers' first rickety flying machines, which eventually flew faster and longer than any bird. Still, as another song goes, there ain't nothing like the real thing—as confirmed by the most famous human aviator of all time, shortly before his death in 1974.

"I have come to realize," said Charles Lindbergh, "that if I had to choose, I would rather have birds than airplanes."

HOW BIRDS FLY

There are more than 9,700 modern bird species, every one perfectly adapted by evolution to be able to scale and streak across the sky on a wing and a whim and with aerodynamic brilliance, laughing all the way at gravity. Sharing the same endoskeletal and biomechanical systems, birds have bones that are light enough not to cause a drag but strong enough to withstand the air pressure and the furious flapping of their own wings, the bones of which are long, pliable, and cushioned by sacs that swell with air. Unlike humans and other mammals, birds need not breathe to force air into their lungs. No huffing and puffing is required to maintain energy flow, and no premature fatigue sets in; instead, air is simply "autoinjected" by the pumping action of the bird's sternum (breastbone) and furcula (wishbone). A bird's engine is its pectoral and supracoracoideus muscles, which together are larger, at around 25 percent of total body mass, than the corresponding muscle networks of any other four-limbed animal in the world, including *Homo sapiens*. For the average human, the infrastructure required to support this muscle mass would roughly correspond to a breastbone 6 feet (2 meters) long!

A bird's smaller supplemental muscles are like joysticks that control quick, sudden moves—a midair turn, a

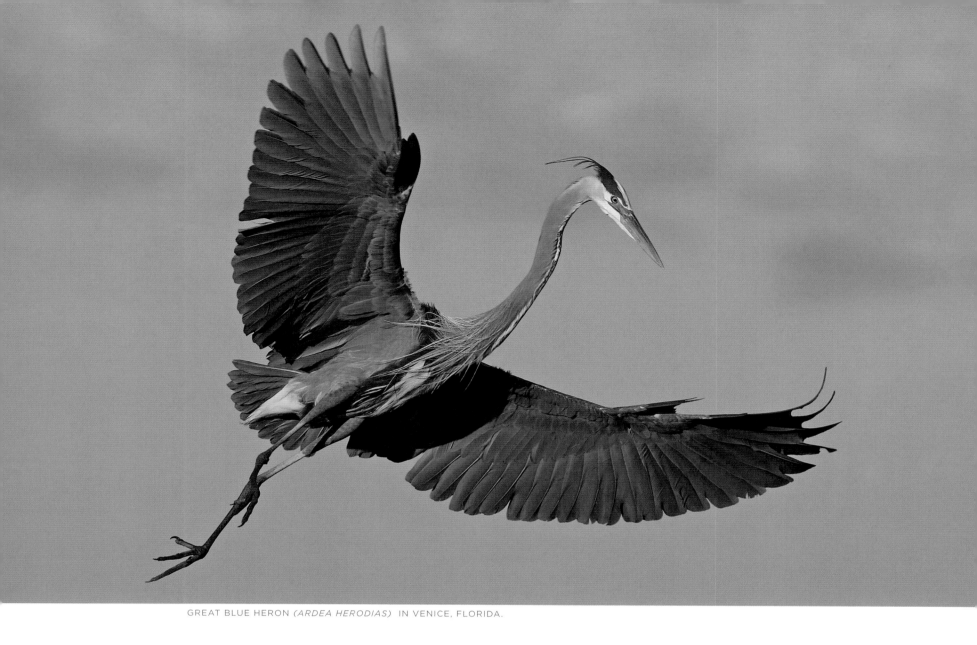

GREAT BLUE HERON (*ARDEA HERODIAS*) IN VENICE, FLORIDA.

high-speed takeoff from a limb, or a sudden drop from the sky, all executed as smoothly as apple butter. Hopping around on land on their two legs, birds can look goofy. But up in the sky, riding the wind with wings unfurled and the diesel throttled up, there are no klutzes. After a few million years of evolution, natural selection has given the skies over to only those species that have proved their mettle—not necessarily the brawniest or the fastest, only the toughest. Even so, the vicissitudes of survival can make each day a perilous journey for the most intrepid travelers. Such is the capriciousness of the food chain. And while all that soaring and dipping appears to be carefree and no more complicated than a kid riding a roller

coaster, a lot is happening on a subtler level. For one thing, to get around the laws of gravity, a bird's flight muscles are ingeniously attached to its sternum, keeping the center of gravity below its wings, which is crucial to attaining smooth, stable flight. A bird must also manipulate the motion of air about it, cutting through the airflow in such a way that the dynamic pressure of the air diverted below buoys its body. In a sense, we can say that birds actually ride on a bed of air.

This leads us to perhaps a bird's most remarkable aerodynamic feature: Its wings act as airfoils, propelling the bird up and forward with their rhythmic up-and-down motions. The basic interaction between the airflow

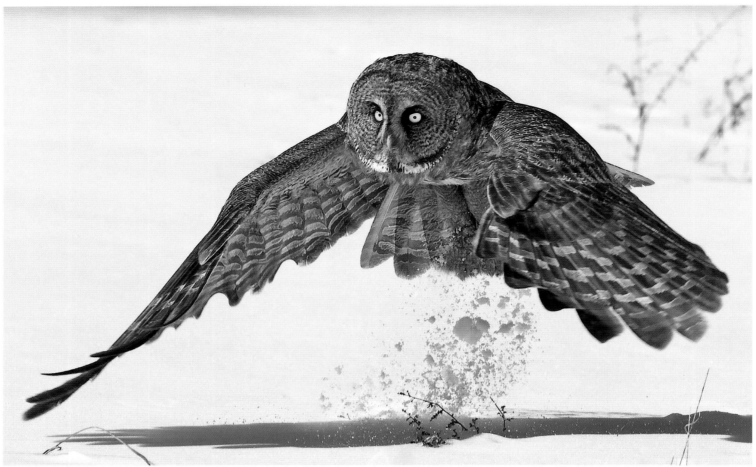

GREAT GRAY OWL (STRIX NEBULOSA) IN NORTHERN ONTARIO, CANADA.

and the wing's front edge provides a small force against gravity, known as lift, but very little forward force. On the downstroke, the wing pushes air down and back, producing a reaction force called thrust. It is the considerable forward component of this force, created by the physical pressure of wing against air, that allows the bird to move through the air horizontally, rather than only up and down. On the upstroke, however, the bird adjusts the angle its wings make in relation to the wind in order to reduce resistance from the air, which is known as drag. This combination of repeatedly cutting through the air and then exerting a force against it is what propels the bird up, up, and away!

In addition to steering a bird's course through the air, the airfoil of the wing has another function: helping to spring the bird into the air. The initial lift, which is the result of a slower airstream cushioning the wing below and buoying it up, can be obtained just through a running start and a leap for smaller birds with lighter bodies and shorter wingspans. However, falcons, hawks, and other large birds with broad wings typically face into the wind or, if possible, perch on a tree or cliff so that they can drop into the air.

But why are hawks and falcons able to fly faster and longer than, say, barn swallows? Again, the answer lies on the wing. A falcon's wingspan is generally larger than most—the peregrine's can be more than 40 inches (102 centimeters)—so it will be able to deflect more air downward into the "cushion" than a bird with stumpier wings, and it can fly more effortlessly, with less frequent flapping. So, too, birds with long tails, which serve as a kind of steering rudder, can make those hairpin turns

more easily than birds with shorter tails, though the latter can fly faster; less tail means less weight and drag. With birds, it's always a matter of give-and-take. Moreover, the number of wingbeats per second has little bearing on the distance and speed, since larger birds have slower wingbeat frequencies (10 to 25 wingbeats per second) but fly a whole lot faster than, say, a hummingbird, which at 70 wingbeats per second has the highest frequency of all.

Wing shape also influences the type of flying a bird does. Bird flight falls into two general categories: powered and unpowered. Powered flight is usually fast and straight as an arrow, while unpowered flight, such as gliding or soaring, is often more leisurely and peregrine.

Incidentally, the peregrine falcon uses both powered and unpowered flight. The peregrine's maximum-speed jaunts—those almost perpendicular dives at 200 miles (322 kilometers) per hour—are actually unpowered,

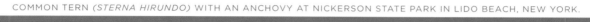

COMMON TERN *(STERNA HIRUNDO)* WITH AN ANCHOVY AT NICKERSON STATE PARK IN LIDO BEACH, NEW YORK.

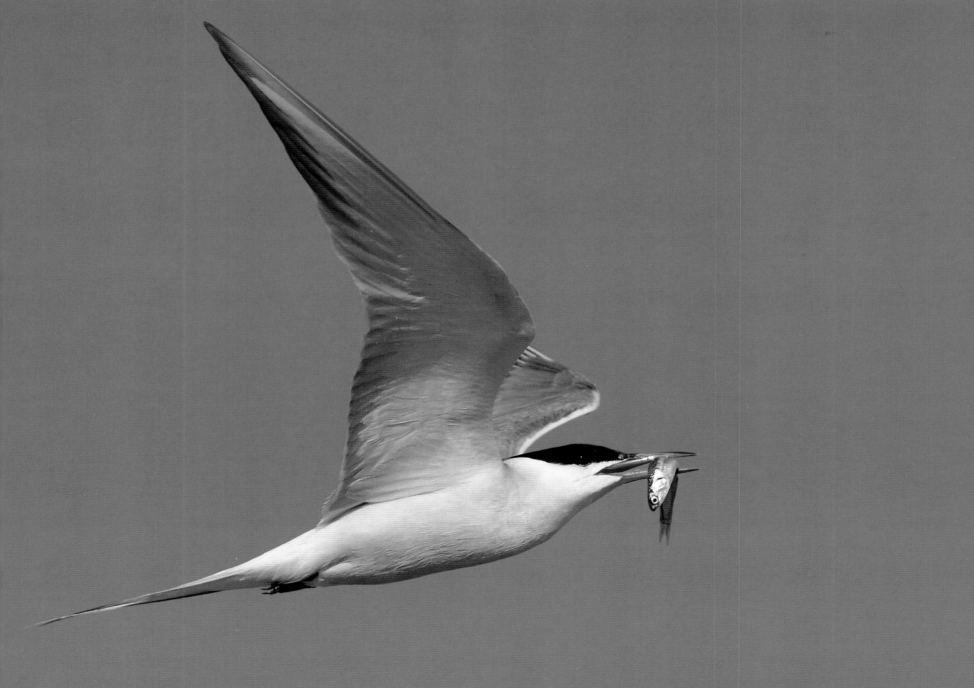

because they rely on a period of circling around and gathering up momentum that doesn't involve continual wing action. In this case, gravity is the bird's ally, pulling it down ever faster. Believe it or not, the falcon's dive-bombing is, in strict terms, a form of gliding.

The other kind of unpowered flight is soaring, which is best thought of as gliding in reverse—gaining altitude after gaining momentum, rather than losing altitude while gaining momentum. Albatross, which have the widest wingspans of all birds, migrate by soaring on prevailing winds to save energy over the great distances they must travel to forage. In fact, the basal heart rate of an albatross at rest is not much lower than its heart rate in flight.

The flight behavior of certain birds and bird groups, including migratory patterns, will be discussed in the second section. However, as a brief overview, I will note that shorebirds are among the fastest—not that the peregrine falcon wouldn't guffaw at a tern's top speed of 70 to 80 miles (113 to 129 kilometers) per hour—while the slowest is likely the house sparrow, clocking in at 15 to 18 miles (24 to 29 kilometers) per hour.

Those are the basics of bird flight. But how did all these processes develop? For that, we need some history.

HOW BIRD FLIGHT EVOLVED

The oldest bird fossils, found in 1860 in a stone quarry in Bavaria, Germany, and described in 1861 by Christian Erich Hermann von Meyer, belonged to a flying reptile known as *Archaeopteryx*, or "ancient wing." It had feathers (a single feather formed the fossil impression that Meyer examined, in fact), much like modern aviary vertebrates, on its wings and tail—and a nice set of teeth, to boot. The creature was capable of flight, though probably not by flapping its wings. The remains were dated back to the late Jurassic period, some 150 million years ago. But the discovery, while heralded as the "missing link" of bird evo-

lution, only intensified the argument that had been raging for centuries: Did this mean birds evolved from dinosaurs, or had they already been around for millions of years before that?

For all that is known of the biological mechanisms by which birds fly, the evolutionary process by which these modern techniques of flight developed is still wide open for debate. Recent archaeological findings in China have begun settling some questions, however, such as whether feathers—along with wing-flapping flight—developed as insulation from the cold or as a mutation of body scales after early birdlike species had become proficient in leaping from tree to tree for thousands of years. The trees-down theory (as opposed to the ground-up theory) posits that smaller theropods, the group of Triassic dinosaurs which were to evolve into birds, began climbing into trees and then sort of parachuting down, gradually developing the means to glide farther and longer. In contrast, the ground-up theory suggests that the ancestors of modern birds were runners and jumpers who evolved feathers to keep their bodies warm, or as a mating display, before they developed the ability of flight. Whether modern birds are descended from shivering ground-dwellers or daredevil tree-dwellers, however, is not a question to be settled here. The mere fact that birds carried on after the Cretaceous–Tertiary event that wiped out the dinosaurs attests to their remarkable instinct for survival.

By the end of the Paleocene epoch, some 55 million years ago, most of the major orders of modern birds were here and flying on feathered wings. One vestigial holdover, the soon-to-be-extinct *Diatryma* (*Gastornis* in Europe) genus, didn't fly, mercifully, as it stood 6 feet (2 meters) tall, weighed 385 pounds (175 kilograms), and had a head comparable in size to that of a horse.

By the late Eocene epoch, around 35 million years ago, most modern bird families were entrenched, though most modern species evolved during the Pleistocene

epoch, which ran from 1.8 million to 11,500 years ago. For reference, *Homo sapiens* also appeared during the Pleistocene epoch, about 250,000 years ago.

Since then, the most significant changes have been additional cleaving of bird orders into new species, a process known as speciation. This occurs when physical or geographical barriers get in the way of interbreeding. An extreme (and noteworthy) example is the family of finches Charles Darwin observed on the Galápagos Islands. These fourteen distinct species (and two subspecies) were classi-fied by Darwin according to the sizes and shapes of their beaks into the genera *Geospiza*, *Camarhynchus*, *Certhidea*, and *Pinaroloxias*. Each species had evolved separately from a common ancestor on a different island, isolated geo-graphically into populations until interbreeding between genera and species was no longer possible.

Which brings us to the cast of characters that grace this book—how their flight behavior differs, where they can be found, and what it is about their distinct portions of genius that makes them so mesmerizing.

ROSEATE SPOONBILL *(PLATALEA AJAJA)* IN OSCEOLA COUNTY, FLORIDA.

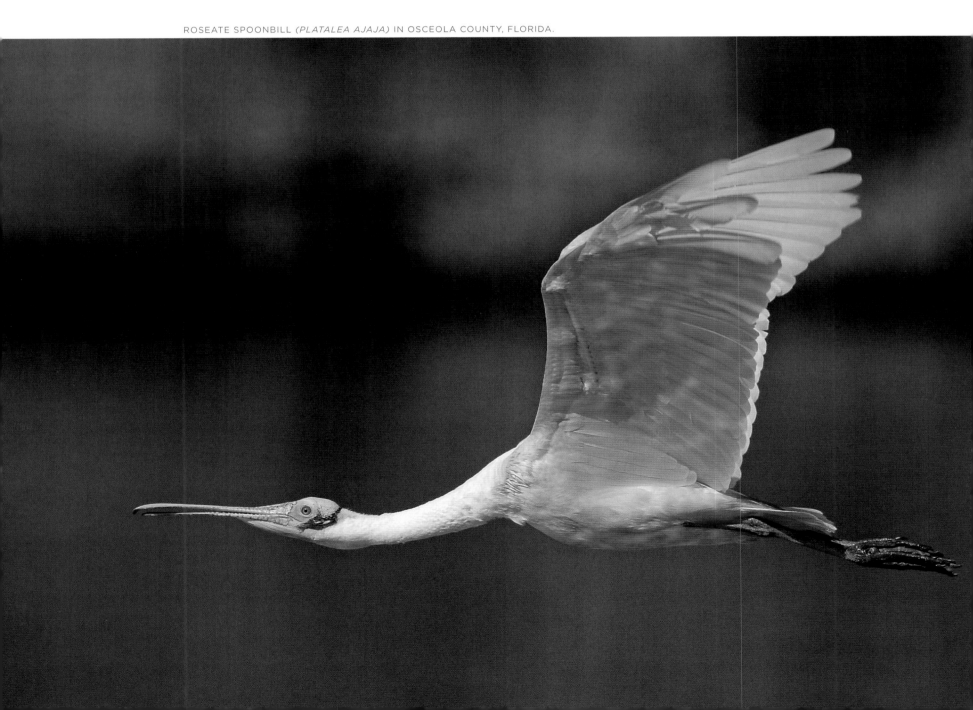

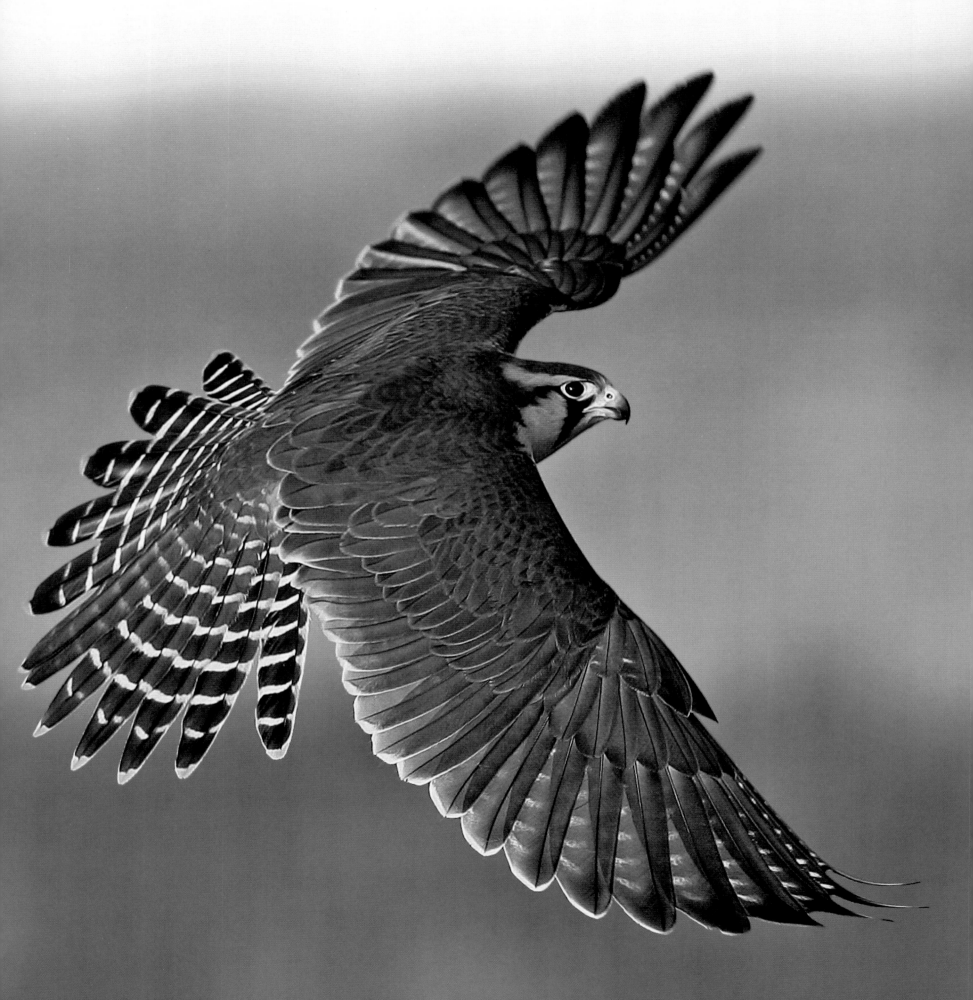

High Fliers, World Travelers, and Frightful Hunters

CATEGORIES OF BIRDS AND FLIGHT

Getting as many different species of birds into the pages of this book placed far behind choosing the absolute best flight shots reflective of genius, not genus. Even so, there are still many species to behold here, a fairly exhaustive cross section of the major genera of top-class flying birds. Because you can't tell the players without a scorecard, what follows is a somewhat reductive lineup according to general groupings, major traits, and in-flight behavior, such as migration patterns, altitude, speed capabilities, and so forth. One must bear in mind that these classifications do not mean that all the species within them do everything the same way. Birds just don't fly to the same beat, and they are most predictable in their unpredictability. However, it will help to establish some form of order and meaning to our flying circus by identifying them this way:

I. KILLERS ON THE WING

These birds, specially adapted for hunting, fall into four families, all within the order Falconiformes; nearly every bird in this order is carnivorous, ranging in size from the cinereous vulture, an impressive scavenger at 31 pounds (14 kilograms), to the black-thighed falconet, weighing in at 1 ounce (28 grams). From the family Falconidae, we have the crested caracara, aplomado falcon, gyrfalcon, merlin, peregrine falcon, prairie falcon, American kestrel, lesser kestrel, and nankeen kestrel. From the family Accipitridae, we have the bald eagle, white-tailed

OPPOSITE: APLOMADO FALCON (FALCO FEMORALIS).

eagle, white-bellied sea eagle, northern harrier, eastern marsh harrier, Cooper's hawk, ferruginous hawk, goshawk, Harris's hawk, red-shouldered hawk, rough-legged hawk, sharp-shinned hawk, black-eared kite, black-shouldered kite, snail kite, swallow-tailed kite, and griffon vulture. The lone representative of the family Pandionidae is the osprey. Lastly, the family Strigiformes includes the barred owl, burrowing owl, great gray owl, great horned owl, and snowy owl.

2. WINGS ALONG THE SHORE

There are a number of terrific migrators among the shorebirds, including the famous arctic tern and Atlantic puffin. There is some overlap between this group and the third, but the reason for that is the great variation within each of the three orders to which these birds belong. From Charadriiformes, representing waders and gulls, we have the American avocet, pied avocet, far eastern curlew, black-backed gull, silver gull, killdeer, American oyster-catcher, semipalmated plover, Atlantic puffin, black skimmer, arctic tern, common tern, least tern, whiskered tern, and lesser yellowlegs. From Ciconiiformes, we have the great egret, snowy egret, and white ibis, all of which are waders with long bills. From the web-toed order Pelecaniformes, we have the double-breasted cormorant, northern gannet, and Dalmatian pelican.

3. WINGS OF THE WETLANDS

Although some of the species that call wetlands home are great migrators, many of them keep to the water and only fly very short distances, usually to escape from predators. From Anseriformes, representing waterfowl, we have the bufflehead, common teal, Eurasian wigeon, hardhead, long-tailed duck, mallard, northern pintail, northern shoveler, white-winged scoter, and snow goose. From Charadriiformes, we have the black-necked and black-winged stilts. From Ciconiiformes, we have the gray heron, great blue heron, green heron, purple heron, tricolored heron, black-faced spoonbill, roseate spoonbill, and white stork. From Coraciiformes, which includes near passerine species of the Old World, we have the belted kingfisher, common (European) kingfisher, pied kingfisher, and white-throated kingfisher. From Gruiformes, which literally means "cranelike," we have the Eurasian coot and common (Eurasian) crane.

4. SONGBIRDS ON THE WING

Songbirds are mostly perching birds, or passerines, which are members of the order Passeriformes. This order, which comprises more than half of all living bird species, is represented here by the eastern meadowlark, barn swallow, and tree swallow. Also represented in this volume are the rainbow bee-eater, from the near passerine order Coraciiformes, and the ruby-throated hummingbird, from the order Trochiliformes (or Apodiformes, meaning "footless," which refers to the limited capabilities of the hummingbird's underdeveloped legs).

It is worth noting at this point that, although most of the birds that appear in this book are thriving in the wild, a handful are on the Red List issued by the World Conservation Union (known by its old acronym, IUCN, for International Union for the Conservation of Nature and Natural Resources). Among the birds of prey, lesser kestrels are listed as Vulnerable, which means they face a high risk of extinction in the wild, and ferruginous hawks are Threatened, which means that they may qualify as Vulnerable in the near future unless conservation measures are enacted. From the shorebirds, Dalmatian pelicans are considered Vulnerable, and from the wetland avians, black-faced spoonbills are Endangered, which means that they face a very high risk of extinction.

Now, to explain how and why they fly as they do, some essential physics of flight.

FACTORS OF FLIGHT BEHAVIOR

Ornithologists have determined four major types of wing structure: elliptical wings, high-speed wings, high aspect ratio wings, and soaring wings with slots. While there is plenty of variation among species, the birds in each group share some behaviors common to others with the same wing type. For instance, birds in most woodlands and shore areas such as songbirds, crows, quails, and grouse have elliptical wings, which are short and broad, the better to maneuver through dense woods. Thus, with a few exceptions, these birds aren't apt to break airspeed records, or altitude records for that matter, as their anatomy best suits brief bursts of flight at shallow heights.

Many of a bird's capabilities are also determined by its habitat. Forest hawks and barred owls also have elliptical wings, but other hawks and owls that live in open areas have long and narrow wings—the signature of high-speed wings. This crowd includes falcons, swifts, terns, and a good many shorebirds. These are powerful fliers that feed on the wing and dive-bomb their prey, expending fantastic

NORTHERN FLICKER *(COLAPTES AURATUS)* AT JONES BEACH, NEW YORK.

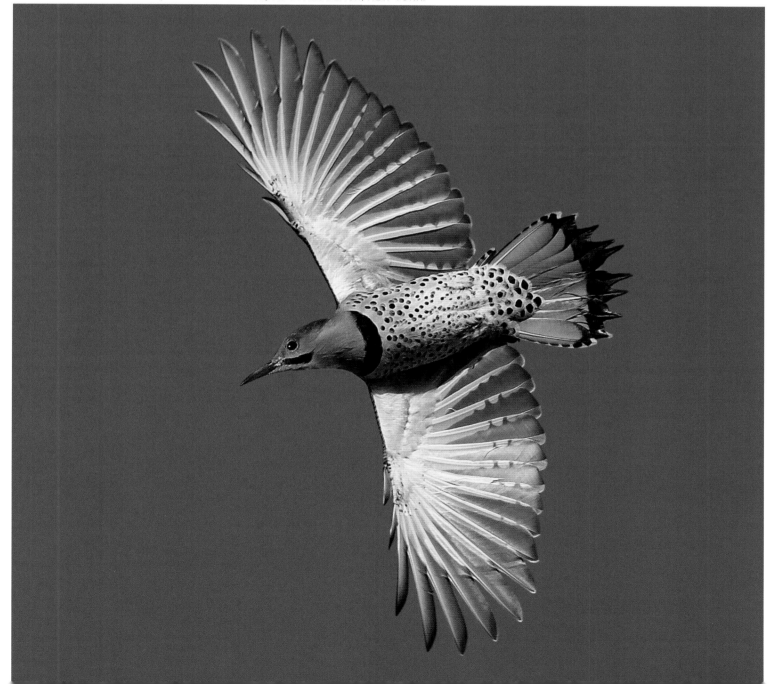

energy with their furious wing-flapping. They are sleek and gorgeous, their bodies tightly tapered and their wings pointed backward.

But high-speed fliers pay a price for all that energy: They can't stay aloft for long. That is the province of the birds with slotted, high-lift wings, the distance fliers that keep us mesmerized, inspiring poetry with their effortless soaring across the field of vision. One of their rank, of course, is the symbol of America, gracing its skies and its currency. But eagles, bald or otherwise, are no more graceful or high-climbing than the less endearing birds in this class, such as hawks and vultures, perhaps the most frightful of all winged things. All of these species are big (the critically endangered Philippine eagle, which is one of the largest birds in the world, can grow more than 3 feet [1 meter] long) and fierce, with eyes that can make a grown man wither. Their wings spread as wide as 6 feet (2 meters) and more, and their outer primary wing feathers are slotted, or notched, for greater flight stability and lift. The wings themselves are rounded and the tails are thick, allowing the birds to circle the upper reaches of the sky, slowly and determinedly, scoping out their prey below. When they attack, they do so with devastating quickness, never even touching down to make the kill.

These birds expend very little effort to dominate the sky, and they have ways to make it easier to stay airborne. One way is to ride columns of warm, buoyant air rising from sun-baked mountainsides (or even asphalt parking lots) in the summertime. During migration periods, a single hawk or eagle riding an updraft will often transform into a feathery convoy, with hundreds sharing the magic carpet ride, from one front of warm air to another, all the way across an entire country or continent, maintaining heights of 6,000 feet (1,829 meters)—yet using only a small fraction of the energy they would have required without the updrafts. Neither does a hawk mind a bit going out of its way to avoid large bodies of cold water that don't reflect heat upward, especially if there's no strong headwind to help it get aloft. Hence, an optimum vantage point for viewing migrating hawks in North America is along the shorelines of the Great Lakes, which they circuitously trace from above on the journey westward.

MIGRATION

Shorebirds may not be the highest or longest fliers, but they are probably the hardiest, simply because they make the longest migrations. Many of these birds traverse not only continents but hemispheres and oceans as well, and with clockwork precision. No surprise that they're built for distance, being small to medium in size with slender, probing bills and long, streamlined legs and tails. There are sandpipers that set out from South America, Australia, Africa, or the South Pacific Islands and wind up in the high Artic regions of Canada before reversing their trip in the fall. Some plovers summer along the Siberian and Alaskan coastlines, then head for the lush beaches of the Hawaiian Islands for the winter. No birdbrains, these.

The distances covered by migrating shorebirds would seem mythic if they weren't so well documented. An arctic tern can, and does, log around 24,000 miles (38,625 kilometers) of travel in a single year—about equal to Earth's circumference. But at least they can land on water and feed themselves en route to wherever they're going. The blackpoll warbler cannot, yet it treks nonstop over water from the northeast United States to South America. That's four straight days and 2,480 miles (3,991 kilometers) in the air. Such large, strong shorebirds, with no need to descend, can find a comfy cruising altitude at 15,000 feet (4,572 meters). And where there are high, mountainous regions to traverse, their innate navigation systems guide them even higher.

Once again, though, you cannot always judge a bird by its grouping; astonishingly, some vultures and crows

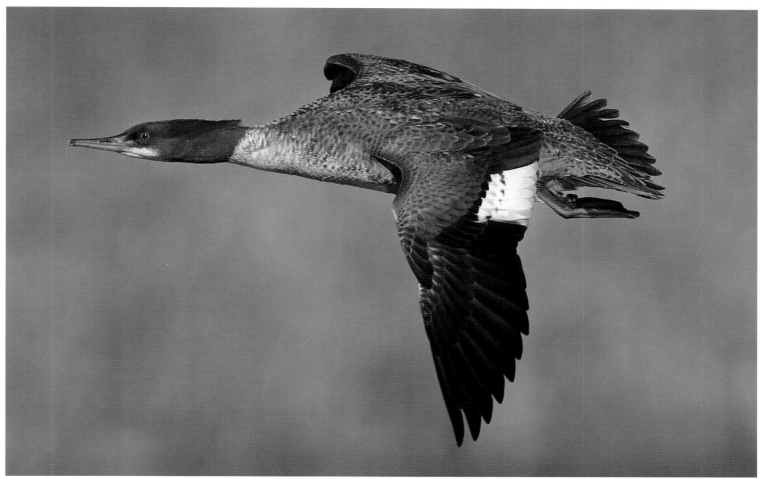

COMMON MERGANSER *(MERGUS MERGANSER)* AT LAKE ONTARIO IN WHITBY, ONTARIO, CANADA.

have been recorded at heights of nearly 28,000 feet (8,534 meters). While it's hardly uncommon for birds to fly into airplanes at low altitudes, a mallard once reportedly smacked into a plane at 21,000 feet (6,401 meters). First prize, however, goes to the African vulture that struck a plane at 37,000 feet (11,278 meters) above the Ivory Coast.

Migration patterns can help a birder gauge where and when certain high-flying birds might appear. Hawks, as mentioned, avoid flying over large bodies of water and stick to the shorelines. But flocks of migrating birds don't fly low enough for humans on the ground to make out individuals (some birds, including songbirds, also migrate almost solely at night). Only when migrations are disrupted by stormy weather or high winds do they come down into sight range. Hurricanes that bleed north along coastal areas from equa-

torial oceans can yield some truly spectacular opportunities to spot rarely seen species, such as albatross, petrels, skuas, and frigate birds. By contrast, the lusty winds of a cold front might just as easily shove flocks of migrating raptors farther down the coastlines than one might expect them to be. Moral: Don't get too comfortable with the patterns; birds will always keep you guessing.

HUNTING

Birds are obsessed with finding a good meal. For most humans, the hunt for food is no more arduous than a trip to the kitchen. For birds on the wing, it's the entire basis of survival, a shadow dance of flight and fight, a routine of eating or being eaten—an acrobatic show of stalking,

zeroing in, making the kill, and carrying off the victim. The actual consumption part is the least of it; it's the conquest that makes it compelling, more so given that this fierce and athletic ballet can take place completely airborne. In fact, some of the most dizzying shots in this book capture birds not just on the wing but also on the hunt.

All birds become hunters at some point, and whether the victim is a fish, a bug, or another bird, a bird's eyes are most intense at the point of attack. The great gray owl, for example, seems like a fairly placid bird. It can't fly more than short distances and is usually seen on a perch, taking in the world like an elderly man on a park bench. But all that saved energy comes to life in an instant when the great gray owl goes on the prowl, morphing into a killing machine, springing into action with large, heavy wings, and swooping without a sound upon its prey. Some owls will even hover like hummingbirds while configuring the attack, just before plucking a small bird out of the air with their thick, gnarly talons. Some can emulate black skimmers, surfing the surface of the water for a fish. There is actually a species called the hawk owl, for obvious reasons: One of its talents is funneling under snowbanks for its prey. Some owls prey on cats, small dogs—even turkeys. The idea that owls are peaceful observers is, well, a hoot.

The most ferocious hunters, not surprisingly, come from the raptor group. There is a reason why the word "raptor" is derived from the Latin word for "plunderer." Most raptors—falcons, hawks, eagles, ospreys, accipiters,

vultures, and, yes, owls—must kill other animals to survive. The faster they are, the more the odds shift in their favor, though all hunting birds start with an advantage: sharp claws and sharp vision. It has been determined that a hawk's eye, with its bulbous cornea, can focus eight times faster than the human eye, making photographs of hawks extra-extraordinary. Anyone lucky enough to train a camera lens fast enough on a hawk should be aware that if it has seen you, it will likely have determined your intentions before you get to press the shutter button and will either be gone from range or coming at you to scare you to death. The latter is something of an occupational hazard for photographers who court birds of prey, and those birds seem to get a great kick out of doing it.

Raptors have a wide range of evolutionary adaptations for hunting. From a purely physiological perspective, hawks, for example, are closer throwbacks to the flying reptiles of the dinosaur age than any other bird. Indeed, hawks even have a vestigial tooth on the ridge of the upper mandible that locks onto and severs the neck bones of its prey. Other raptors have a long hook on the mandible to snare crawling insects. Ospreys have bristly spines called spicules, which are perfect for holding squirmy fish.

Given all the factors of flight and all the options nature has provided birds of every stripe and habit, how can one possibly hope to isolate the peak fraction of a second when they are at their most kinetic, frenetic, and imposing? It is here that art meets ornithology.

*B*ehind the Camera

*W*e conclude with a brief note on the bird photography in this volume itself. Seven very different people from very different backgrounds and geographical areas united to create this book with a very singular vision: getting the ultimate shots of birds in flight. And though you see birds in their photographs, you are also seeing that vision combined with the commitment and the daring to make the impossible seem remarkably routine—preserving freeze-frame images of birds at their most spectacular with crystal clarity, focus, and a liquidity of movement and aestheticism.

You may be inclined to wonder at the nuance and detail of some of these birds, like delicate Chinese art, and the blurry ferocity of others. Bird photography is a feast of boundless energy and private dramas too busy for human eyes to follow. At any given moment are daredevil feats of derring-do, blatant showing off, dive-bombing to and even beneath the water's surface for fish, and quickly formed patterns of flight joined by more and more birds,

easing right into the pack at full speed without losing a beat. There are physical and verbal mating rituals that clearly render bird swains as goofy as any of us when we're smitten by that certain someone. There are female and male birds feeding their young in midair. There are ferocious battles between birds and against other animal predators, fighting for their lives or to protect their progeny— a challenge that can turn a tiny bluebird into a crazed killer capable of tearing a hawk to shreds.

I've seen that killer look in a bird's eye from what might seem to be uncomfortably close range—and a vantage point that, to most wildlife photographers, would seem too close to focus a camera with a steady hand. The first rule of extreme bird photography: Get close enough to see the bird's eye. I always wondered why it was that birds, so full of motion and so dramatic to the naked eye, always seem to look static in photographs. Where was that great swirl of activity, and where were those manic moods? The photographs in these

pages represent birds as they really are and serve as a visual ode to the bird kingdom as you have probably never seen it in pictures before. By this, I mean both the outer characteristics of some of the most delightful and transfixing birds on Earth—and the inner bird you may not have known existed.

You may not believe this, but Zen and bird-watching are related. To be sure, everything in the animal kingdom shares a passion for living in peace and tranquility within our natural boundaries. I'm hardly the Long Island version of the Dalai Lama, but one of the most crucial areas of development in my work is the idea of yin and yang, finding a balance in life between give and take. People

spend a lifetime seeking this, but that's not my suggestion. Put simply, the concept is this: You can't find the inner bird unless you find the inner you. Doing so will allow you to respect your subjects. Stalking the wild bird definitely won't get you there, so don't think that way. You won't be stalking anything. You must enter the bird's space and make a connection. That means losing any notion of superiority. Once in that space, you will find yourself in the Zen—and in the zone. The photographs in this volume came from within that zone.

There's an old Zen proverb: Seeing is being able to tell your story. My colleagues and I believe that every picture in these pages does just that.

JUVENILE BLACK SKIMMER *(RYNCHOPS NIGER)* AT NICKERSON STATE PARK IN LIDO BEACH, NEW YORK.

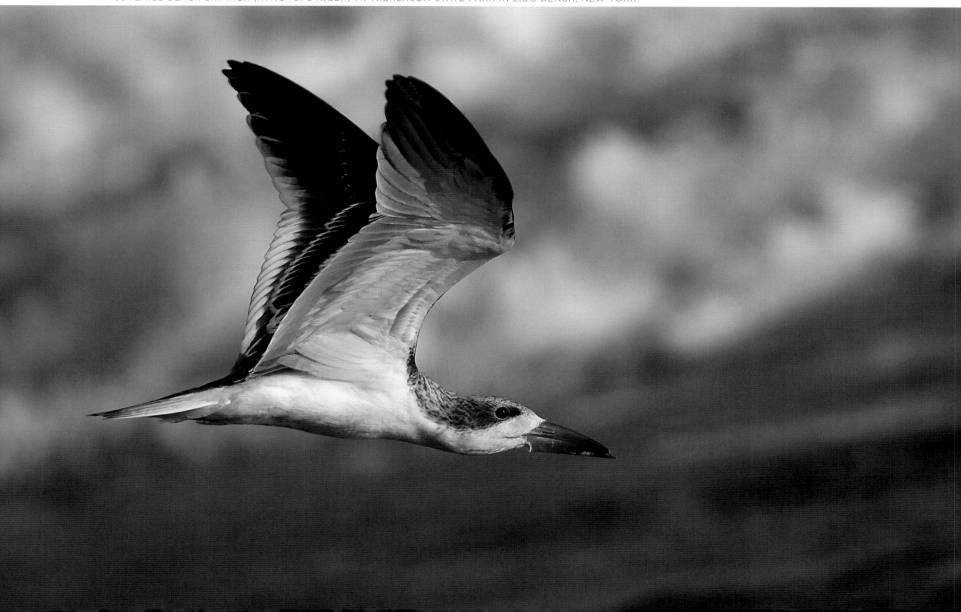

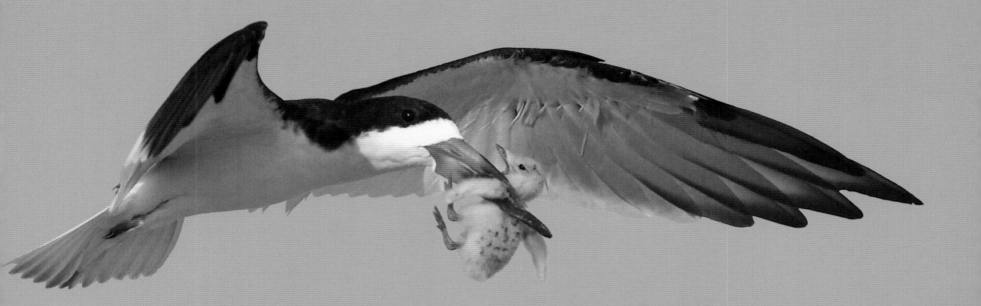

Plates

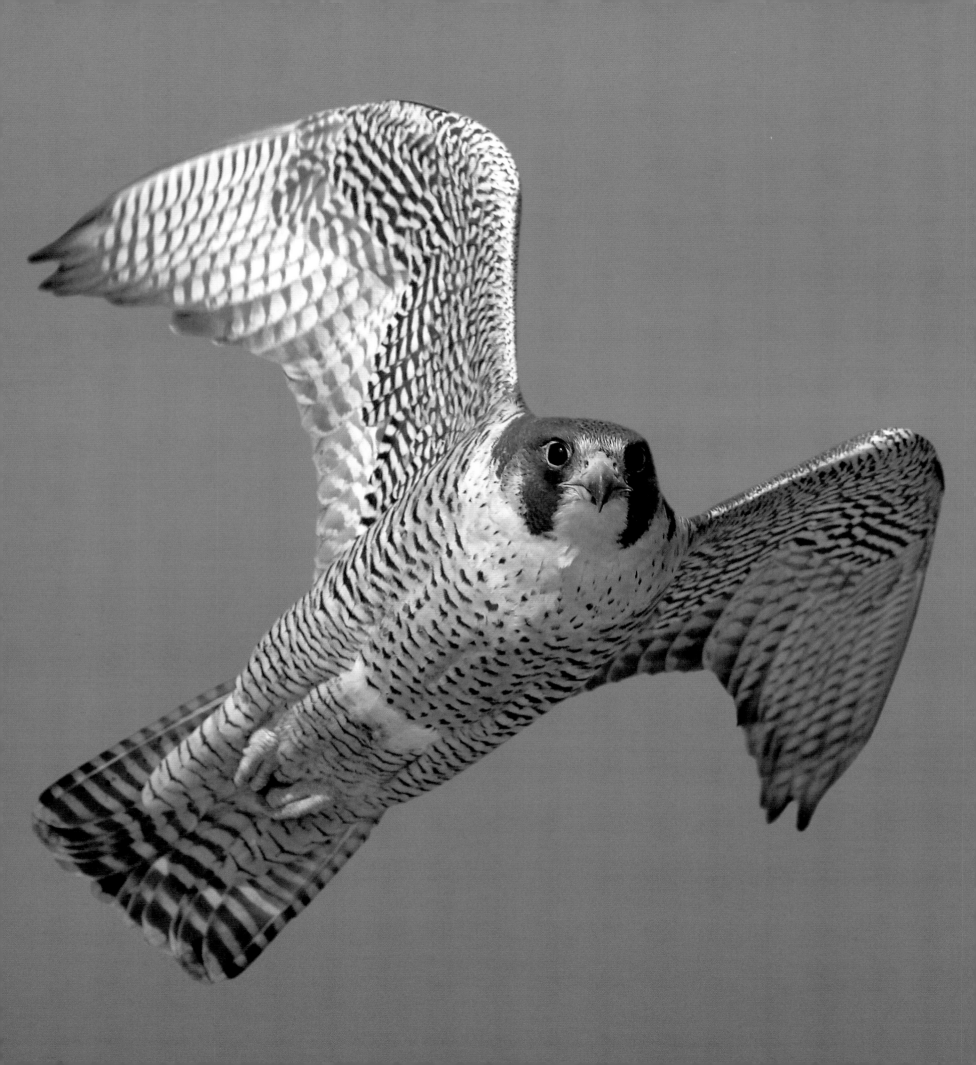

Killers on the Wing

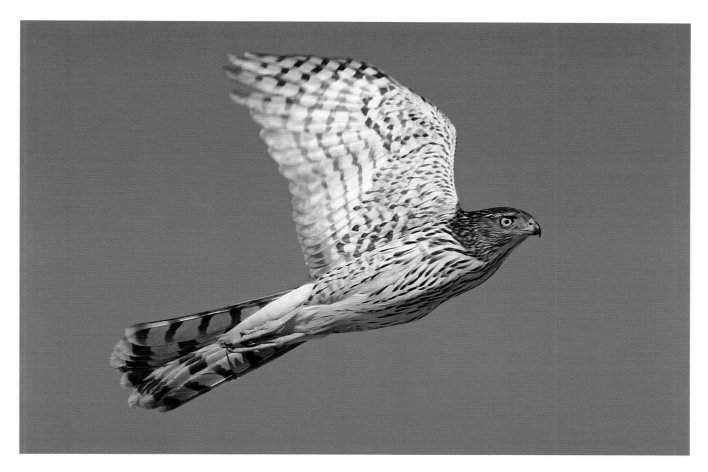

OPPOSITE: *Falco peregrinus.*

HABITAT AND RANGE: Forests, coastlines, and urban areas on every continent except Antarctica. Subspecies *tundrius* and *calidus* are migratory.

ABOVE: *Accipiter cooperii.*

HABITAT AND RANGE: Forests from southern Canada to northern Mexico. Northern populations are migratory.

A PEREGRINE FALCON at Floyd Bennett Field in Gateway National Recreation Area dive-bombs the photographer in this full-frame underbelly shot, which reveals the big, round eyes and hooked beak of the fastest bird in the world—usually all a blur, especially when it's zooming more than 200 miles (322 kilometers) per hour. *Brooklyn, New York.*

Taken during hawk migration season, this shot of a COOPER'S HAWK, named after American Museum of Natural History cofounder William Cooper, captures the bird's butter-smooth grace as it glides over the sand dunes. Although permanent populations of Cooper's hawks are found all over the continental United States, flocks in the northern parts of the species' range may migrate as far south as Panama. *Jones Beach, New York.*

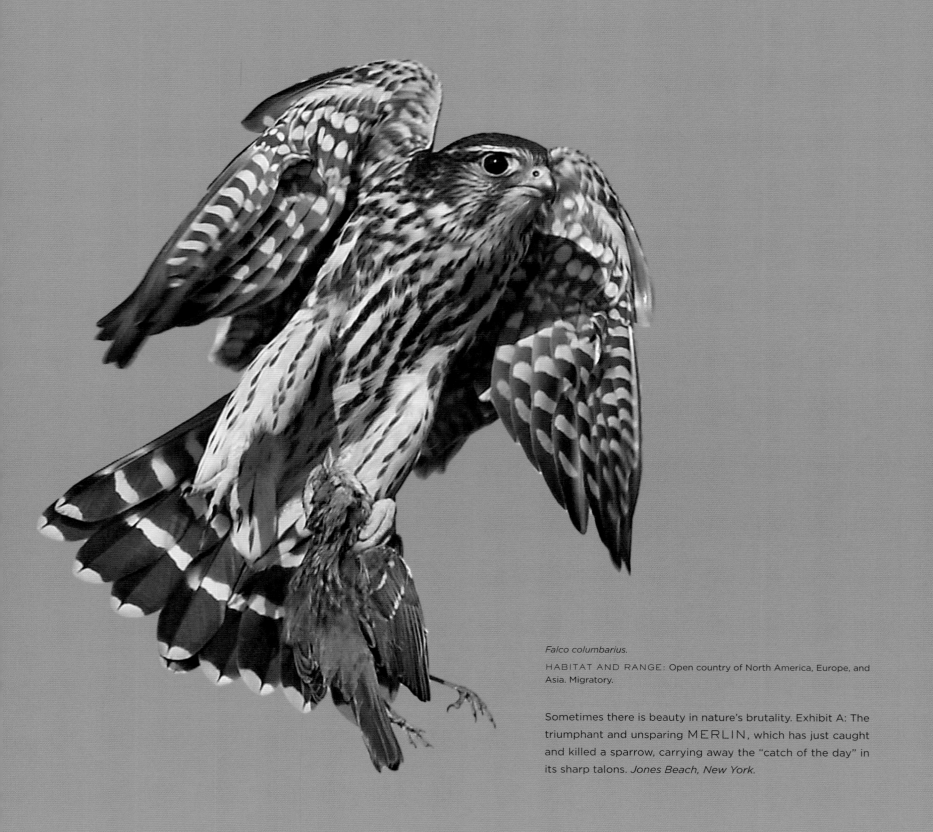

Falco columbarius.

HABITAT AND RANGE: Open country of North America, Europe, and Asia. Migratory.

Sometimes there is beauty in nature's brutality. Exhibit A: The triumphant and unsparing MERLIN, which has just caught and killed a sparrow, carrying away the "catch of the day" in its sharp talons. *Jones Beach, New York.*

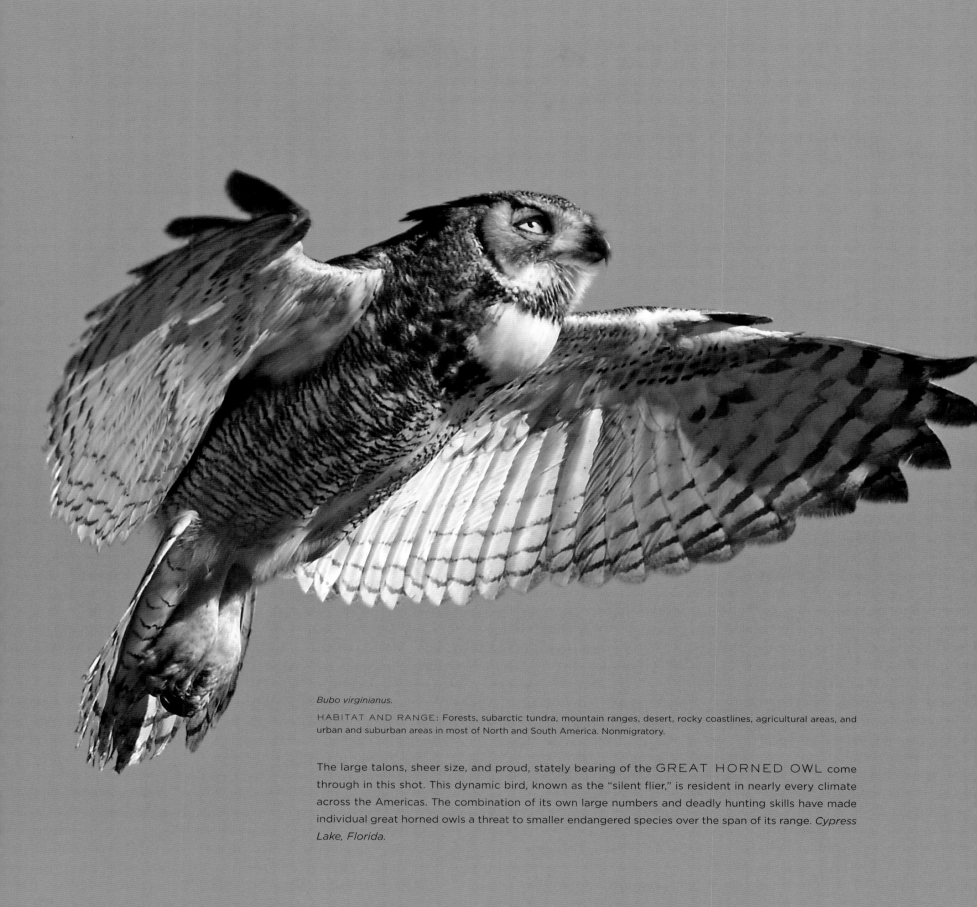

Bubo virginianus.

HABITAT AND RANGE: Forests, subarctic tundra, mountain ranges, desert, rocky coastlines, agricultural areas, and urban and suburban areas in most of North and South America. Nonmigratory.

The large talons, sheer size, and proud, stately bearing of the GREAT HORNED OWL come through in this shot. This dynamic bird, known as the "silent flier," is resident in nearly every climate across the Americas. The combination of its own large numbers and deadly hunting skills have made individual great horned owls a threat to smaller endangered species over the span of its range. *Cypress Lake, Florida.*

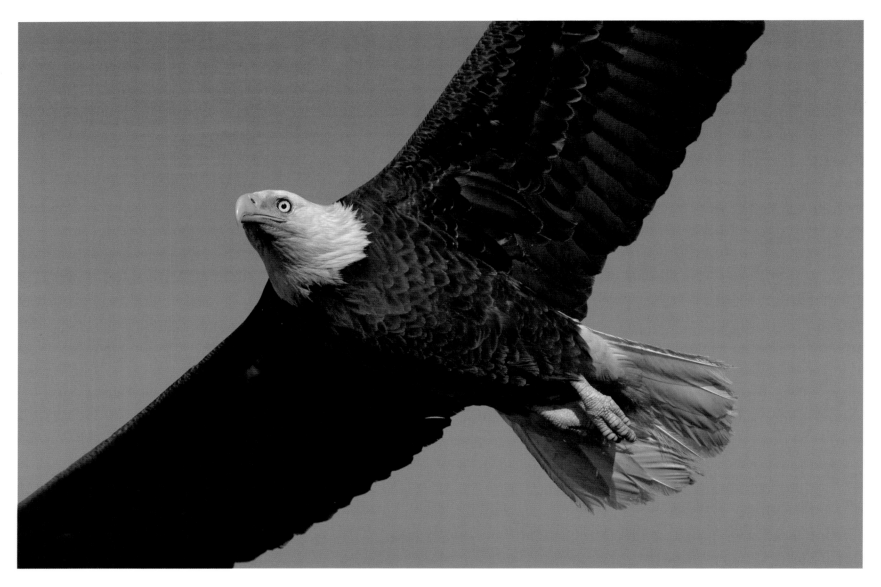

ABOVE: *Haliaeetus leucocephalus.*

HABITAT AND RANGE: Forests, river valleys, and coastlines across North America and Mexico. Partially migratory.

Also known as the AMERICAN BALD EAGLE, this keen-eyed predator narrowly beat out the wild turkey to become the national emblem of the United States in 1782. That terrifying glint in this eagle's yellowish eye reveals what makes the bird such a formidable hunter; nearly deaf, bald eagles rely on their sharp sight to spot and attack their prey—mostly fish—at great speeds. *St. McCloud, Florida.*

OPPOSITE: *Athene cunicularia.*

HABITAT AND RANGE: Grasslands and urban and suburban areas in North and Central America and parts of South America. Northern populations are migratory.

As their name suggests, BURROWING OWLS often burrow in soft, sandy ground, but they also take up residence in people's yards. In fact, in some parts of Florida, laws are on the books protecting the birds' squatters' rights: Because the owls were residents before people were, humans cannot disturb their nests at the risk of a heavy fine. *Cape Coral, Florida.*

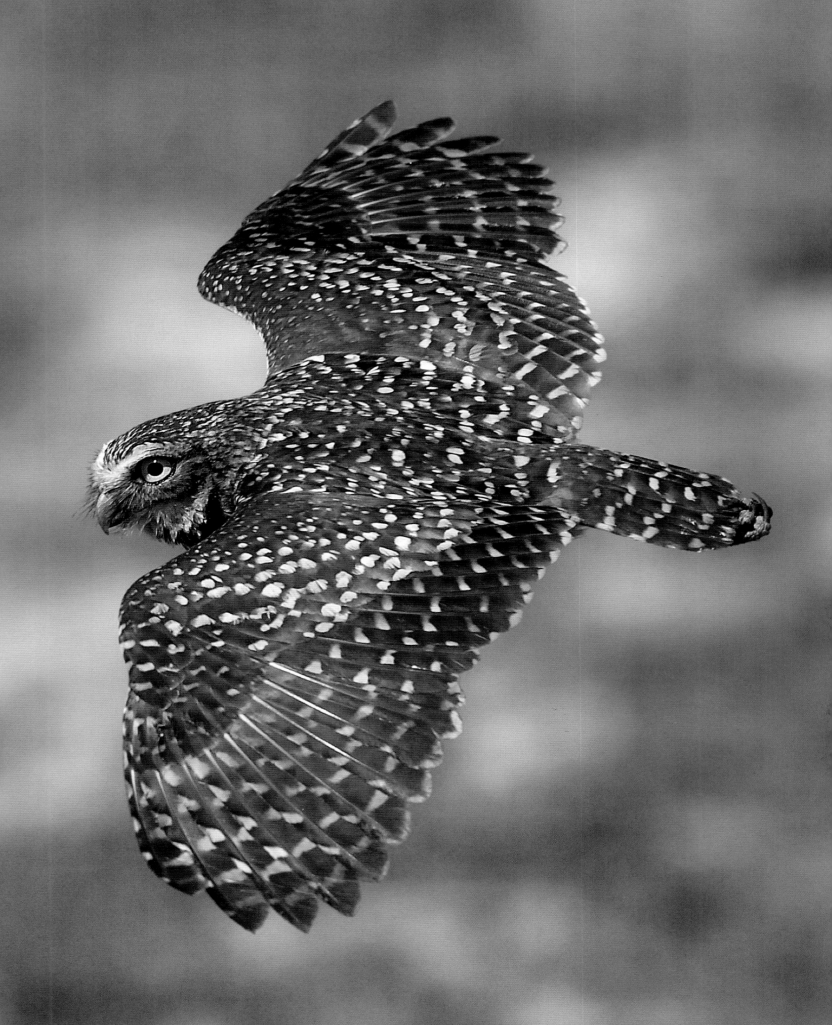

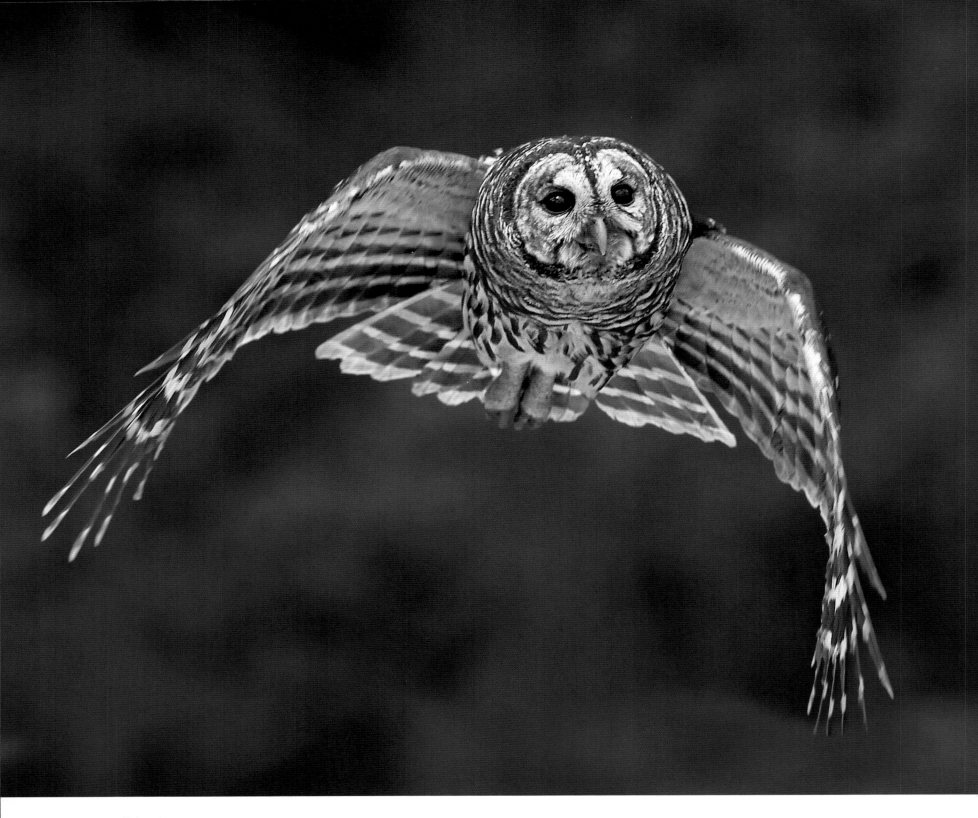

Strix varia.

HABITAT AND RANGE: Forests in the eastern United States, Canada, and parts of Central America. Nonmigratory.

The BARRED OWL, usually a nocturnal flier, decided to come out in the late afternoon. Although the barred owl is a fearsome predator in its own right, threatening populations of the northern spotted owl in the Pacific Northwest, its gravest enemy is the great horned owl, with which it shares much of its range. *Osceola County, Florida.*

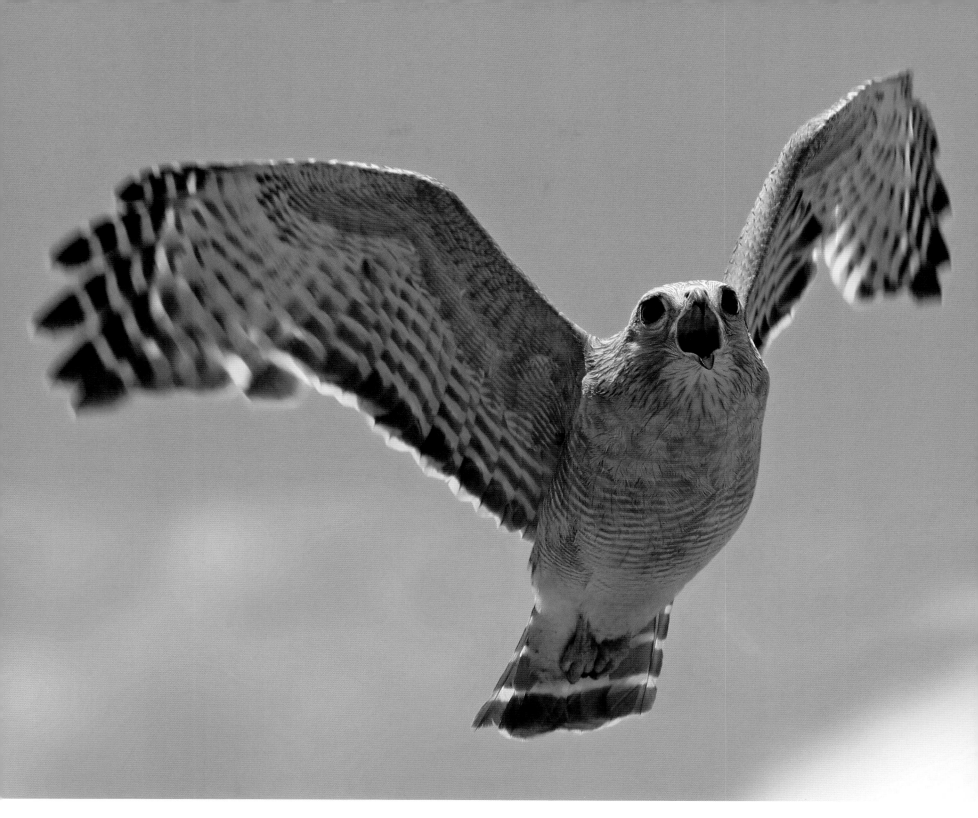

Buteo lineatus.

HABITAT AND RANGE: Forests in North America. Northern populations are migratory.

This RED-SHOULDERED HAWK at the J. N. "Ding" Darling National Wildlife Refuge means business, as is clear from the "get outta my way" expression on its face. Although the young of these medium-size hawks are often preyed upon by bulkier great horned owls, a pair of red-shouldered hawks have been observed turning the tables: tag-teaming an owl and stealing a nestling in retaliation. *Sanibel Island, Florida.*

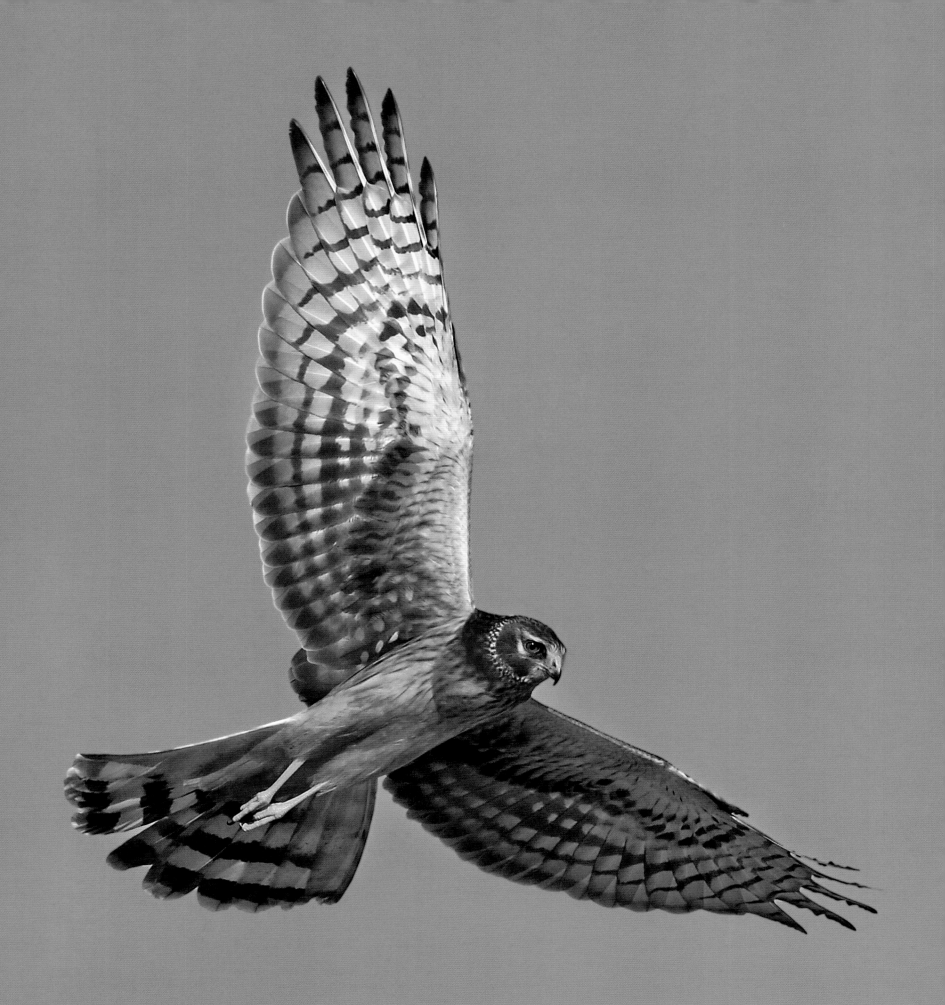

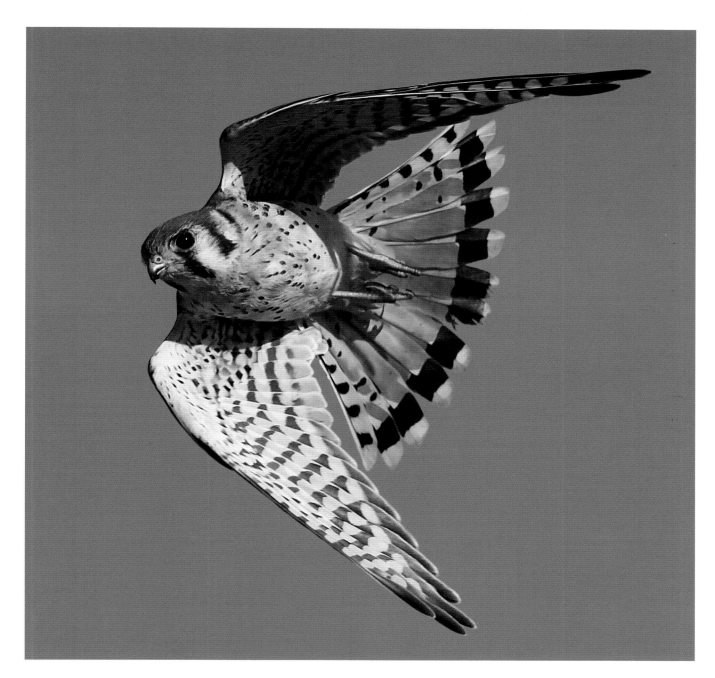

OPPOSITE: *Circus cyaneus*.

HABITAT AND RANGE: Forests, grasslands, wetlands, and open country of North America, parts of South America, Europe, and Asia. Migratory.

The United States Air Force's Harrier jet is fast, graceful, and incredibly sleek. So, too, is its namesake the NORTHERN HARRIER, a species characterized by a wide, aerodynamically perfect wingspan, light body, and awesome fanned tail. However, the harrier is a skittish, elusive sort of bird, and this specimen seems to be eying the camera with some concern. *Jones Beach, New York.*

ABOVE: *Falco sparverius*.

HABITAT AND RANGE: Forests, grasslands, open country, and urban and suburban areas in North and South America. Migratory.

This migrating AMERICAN KESTREL has been caught with its head turned, looking askance, offering a rare glimpse into the eyes—and thus, the personality—of the most common falcon in the Americas. *Jones Beach, New York.*

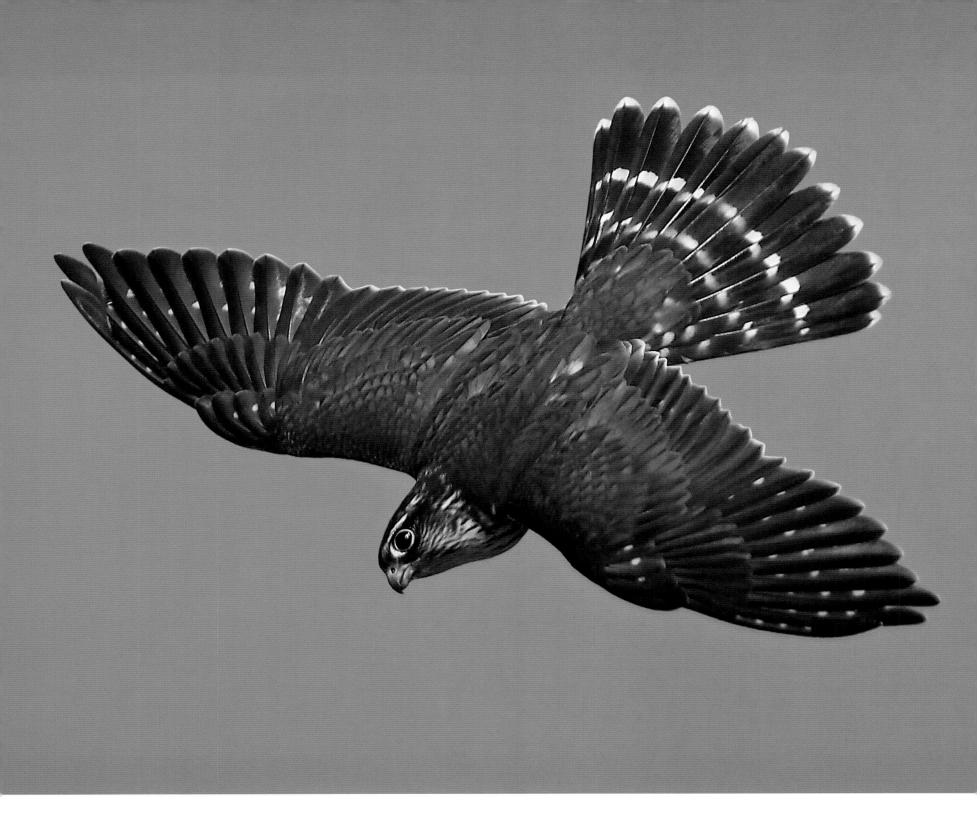

Falco columbarius.

HABITAT AND RANGE: Open country of North America, Europe, and Asia. Migratory.

Members of the falcon family, MERLINS typically fly low to hunt their prey, relying chiefly on speed and agility rather than the element of surprise. This merlin, however, is dive-bombing its target, probably a smaller bird, from way up in the air. *Lido Beach, New York.*

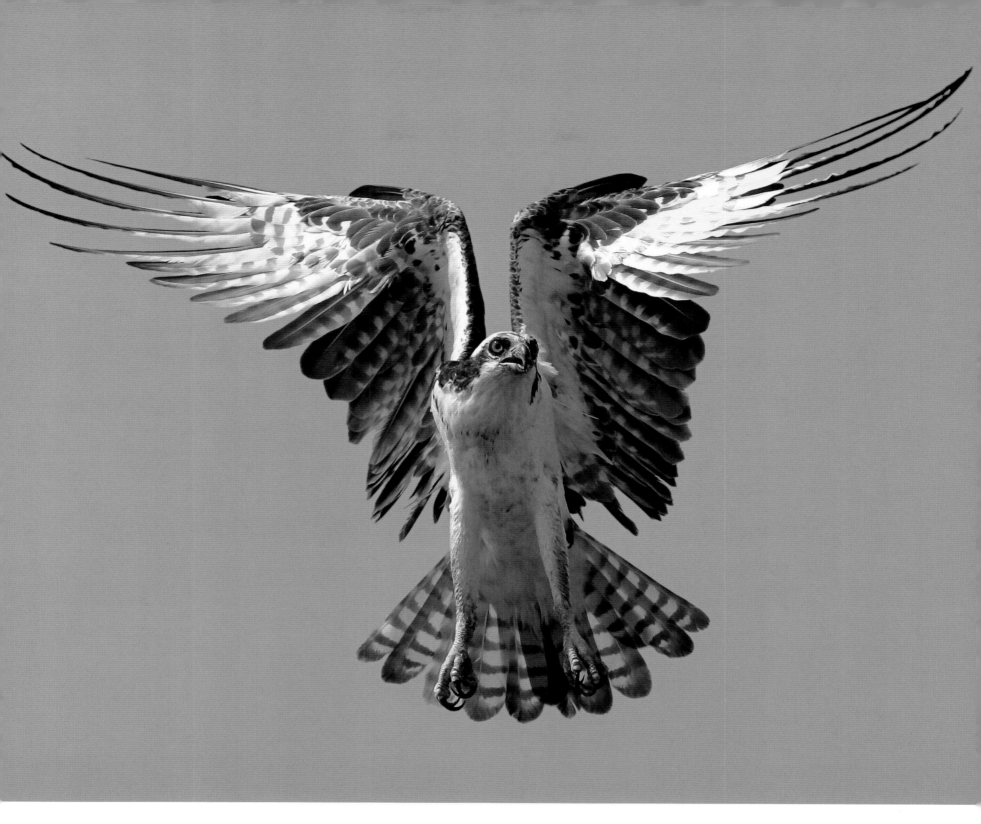

Pandion haliaetus.

HABITAT AND RANGE: Forests and wetlands on every continent except Antarctica. Migratory.

Fearful symmetry, indeed. This OSPREY, flying over Oceanside Marine Nature Study Area, is perfectly intimidating, and one almost feels lucky that its attention is elsewhere. Ospreys are consummate killers by design, with barbed pads on the undersides of their feet to help grip the slippery fish they grab straight from the water. *Oceanside, New York.*

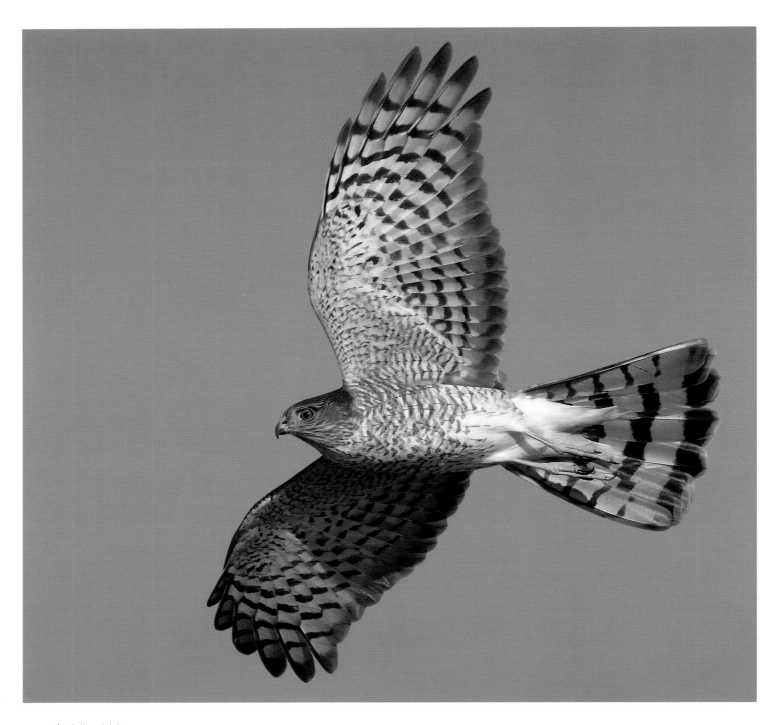

Accipiter striatus.

HABITAT AND RANGE: Forests of North America. Migratory.

The smallest members of the hawk family in North America, SHARP-SHINNED HAWKS typically fly in irregular, almost evasive patterns, using the element of surprise to capture unsuspecting birds—sometimes more than twice their weight! This hawk was soaring high during a late-October migration, although the birds are increasingly opting out of wintering in the South, in favor of a more reliable food source: the denizens of suburban bird feeders. *Jones Beach, New York.*

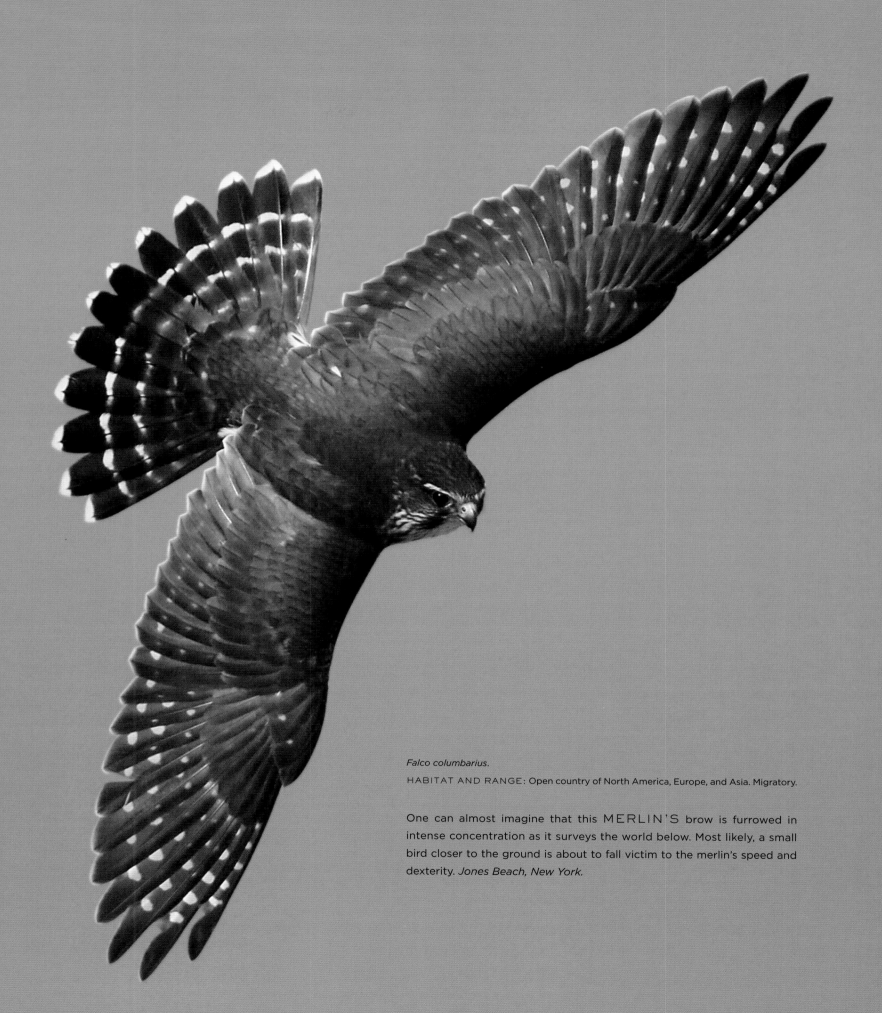

Falco columbarius.

HABITAT AND RANGE: Open country of North America, Europe, and Asia. Migratory.

One can almost imagine that this M E R L I N ' S brow is furrowed in intense concentration as it surveys the world below. Most likely, a small bird closer to the ground is about to fall victim to the merlin's speed and dexterity. *Jones Beach, New York.*

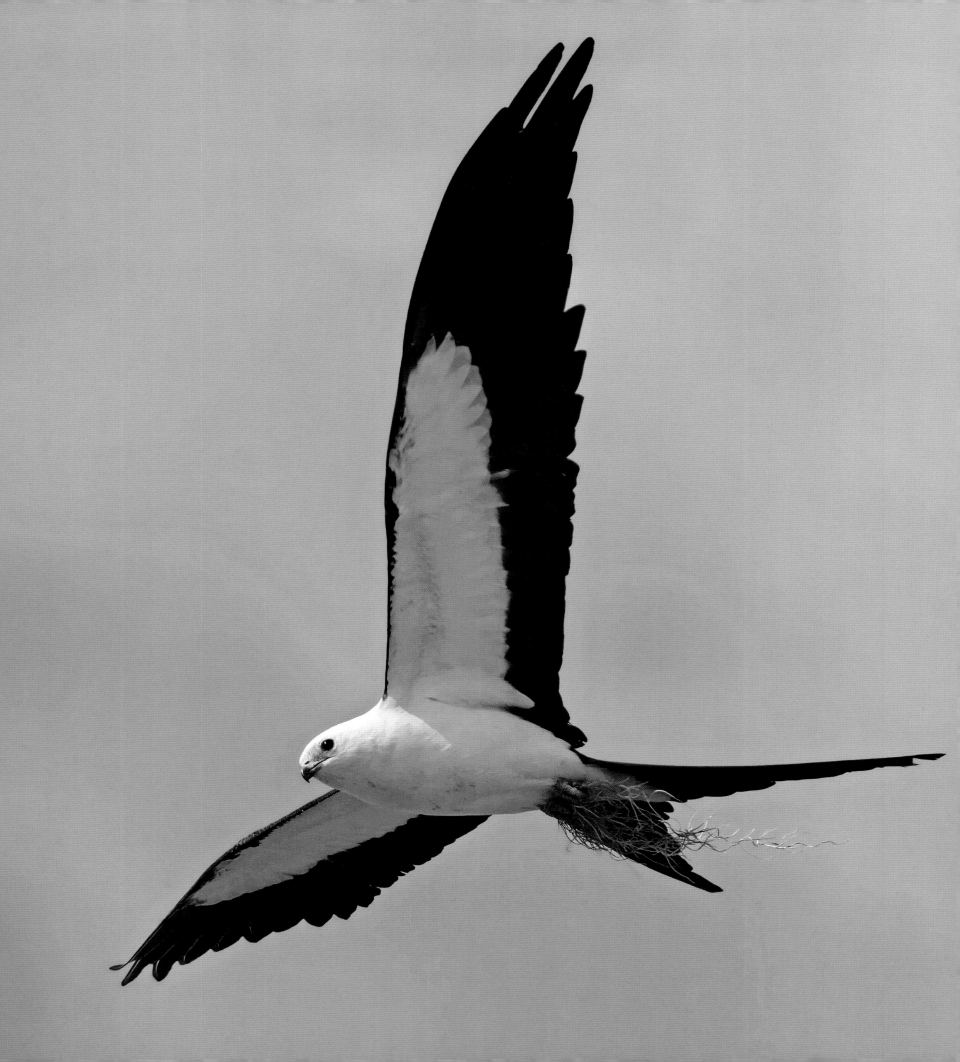

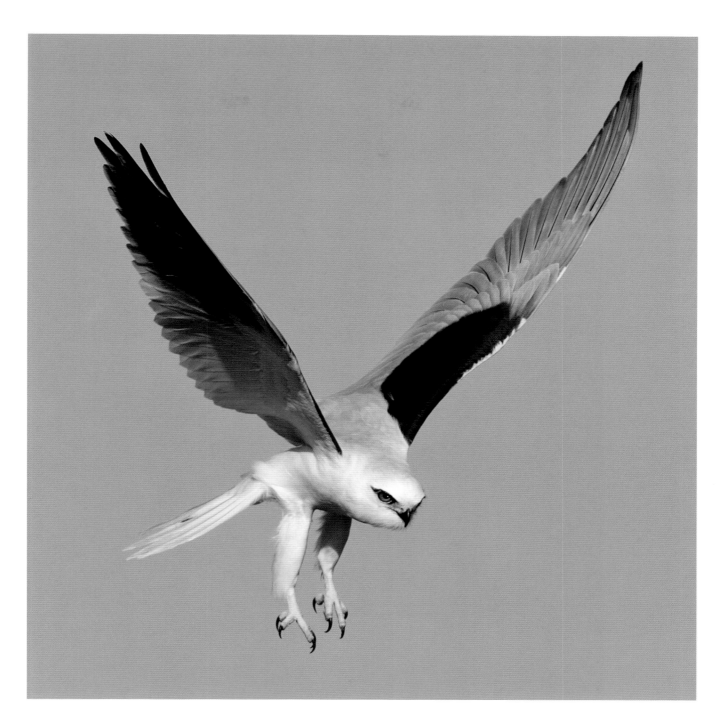

OPPOSITE: *Elanoides forficatus.*

HABITAT AND RANGE: Forests and forested wetlands of southern United States and South America. Migratory.

This SWALLOW-TAILED KITE is flying down low to grab some Spanish moss off the treetops to build a nest. Although these kites are not listed as threatened by the federal government, they are considered endangered in South Carolina and Texas and rare in the state of Georgia. Destruction of habitats is chiefly responsible for the recent decline in their numbers. *Everglades, Florida.*

ABOVE: *Elanus axillaris.*

HABITAT AND RANGE: Open country throughout Australia. Non-migratory.

Long wings spread, claws unfurled, and beady red eyes focused, a majestic BLACK-SHOULDERED KITE drops from the sky overhead, its gaze trained on a rodent with no chance of escape. Like other elanid kites, this species specializes in hunting rodents, thriving almost exclusively on mice. *Sydney, Australia.*

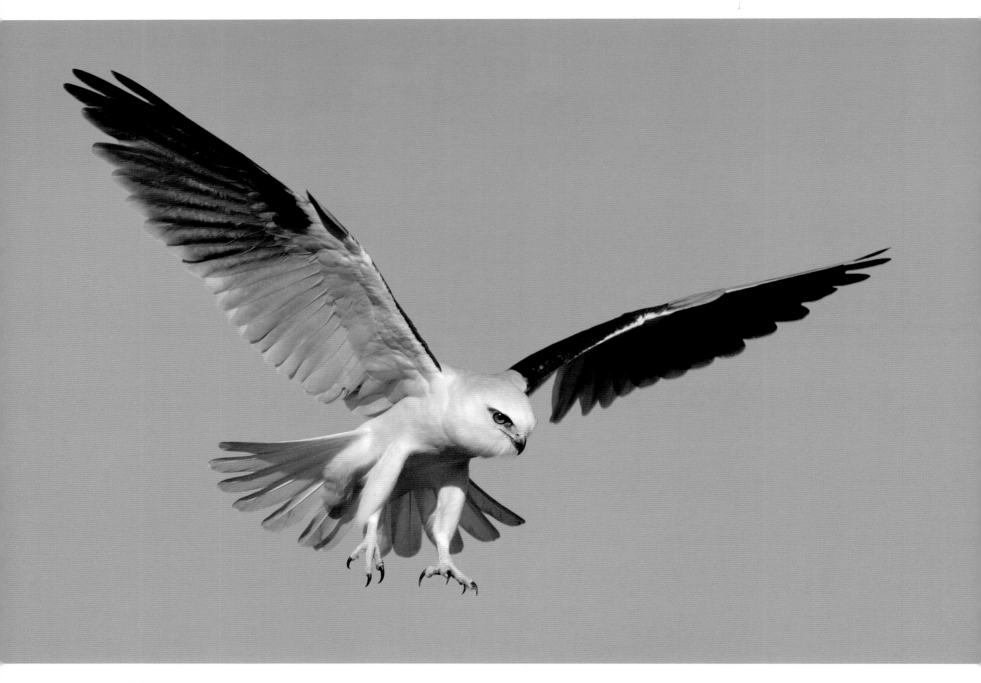

Elanus axillaris.

HABITAT AND RANGE: Open country throughout Australia. Nonmigratory.

Just before making the kill, this BLACK-SHOULDERED KITE fans out its tail feathers to slow the breakneck speed it has built up during the dive. Expert hunters, these kites have been observed to catch as many as fourteen mice in a single hour. *Sydney, Australia.*

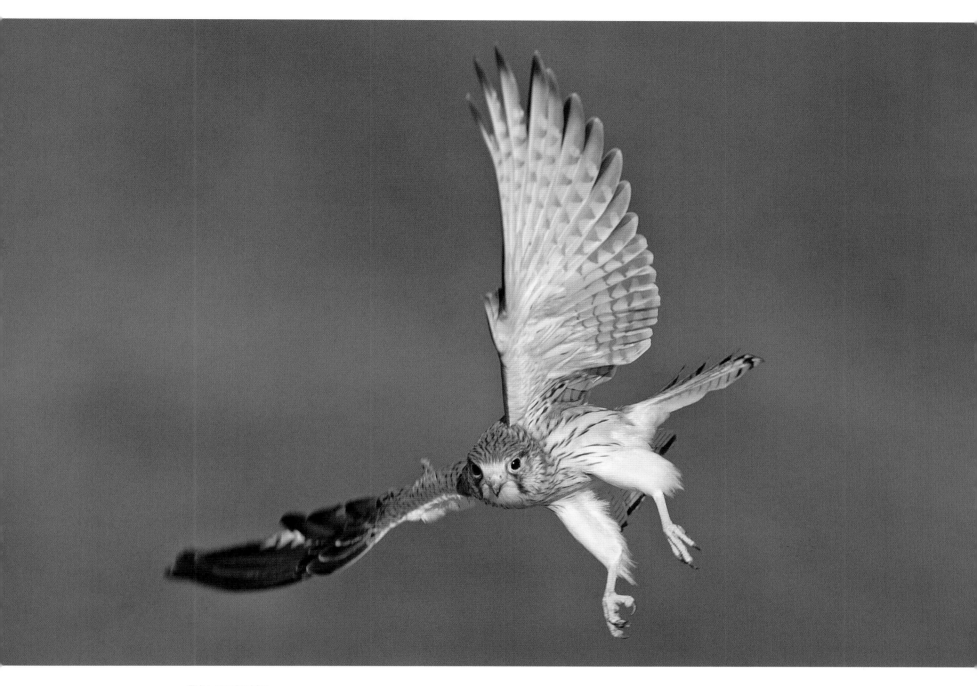

Falco cenchroides.

HABITAT AND RANGE: Wetlands and open country of Australia. Migratory.

A young and hungry NANKEEN KESTREL aligns its claws, setting its sight on a clutch of crickets on the ground. Neither large nor quick, this Australian kestrel species often hovers, almost motionless, over crops and grasslands to spot—and then snap up—its prey. *Sydney, Australia.*

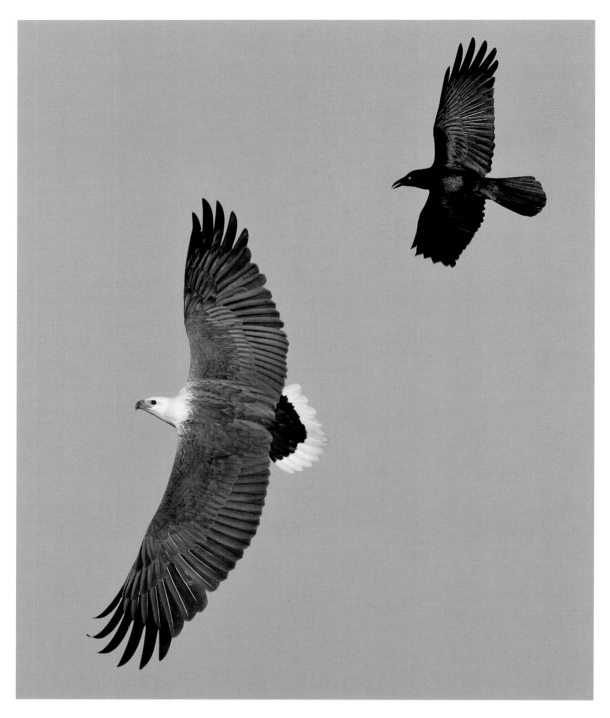

Haliaeetus leucogaster.

HABITAT AND RANGE: Coastlines and major waterways of southeast Asia and Australia. Nonmigratory.

Corvus coronoides.

HABITAT AND RANGE: Urban and suburban areas of Australia. Nonmigratory.

As this WHITE-BELLIED SEA EAGLE flew over Centennial Park, it had to keep an eye on an Australian raven bent on harassing it, as often happens when these two birds meet. Neither of these species is above stealing food from the other, although ravens are more notorious as scavengers than sea eagles. *Sydney, Australia.*

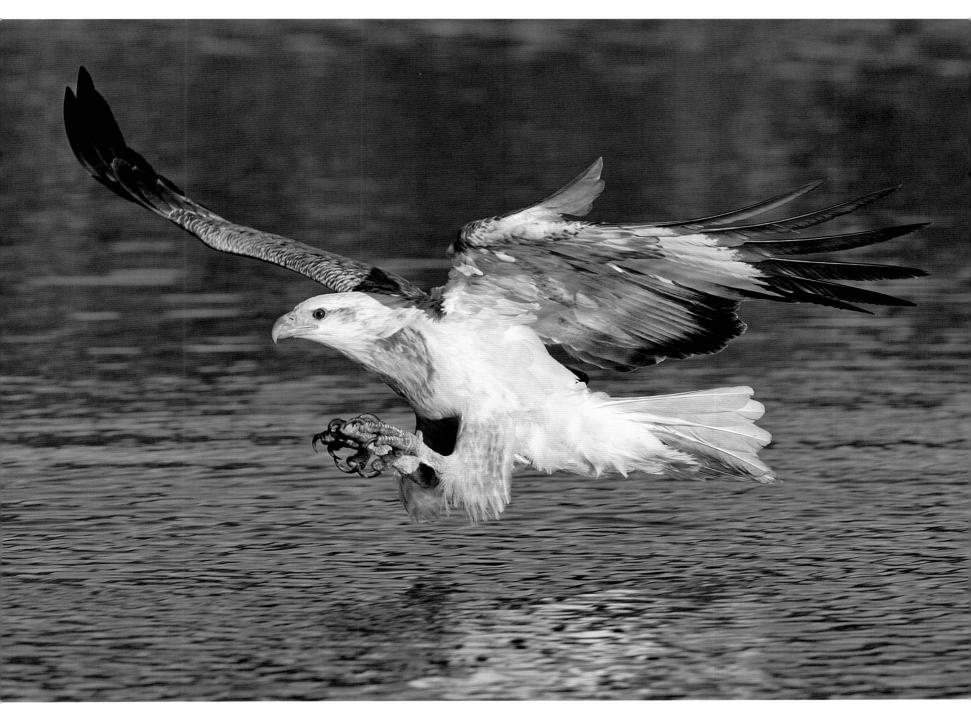

Haliaeetus leucogaster.

HABITAT AND RANGE: Coastlines and major waterways of southeast Asia and Australia. Nonmigratory.

Monogamous and sedentary, WHITE-BELLIED SEA EAGLES mate for life and rarely leave their home territories. Here we see another kind of pair: This white-bellied sea eagle is so close to the pond at Centennial Park that its reflection glistens in the water just below. *Sydney, Australia.*

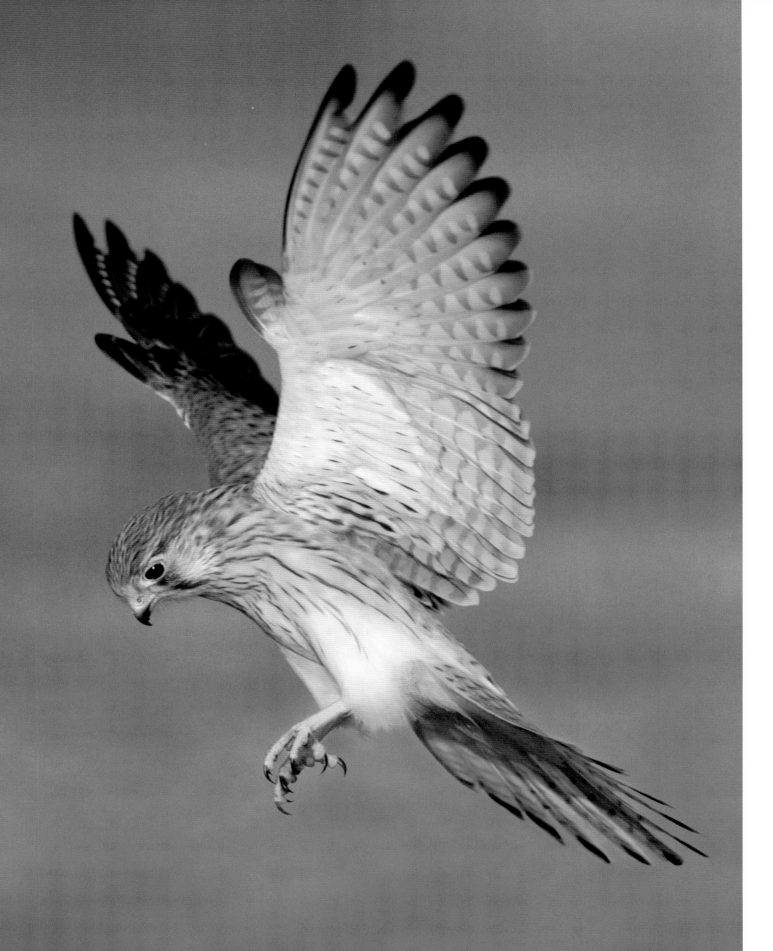

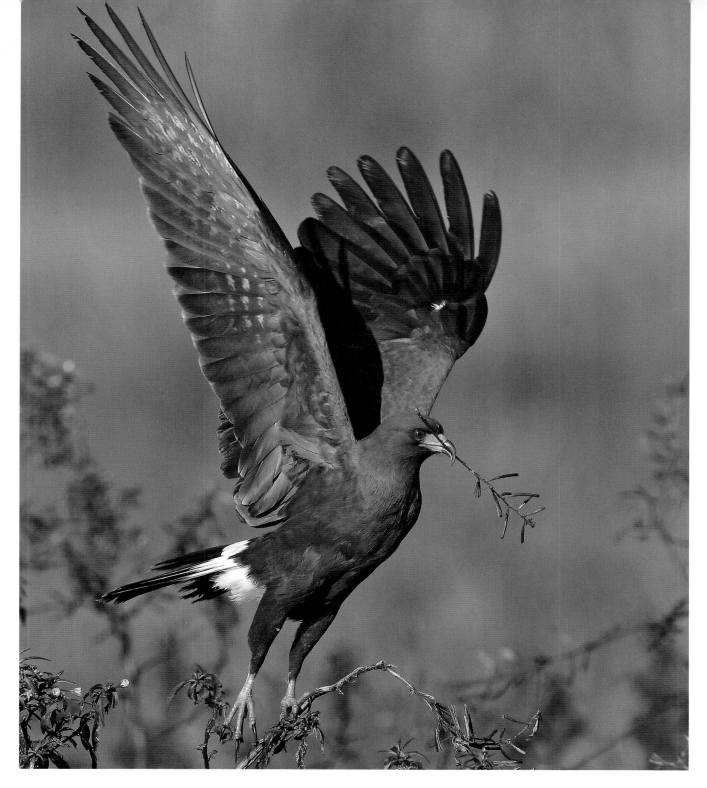

OPPOSITE: *Falco cenchroides.*

HABITAT AND RANGE: Wetlands and open country of Australia. Migratory.

ABOVE: *Rostrhamus sociabilis.*

HABITAT AND RANGE: Freshwater wetlands of southern Florida and Central and South America. Nonmigratory.

Fluttering toward a soft landing, a young NANKEEN KESTREL was coaxed over with some crickets purchased from a nearby pet shop. The nankeen kestrel eats many insects, but this diminutive falcon will also hunt smaller birds, reptiles, and rodents. *Sydney, Australia.*

Lifting off in a flash, a male SNAIL KITE carries a freshly pulled branch in its beak to shore up its nest. As the name implies, these birds of prey dine almost exclusively on freshwater mollusks of the family Ampullariidae, known as apple snails. *Osceola County, Florida.*

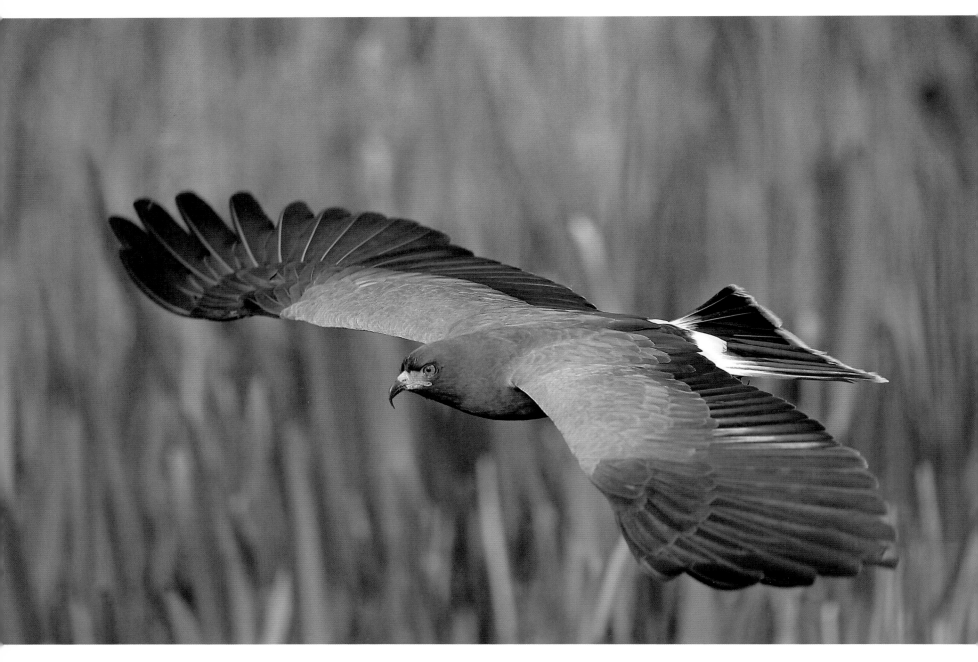

Rostrhamus sociabilis.

HABITAT AND RANGE: Freshwater wetlands of southern Florida and Central and South America. Nonmigratory.

The fine, sharp point of this SNAIL KITE's beak stands out clearly against the pickerelweed in the background. Usually, this type of kite hunts by circling slowly with its head tilted downward, searching for snails. *Osceola County, Florida.*

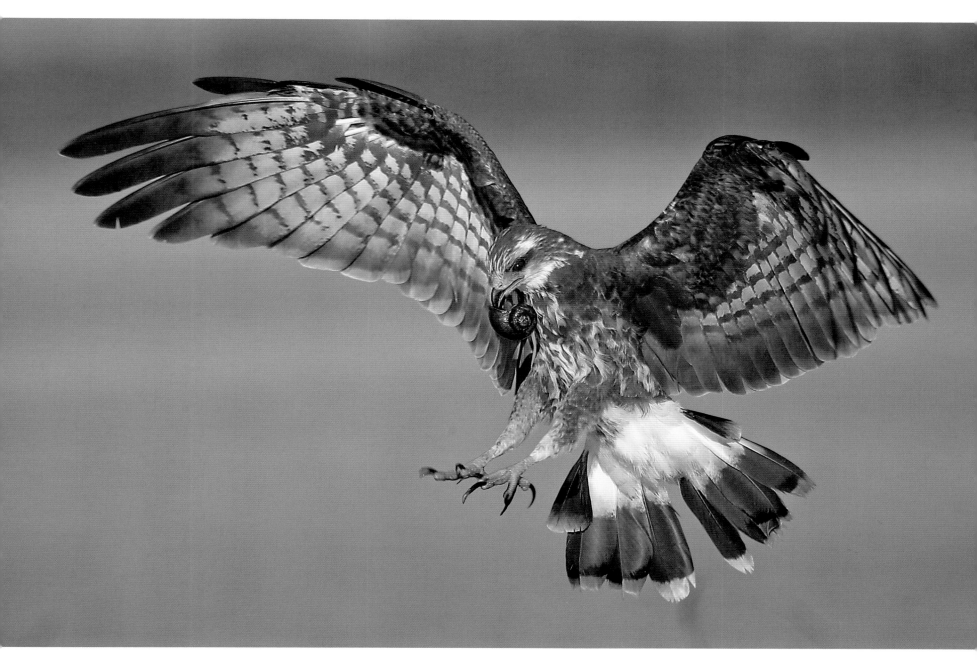

Rostrhamus sociabilis.

HABITAT AND RANGE: Freshwater wetlands of southern Florida and Central and South America. Nonmigratory.

This female SNAIL KITE is coming in to land on her favorite perch near the edge of a lake, an apple snail in her beak. In the Florida Everglades, just a little to the south of where this photograph was taken, the snail kite is considered endangered due to environmental depletion of the apple snail population, but there is some hope that crawfish can become an alternate food for the species. *Osceola County, Florida.*

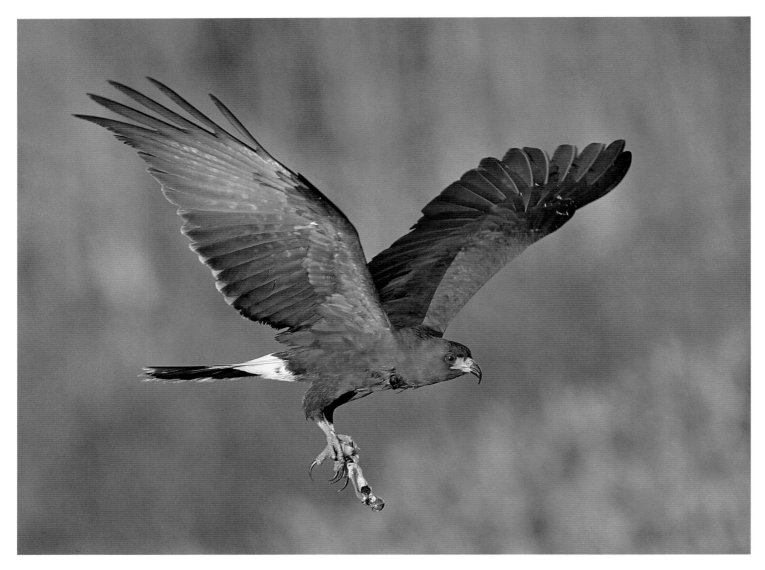

ABOVE: *Rostrhamus sociabilis.*

HABITAT AND RANGE: Freshwater wetlands of southern Florida and Central and South America. Nonmigratory.

A male SNAIL KITE en route to his nest, his talons gripping a de-shelled apple snail as he soars over a lake to feed his fledglings. His mostly brown, rather than blue-gray, coloration is somewhat atypical for adult snail kites. *Osceola County, Florida.*

OPPOSITE: *Rostrhamus sociabilis.*

HABITAT AND RANGE: Freshwater wetlands of southern Florida and Central and South America. Nonmigratory.

Ah, romance! A male SNAIL KITE lands on a female's back just prior to mating. The female sat on this perch near her nest and called for the male all morning. The male answered her call and flew to her, landing on her back to mate—as many as eight times in a single morning. *Osceola County, Florida.*

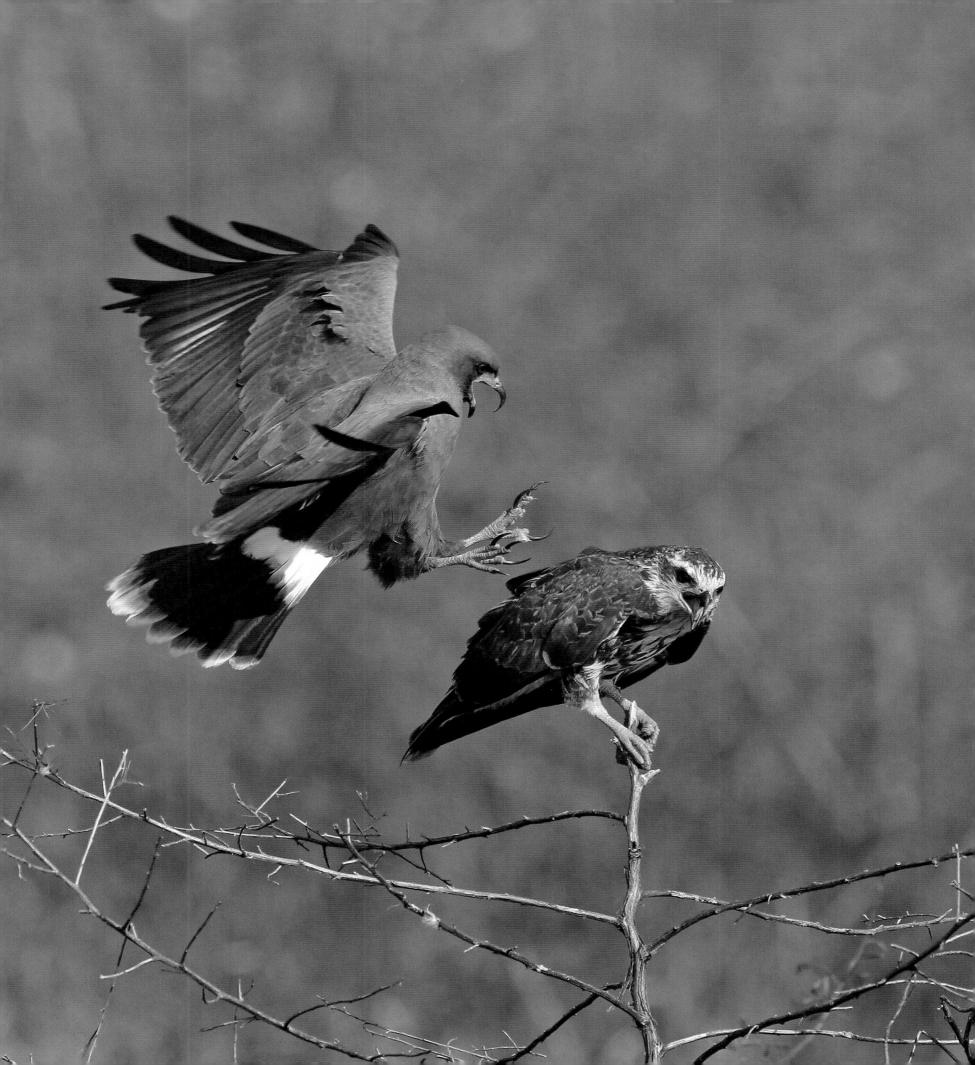

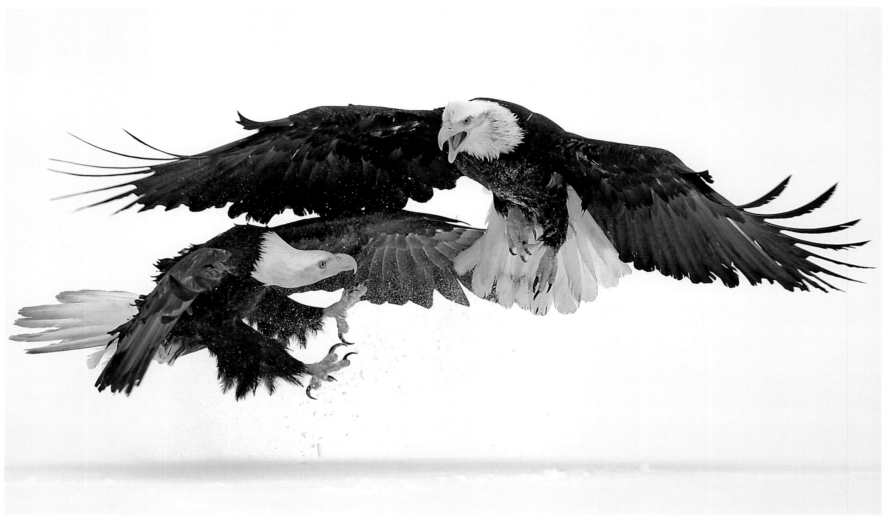

ABOVE: *Haliaeetus leucocephalus.*

HABITAT AND RANGE: Forests, river valleys, and coastlines across North America and Mexico. Partially migratory.

Hey! Get away from my fish! The BALD EAGLE on the left has just dropped his fish in the snow and is trying to keep the eagle on the right from getting it. The blanket of snow below the two has completely concealed the fish in this photograph. *Homer, Alaska.*

OPPOSITE: *Haliaeetus leucocephalus.*

HABITAT AND RANGE: Forests, river valleys, and coastlines across North America and Mexico. Partially migratory.

Anything goes when a fish is up for grabs. Here, the BALD EAGLE on the bottom has just attacked the one on top and forced it to drop its fish—already ripped to shreds—in a midair ballet. *Alaska.*

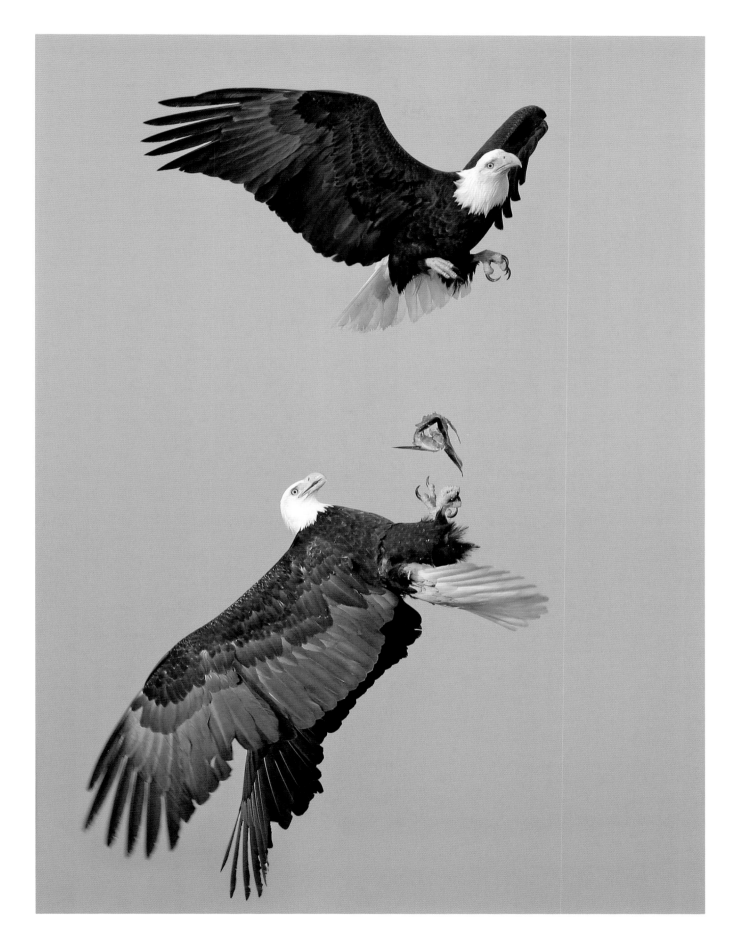

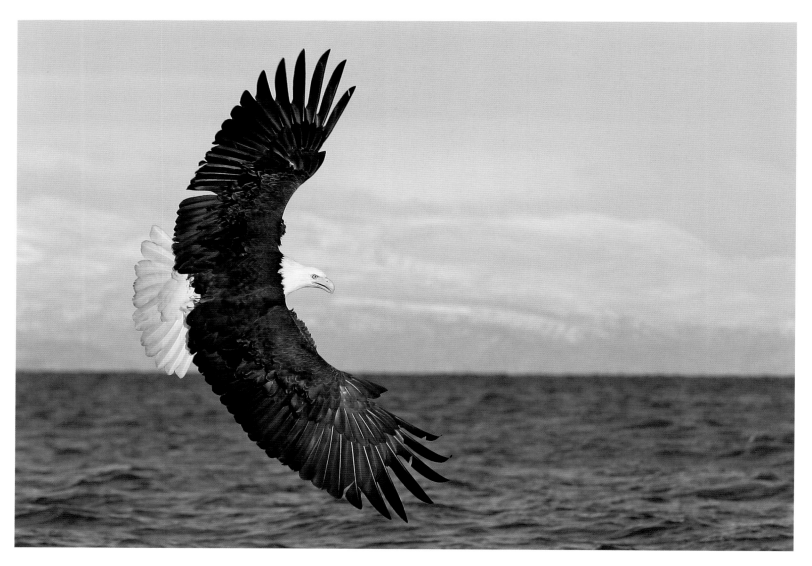

Haliaeetus leucocephalus.

HABITAT AND RANGE: Forests, river valleys, and coastlines across North America and Mexico. Partially migratory.

This adult BALD EAGLE banking over the water looks almost arrogant as it makes its way across the bay. Although they are powerful fliers in their own right, bald eagles often take advantage of warm updrafts to glide on convection currents. *Kachemak Bay, Alaska.*

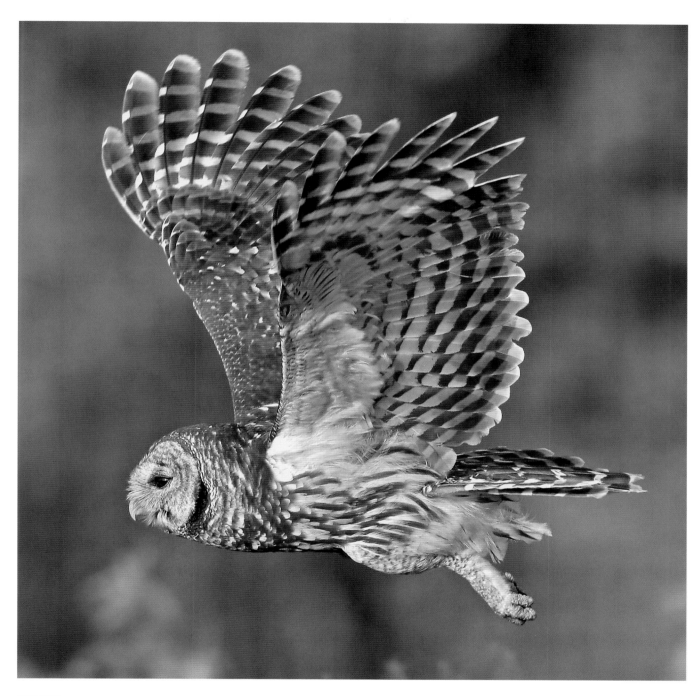

Strix varia.

HABITAT AND RANGE: Forests in the eastern United States, Canada, and parts of Central America. Nonmigratory.

The remote, rural areas of southern Florida are home to flocks of BARRED OWLS. Of all North American owl species, barred owls are the most likely to be active during daylight hours, especially when they are raising chicks. *Osceola County, Florida.*

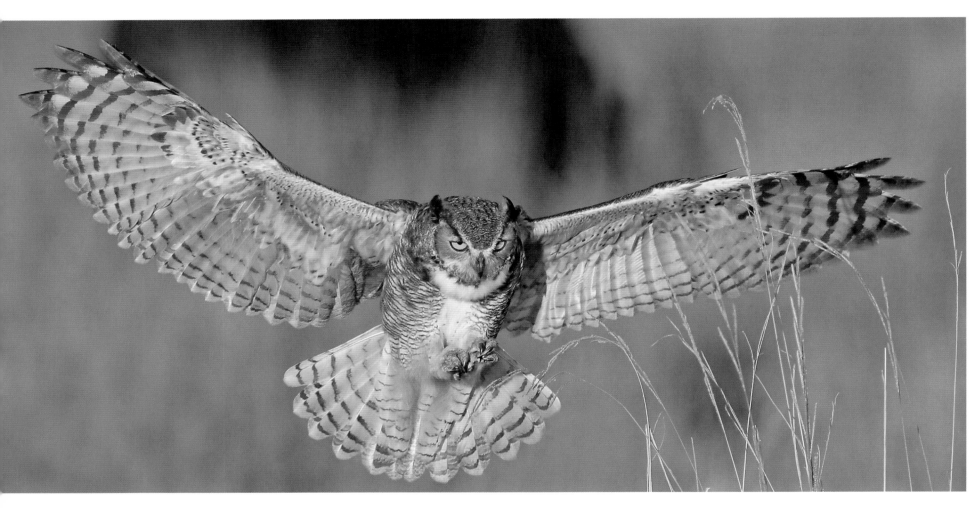

Bubo virginianus.

HABITAT AND RANGE: Forests, subarctic tundra, mountain ranges, desert, rocky coastlines, agricultural areas, and urban and suburban areas in most of North and South America. Nonmigratory.

Don't be misled by the sleepy-eyed look of this GREAT HORNED OWL in flight; it is ready to pounce at a moment's notice! Known to capture and eat other birds as large as the great blue heron, the owl will often freeze leftover meat in the snow in northern habitats to save it for another time. *Osceola County, Florida.*

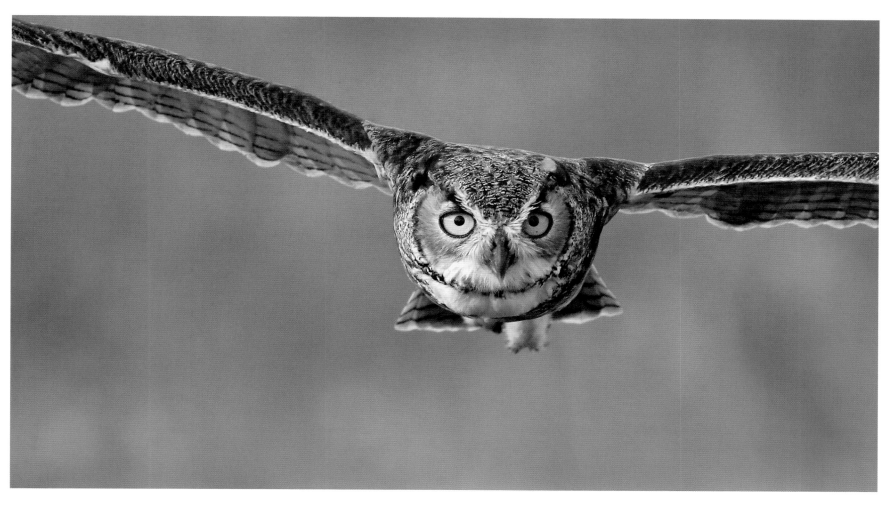

Bubo virginianus.

HABITAT AND RANGE: Forests, subarctic tundra, mountain ranges, desert, rocky coastlines, agricultural areas, and urban and suburban areas in most of North and South America. Nonmigratory.

This GREAT HORNED OWL has no fear of humans at all, evident in this head-on image. Its large, mesmerizing yellow eyes are certainly sharp, but the great horned owl's vision is best at dawn and dusk, when the light is low and their hearing actually helps them perceive depth and elevation. *Osceola County, Florida.*

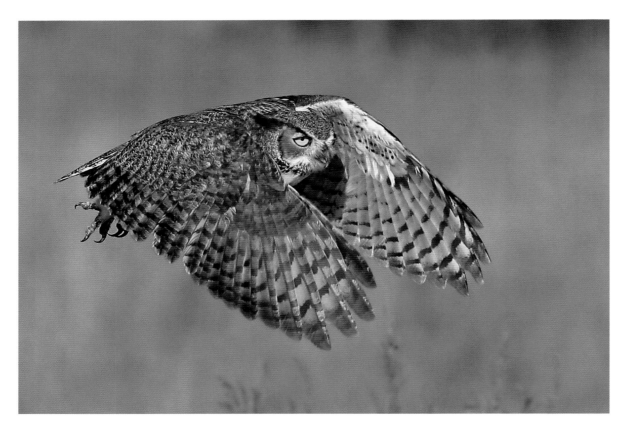

ABOVE: *Bubo virginianus.*

HABITAT AND RANGE: Forests, subarctic tundra, mountain ranges, desert, rocky coastlines, agricultural areas, and urban and suburban areas in most of North and South America. Non-migratory.

A GREAT HORNED OWL'S head peeks out from between its curled, hunched wings as it flies over ranchland. This type of owl can live in nearly any habitat within its range, though it is less common in extreme climates such as deserts and rain forests. *Osceola County, Florida.*

OPPOSITE: *Athene cunicularia.*

HABITAT AND RANGE: Grasslands and urban and suburban areas in North and Central America and parts of South America. Northern populations are migratory.

BURROWING OWLS, which are very likely to be active during the day, are difficult to photograph in flight because they fly very close to the ground for short distances before landing again. Both their affinity for the ground and their diurnal activity set burrowing owls apart from the rest of their kin. *Salton Sea, California.*

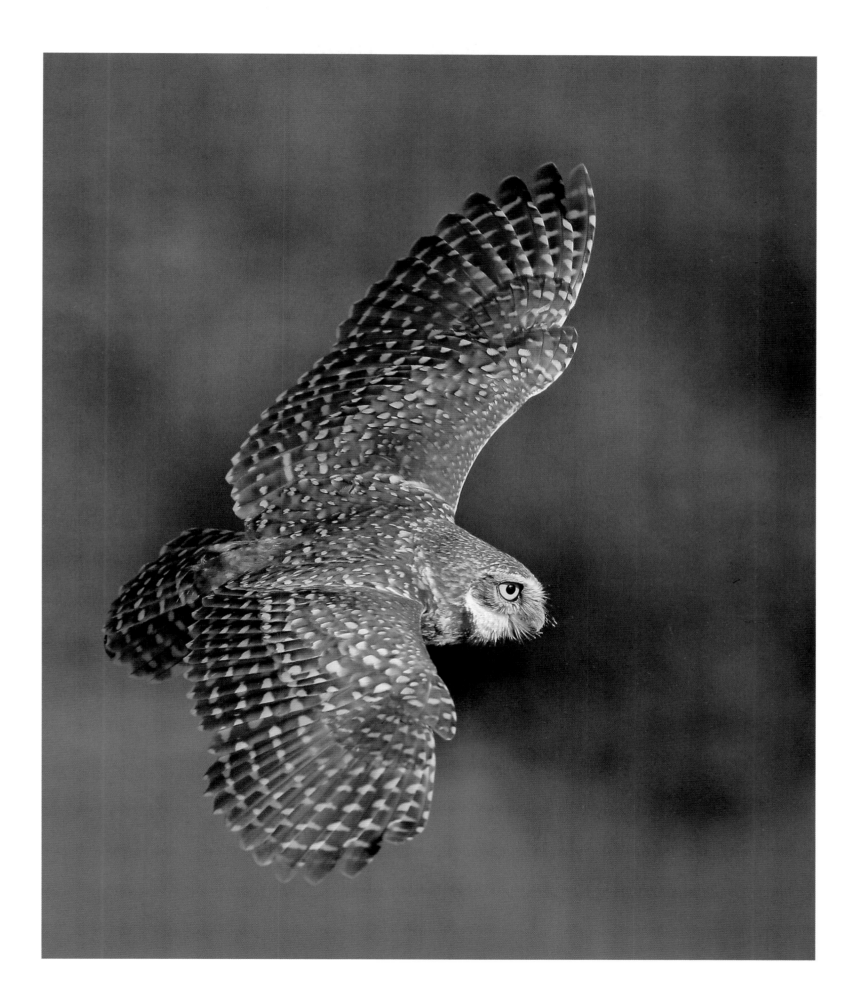

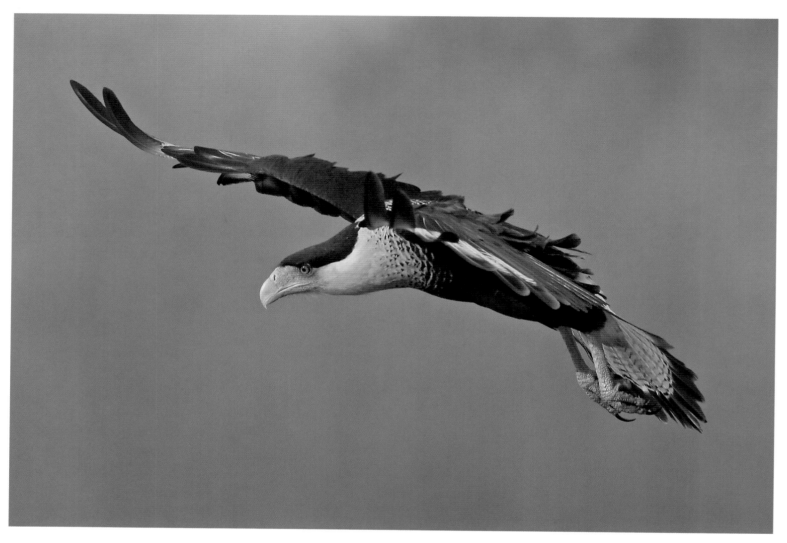

Caracara cheriway.

HABITAT AND RANGE: Grasslands and open country of the southern United States and Central and South America. Nonmigratory.

This CRESTED CARACARA is gliding through the air, preparing to swoop down to feast on the remains of a dead animal. Crested caracaras are often seen on the ground converging on roadkill or other dead animals, although they also make their own kills, feeding on reptiles, amphibians, and other small animals. *Osceola County, Florida.*

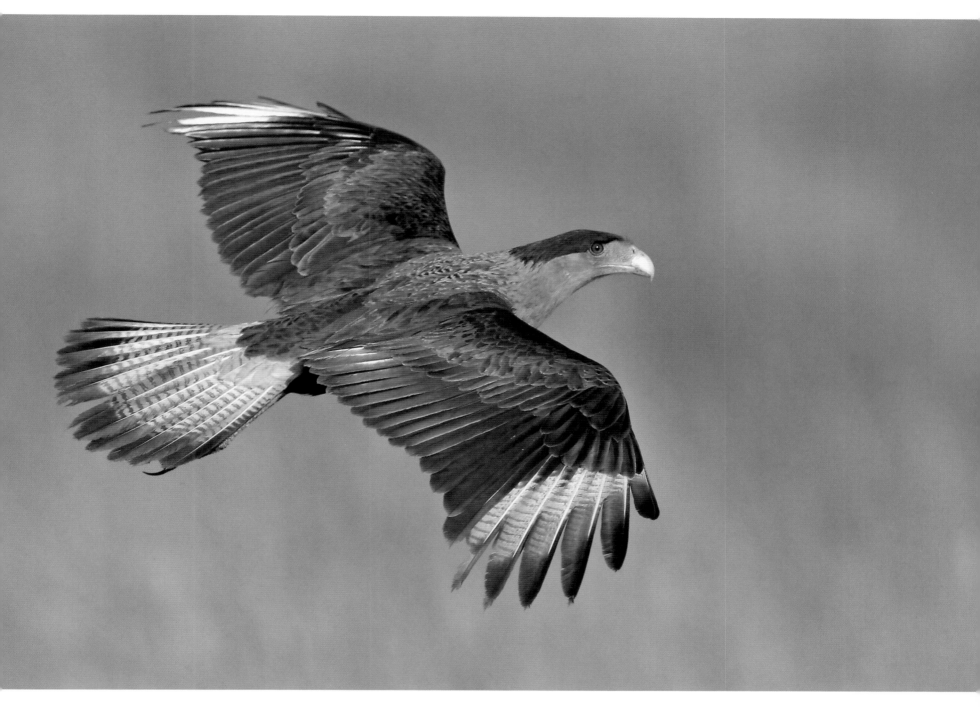

Caracara cheriway.

HABITAT AND RANGE: Grasslands and open country of the southern United States and Central and South America. Nonmigratory.

A juvenile CRESTED CARACARA has just been chased away from its meal by several turkey vultures. Vultures, bald eagles, and caracaras often compete for the same carrion. *Osceola County, Florida.*

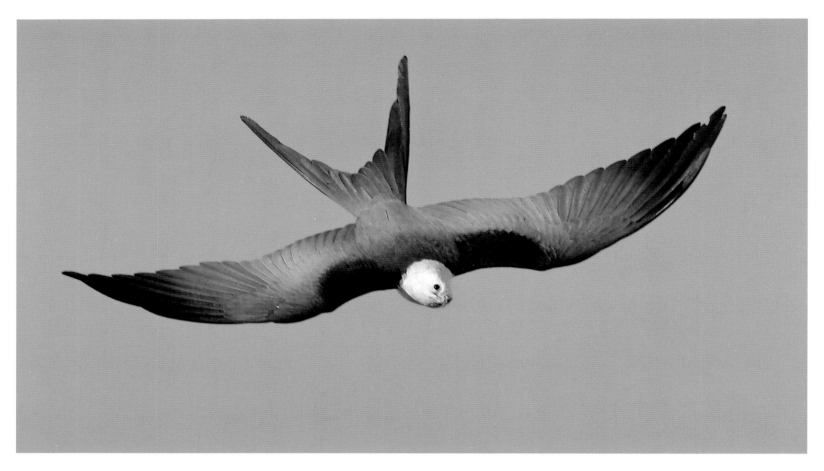

ABOVE: *Elanoides forficatus.*

HABITAT AND RANGE: Forests and forested wetlands of the southern United States and South America. Migratory.

SWALLOW-TAILED KITES are usually seen soaring high in the sky. This one is in a long dive, possibly having spotted some small reptile or insect on the ground.

OPPOSITE: *Milvus migrans.*

HABITAT AND RANGE: Forests of Asia. Migratory.

The BLACK KITE is by far Hong Kong's most common bird of prey. This shot of a kite showing off its top wing was taken at the Mai Po Nature Reserve. Primarily a hunter, the black kite is well suited to life in the city and has been known to eat household refuse when living in densely populated areas. *Hong Kong, China.*

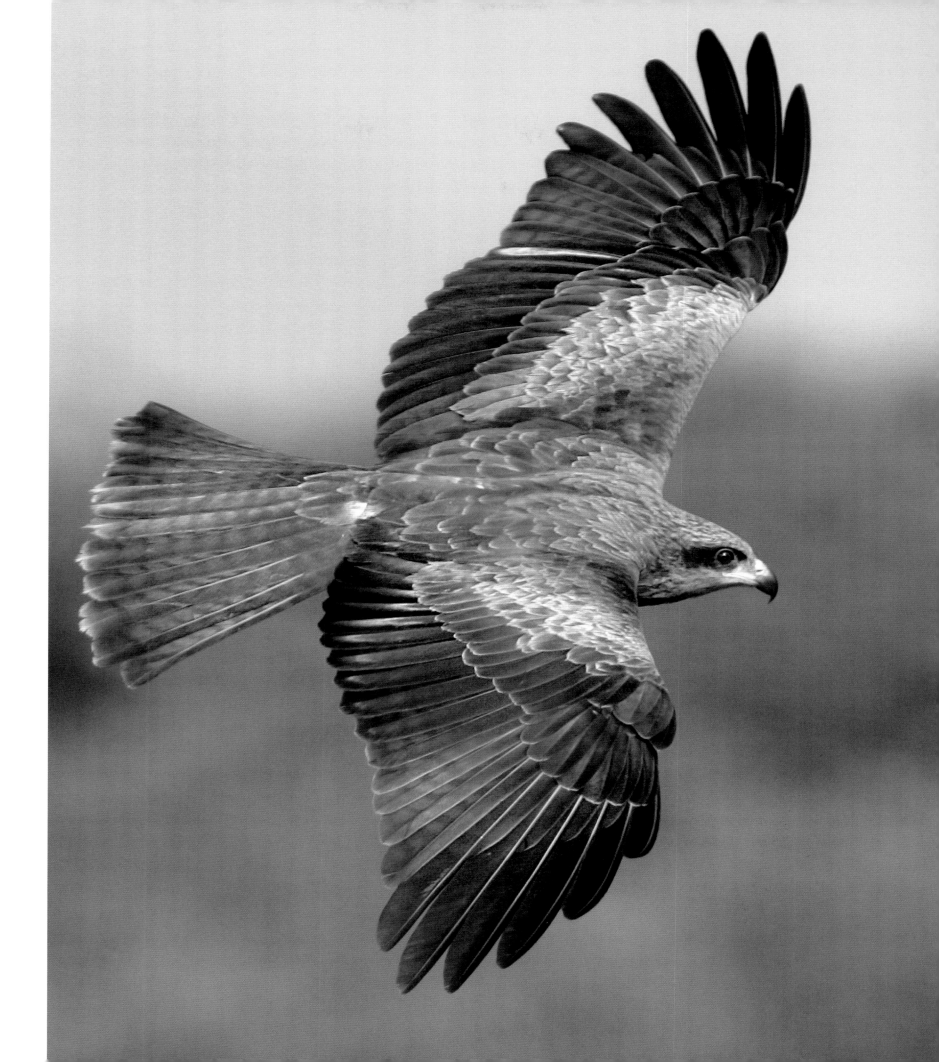

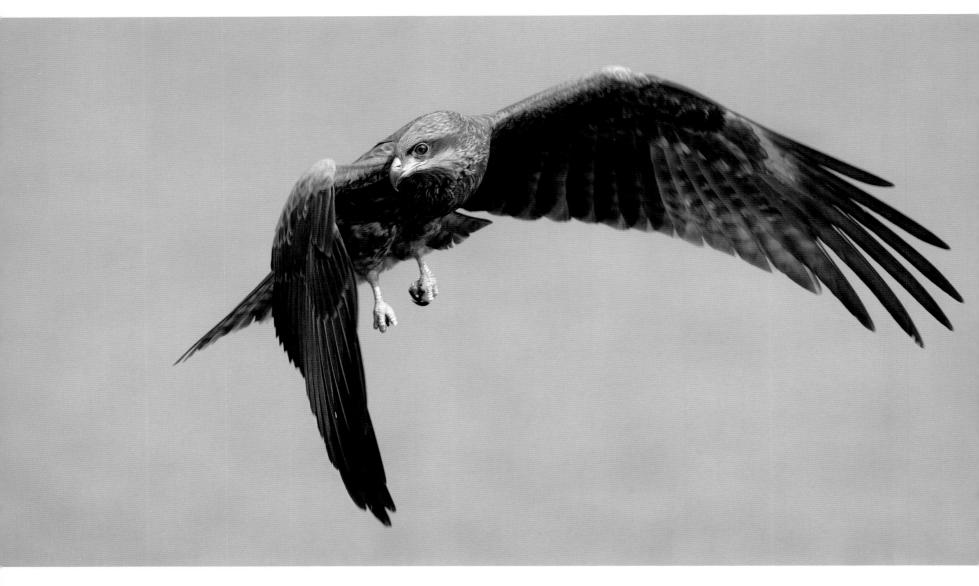

ABOVE: *Milvus migrans.*
HABITAT AND RANGE: Forests of Asia. Migratory.

The BLACK KITE in its extraordinary hunting posture, wings hunched, head angled, and eyes focused like laser beams on its prey—is there a scarier sight in all of nature? Kites will follow smoke to fire, where they pick out escaping insects and other small prey. *Hong Kong, China.*

OPPOSITE: *Circus spilonotus.*
HABITAT AND RANGE: Grasslands and wetlands of Asia. Migratory.

This EASTERN MARSH HARRIER had been circling in the air, its claws poised to attack and its eyes on a pond in the Mai Po Nature Reserve. Now it prepares to dive-bomb its victim, one of the hundred or so ducks dotting the water below. *Hong Kong, China.*

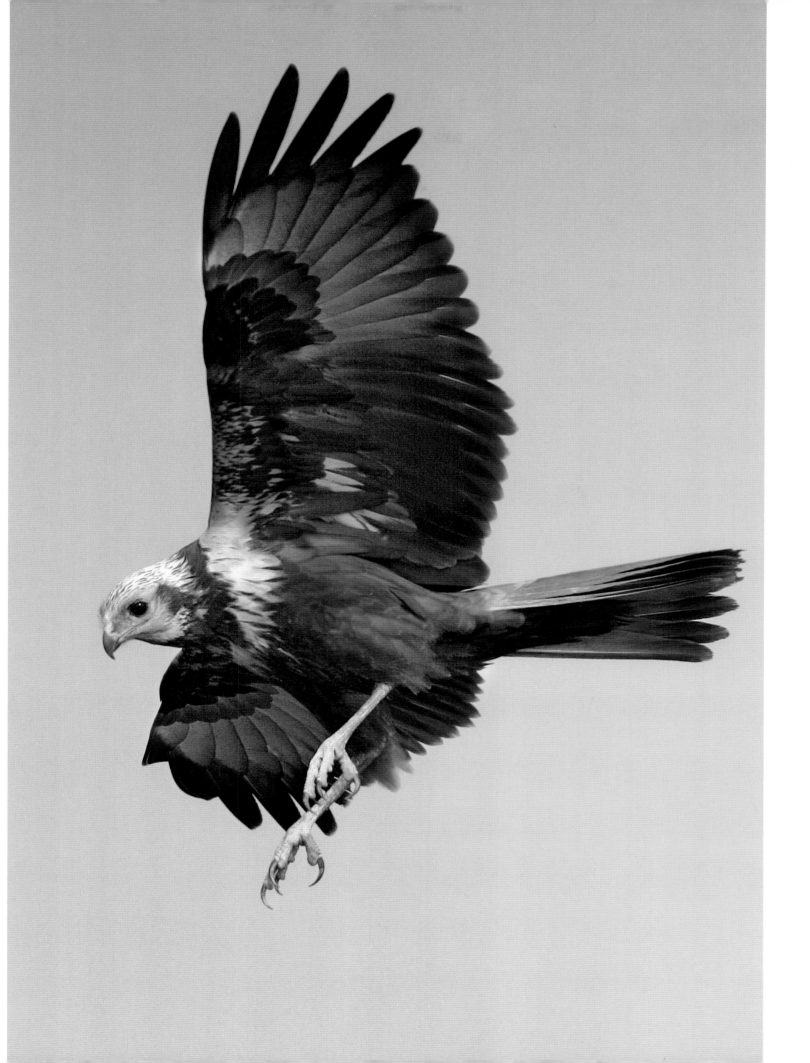

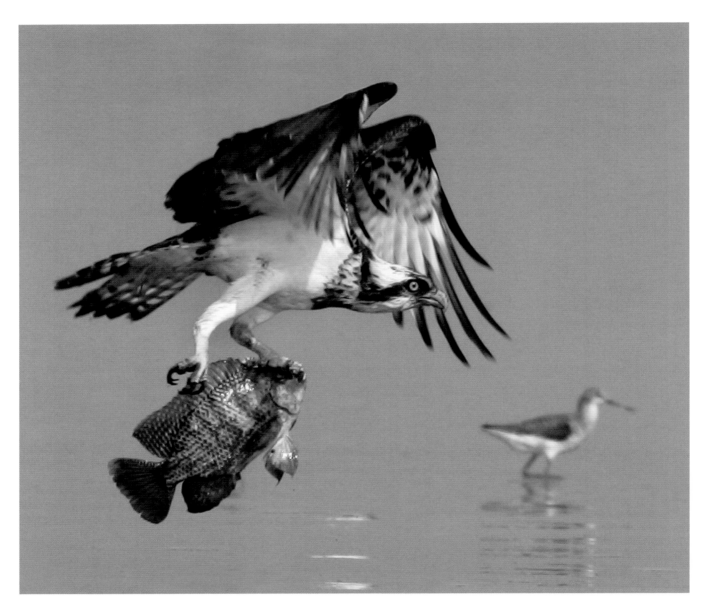

Pandion haliaetus.

HABITAT AND RANGE: Forests and wetlands on every continent except Antarctica. Migratory.

The OSPREY, the fastest-flying bird in the world, is always a fascinating subject. This one is just lifting off, in its claws a fish freshly plucked from the lake below, where a handful of shorebirds appear to be ignoring the osprey but are really keeping their distance at the mud flat of Deep Bay. *Hong Kong, China.*

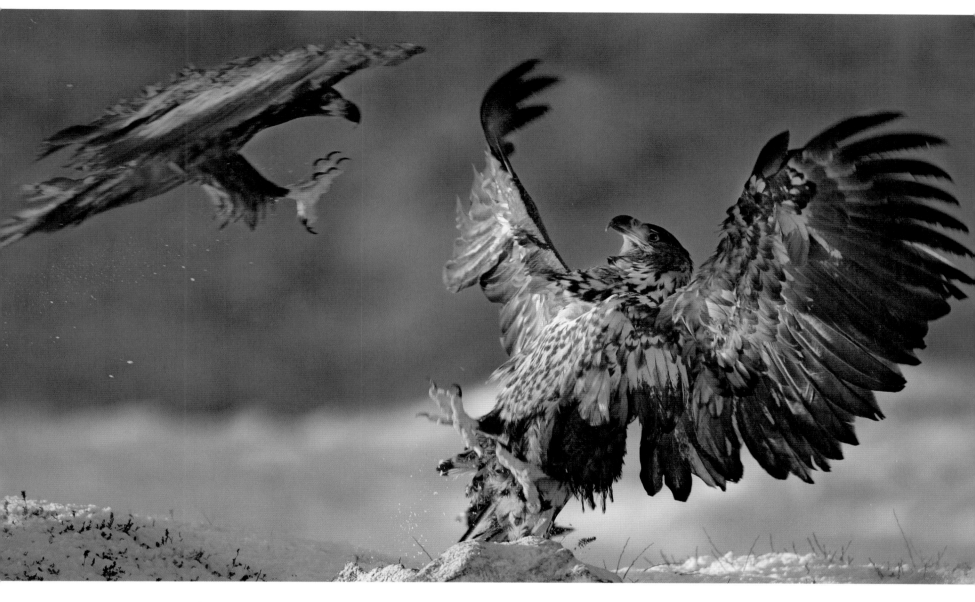

Haliaeetus albicilla.

HABITAT AND RANGE: Forests, grasslands, wetlands, and rocky coastlines of northern Europe and Asia. Migratory.

Two WHITE-TAILED EAGLES begin to fight in midair, like two pterodactyls in a scene from *Jurassic Park*. But even as they tear into each other, the only sound is feathers ruffling. Fights over fish are fairly common, but there is no fish in sight here; possibly, the dispute was territorial. *Norway.*

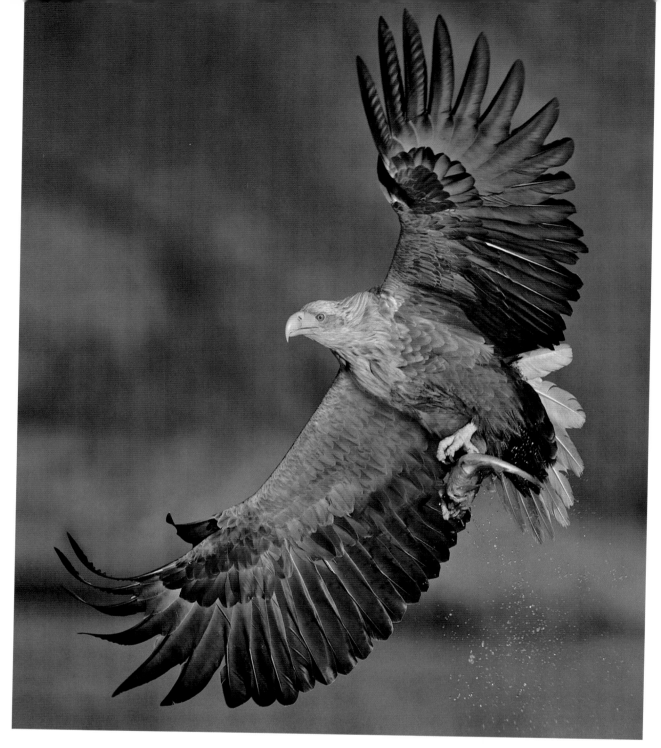

ABOVE: *Haliaeetus albicilla.*

HABITAT AND RANGE: Forests, grasslands, wetlands, and rocky coastlines of northern Europe and Asia. Migratory.

A fat catch clutched in its talons, this WHITE-TAILED EAGLE has made out like a bandit. For the most part, the white-tailed eagle lives in ranges distinctly separate from those of the golden eagle. However, in the fjords of Norway, the two species share territories and must often compete for food. *Norway.*

OPPOSITE: *Haliaeetus albicilla.*

HABITAT AND RANGE: Forests, grasslands, wetlands, and rocky coastlines of northern Europe and Asia. Migratory.

Evident from the pattern of coloration on its head and body, the WHITE-TAILED EAGLE is a close Old World cousin of the American bald eagle. Having just grabbed a fish in its talons, this eagle banks away over the water. *Norway.*

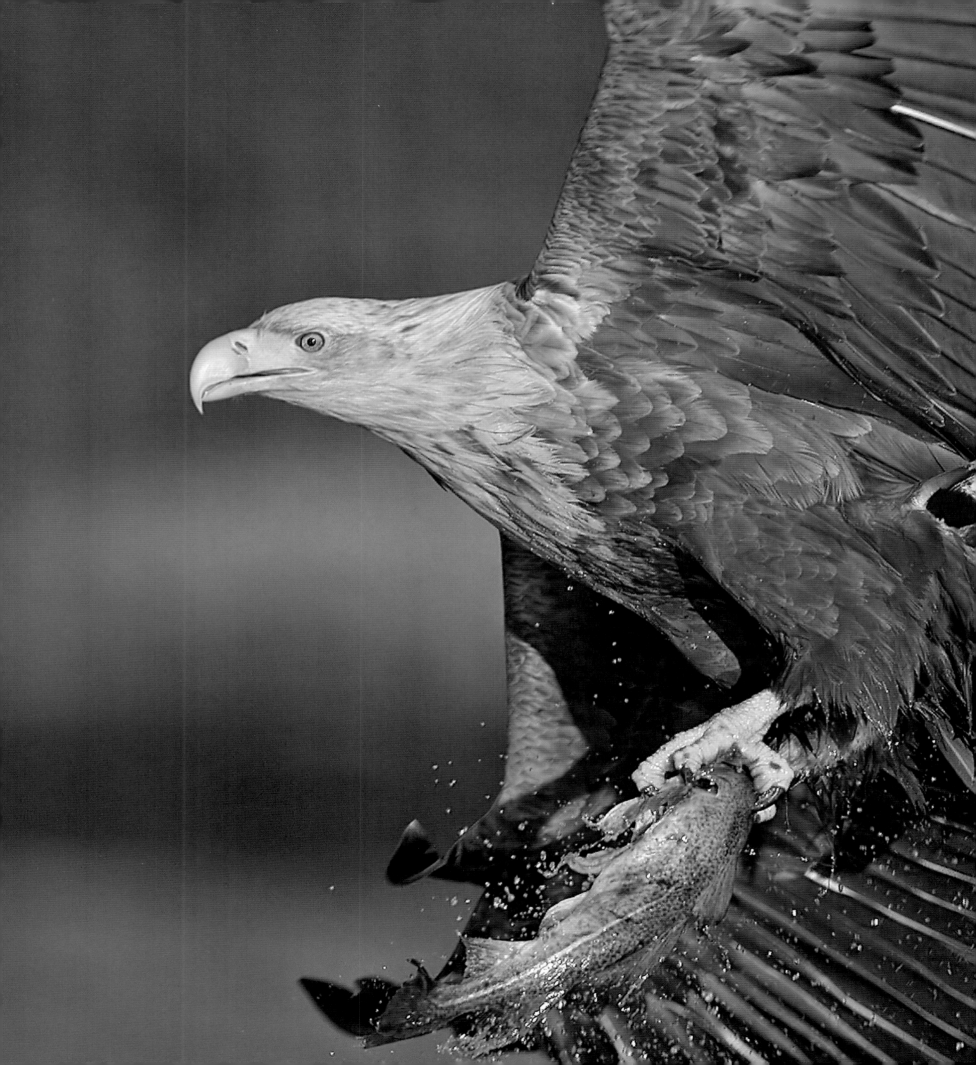

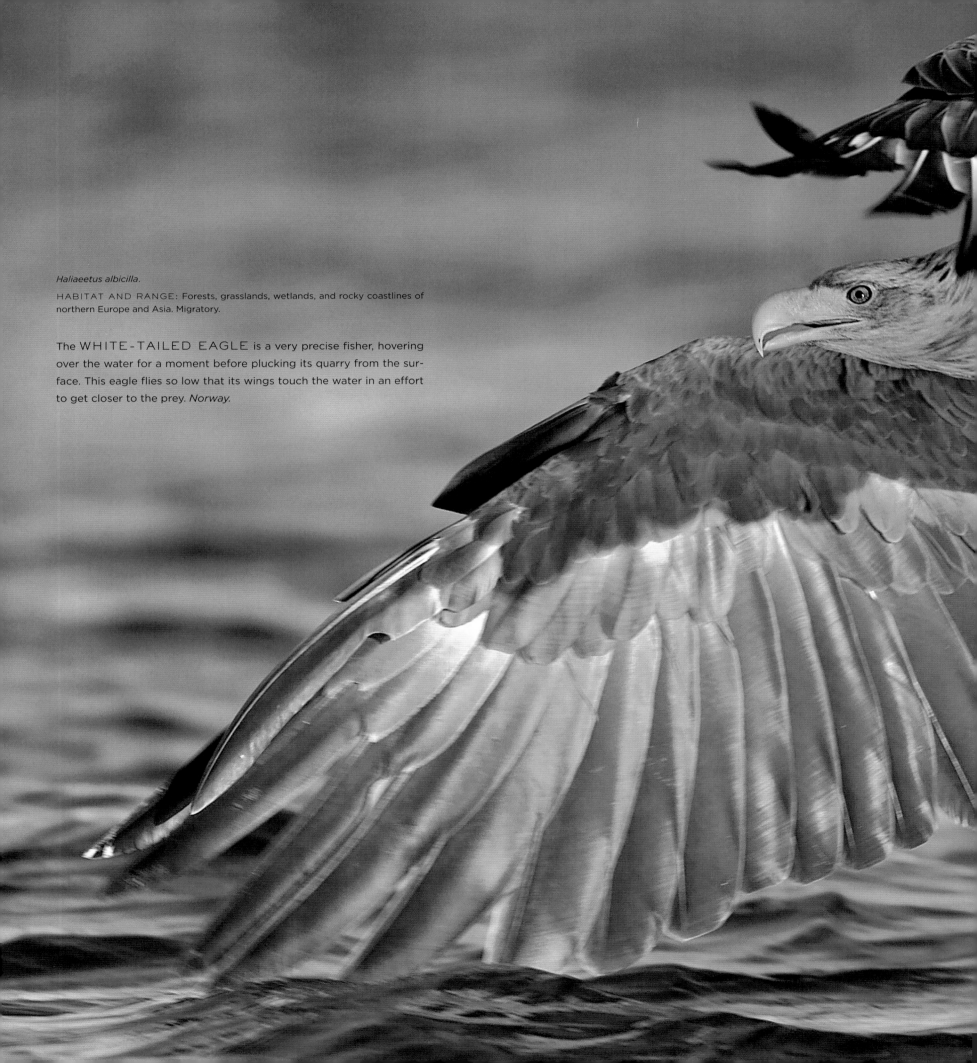

Haliaeetus albicilla.

HABITAT AND RANGE: Forests, grasslands, wetlands, and rocky coastlines of northern Europe and Asia. Migratory.

The WHITE-TAILED EAGLE is a very precise fisher, hovering over the water for a moment before plucking its quarry from the surface. This eagle flies so low that its wings touch the water in an effort to get closer to the prey. *Norway.*

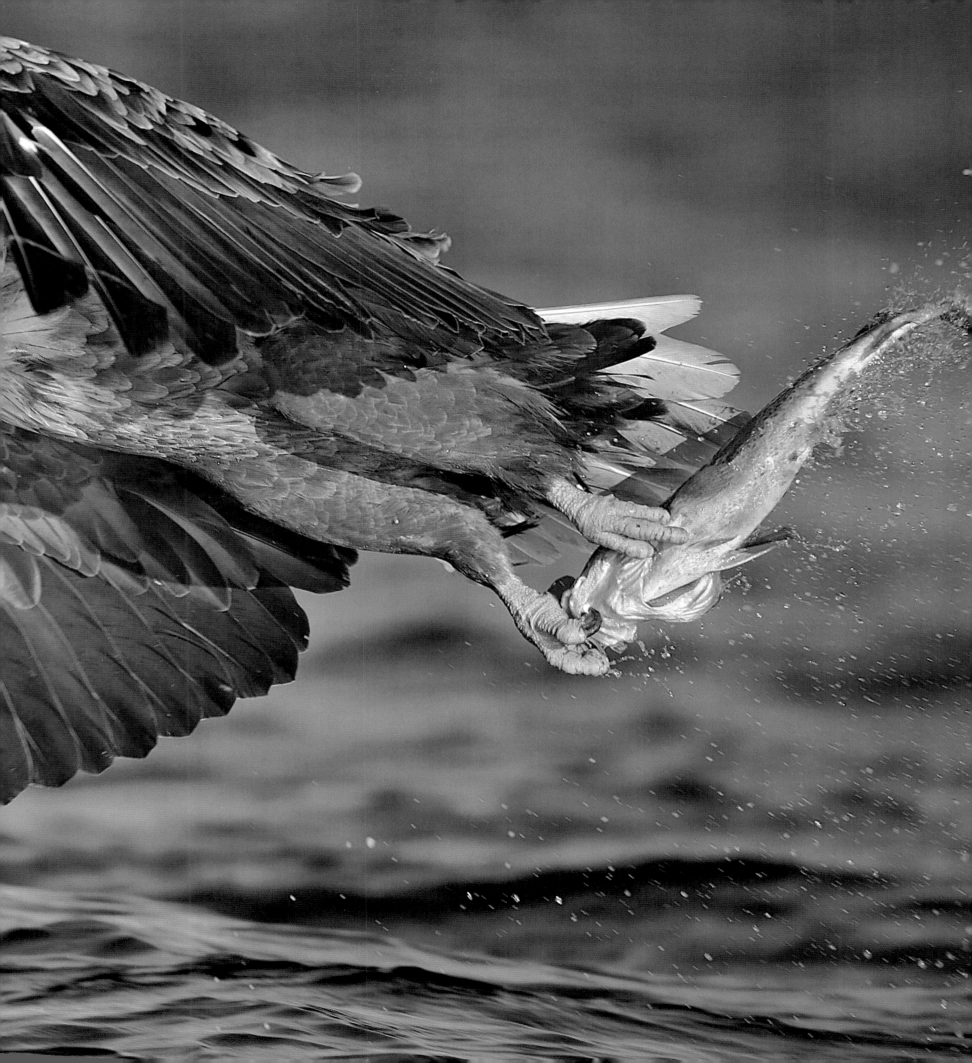

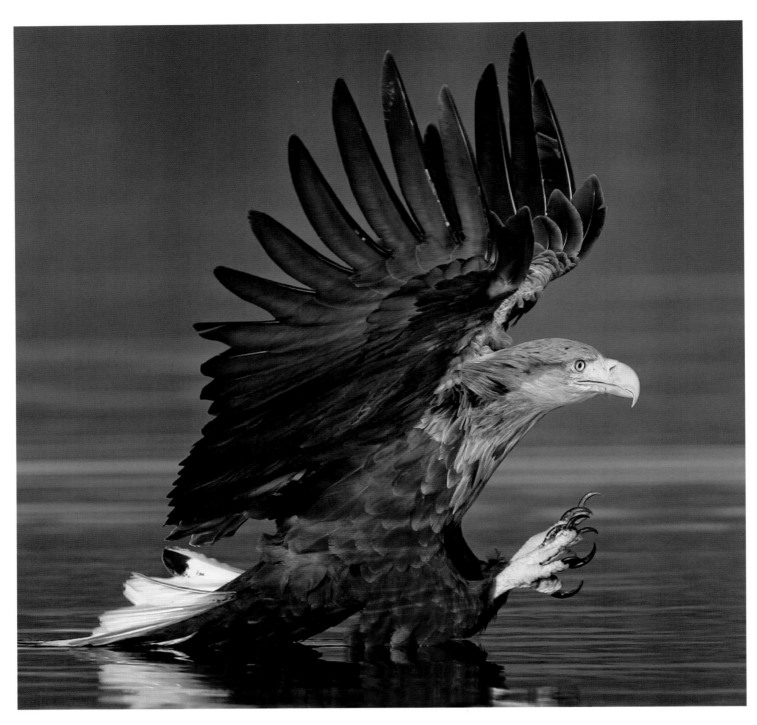

ABOVE: *Haliaeetus albicilla.*

HABITAT AND RANGE: Forests, grasslands, wetlands, and rocky coastlines of northern Europe and Asia. Migratory.

Once again, the WHITE-TAILED EAGLE wets its wings by dropping very close to the surface of the fjord, nearly sitting in the water. This eagle species is something of an opportunist and has been known to circle fishing boats and wait for waste to be thrown overboard. *Norway.*

OPPOSITE: *Haliaeetus albicilla.*

HABITAT AND RANGE: Forests, grasslands, wetlands, and rocky coastlines of northern Europe and Asia. Migratory.

In perfect unison and with shared grace, a gull follows a WHITE-TAILED EAGLE like a wingman in a fighter jet, making sure it will get a chance to steal the fish from the bigger bird. The gulls actually have to hang back, as they're quite agile and fast and can pass the eagles with ease. *Norway.*

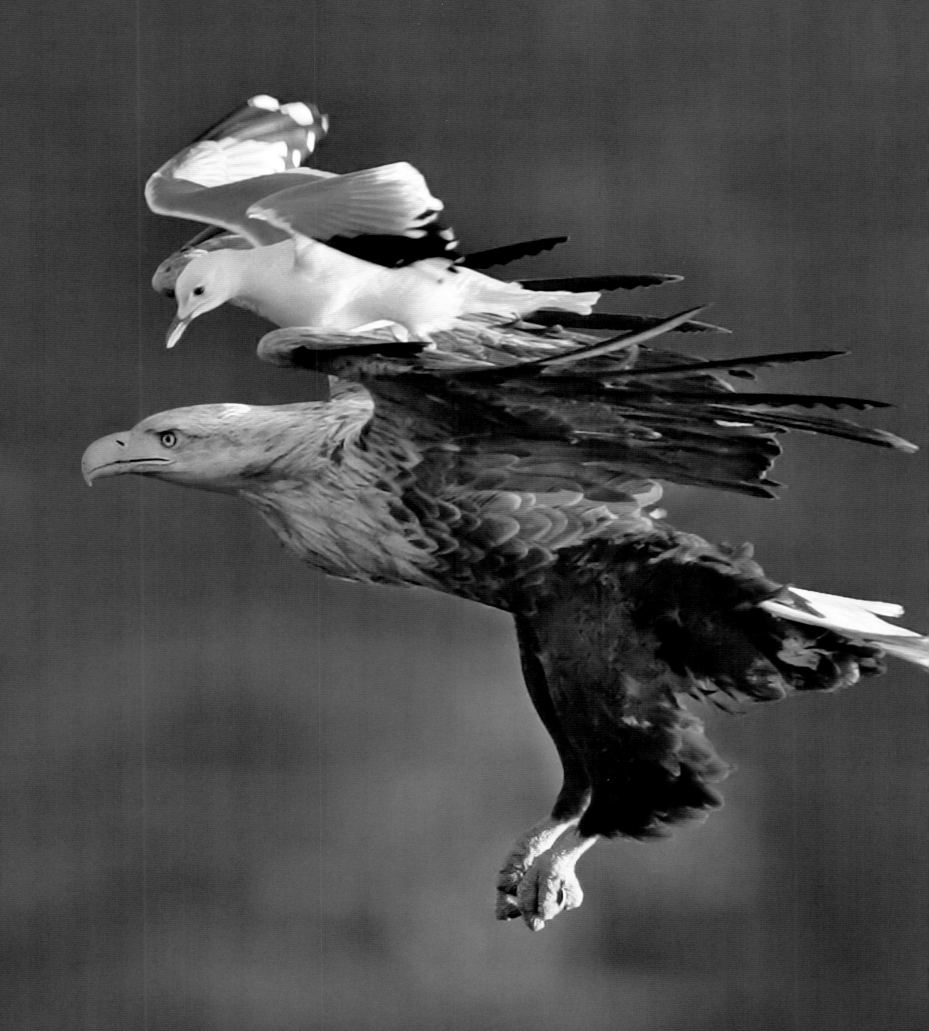

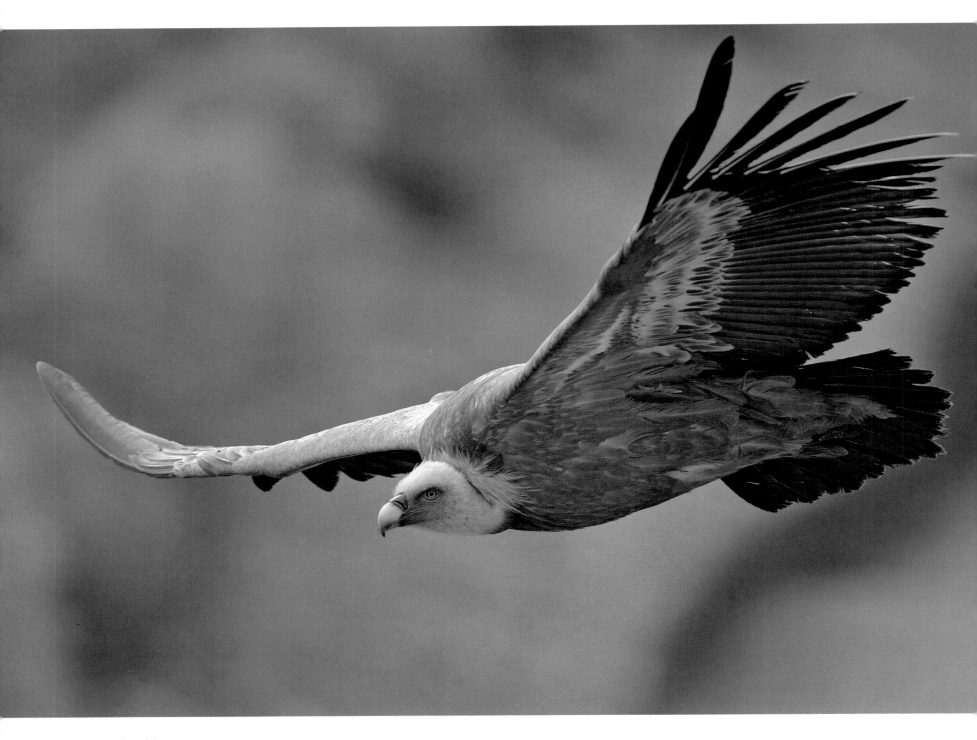

Gyps fulvus.

HABITAT AND RANGE: Grasslands and mountain crags of southern Europe, Asia, and northern Africa. Migratory.

A deep golden GRIFFON VULTURE cuts through the skies over Hoces del Duratón Nature Park, one of the biggest wild vulture reserves in Europe. In Africa, populations of griffon vultures are considered locally threatened, although the species is not recognized as endangered in the rest of its range. *Segovia, Spain.*

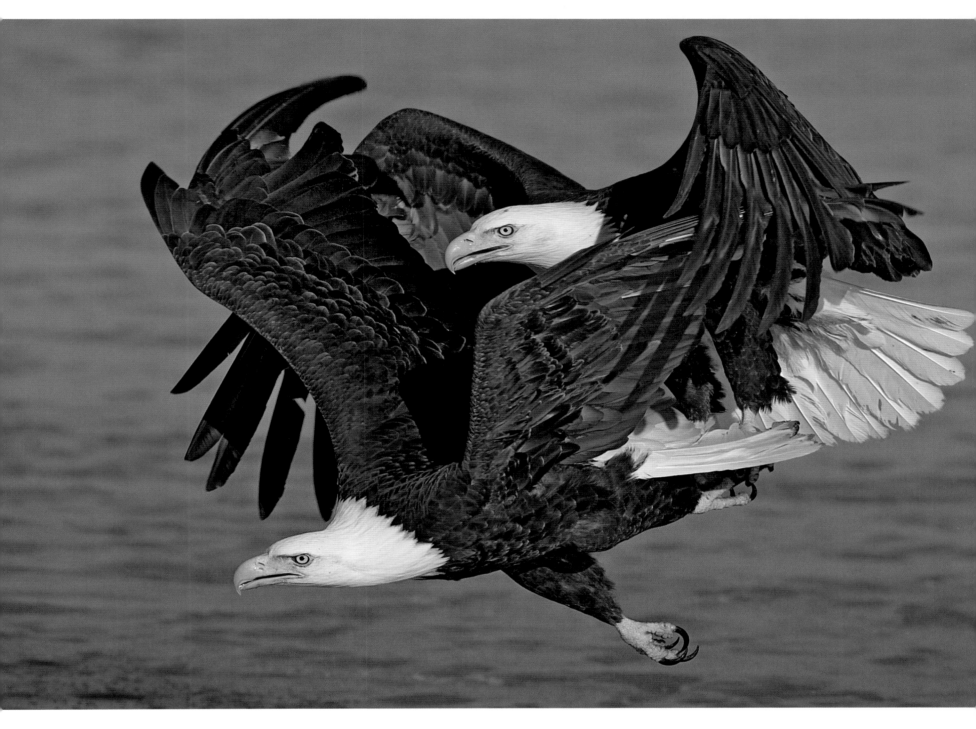

Haliaeetus leucocephalus.

HABITAT AND RANGE: Forests, river valleys, and coastlines across North America and Mexico. Partially migratory.

Flying can sometimes be a team effort. Here, two BALD EAGLES work together to carry a fish—obscured by their bodies in this image—between them as they zoom across the sky above the wilderness. The question is, which one will wind up with the fish when they land? *Alaska.*

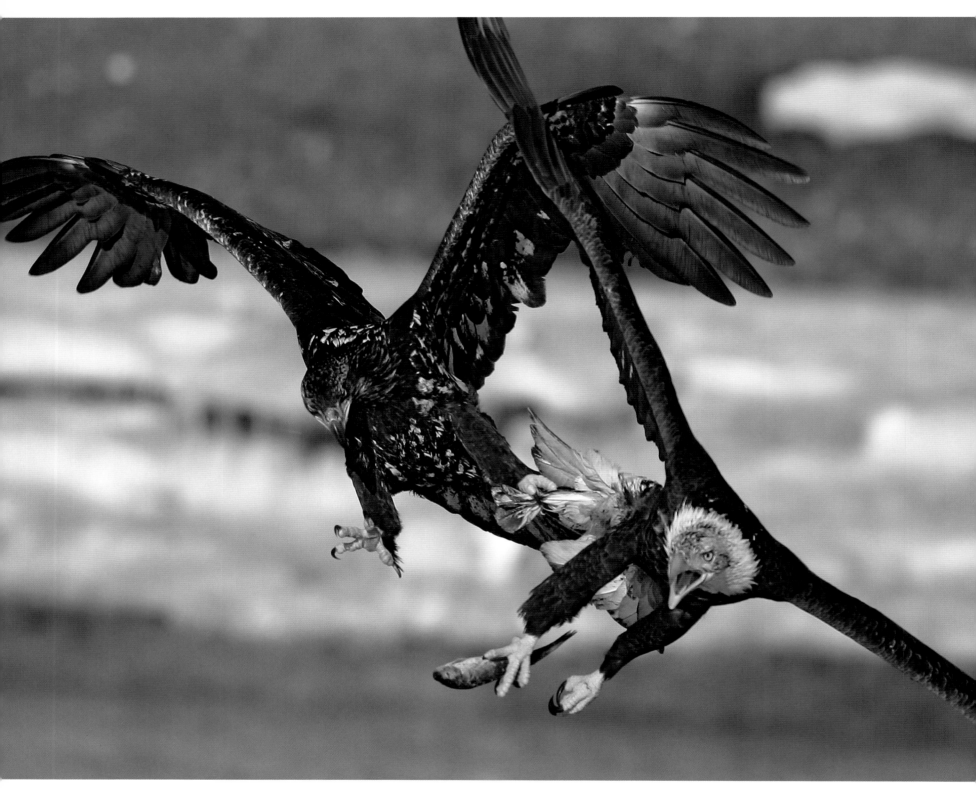

Haliaeetus leucocephalus.

HABITAT AND RANGE: Forests, river valleys, and coastlines across North America and Mexico. Partially migratory.

When food is rare in the long winters of the Arctic, BALD EAGLES fight for their next meal. The victor is the fastest, strongest, and quickest—qualities certainly possessed by the juvenile eagle on the left, which has attacked and all but knocked the other eagle out of the air near a frozen lake. Little wonder the latter has a shocked look on its face. *Alaska.*

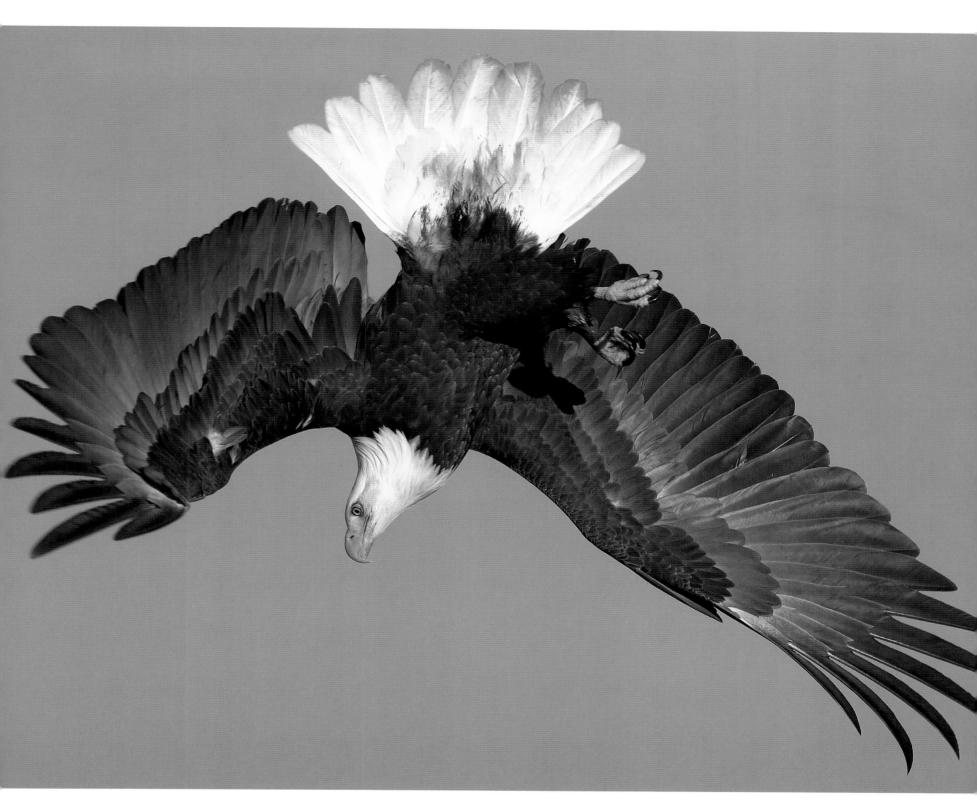

Haliaeetus leucocephalus.

HABITAT AND RANGE: Forests, river valleys, and coastlines across North America and Mexico. Partially migratory.

BALD EAGLES often seem to truly enjoy taking steep dives, such as the one executed by this bird, whose white head and tail feathers are in stark contrast to its sleek black body. *Alaska.*

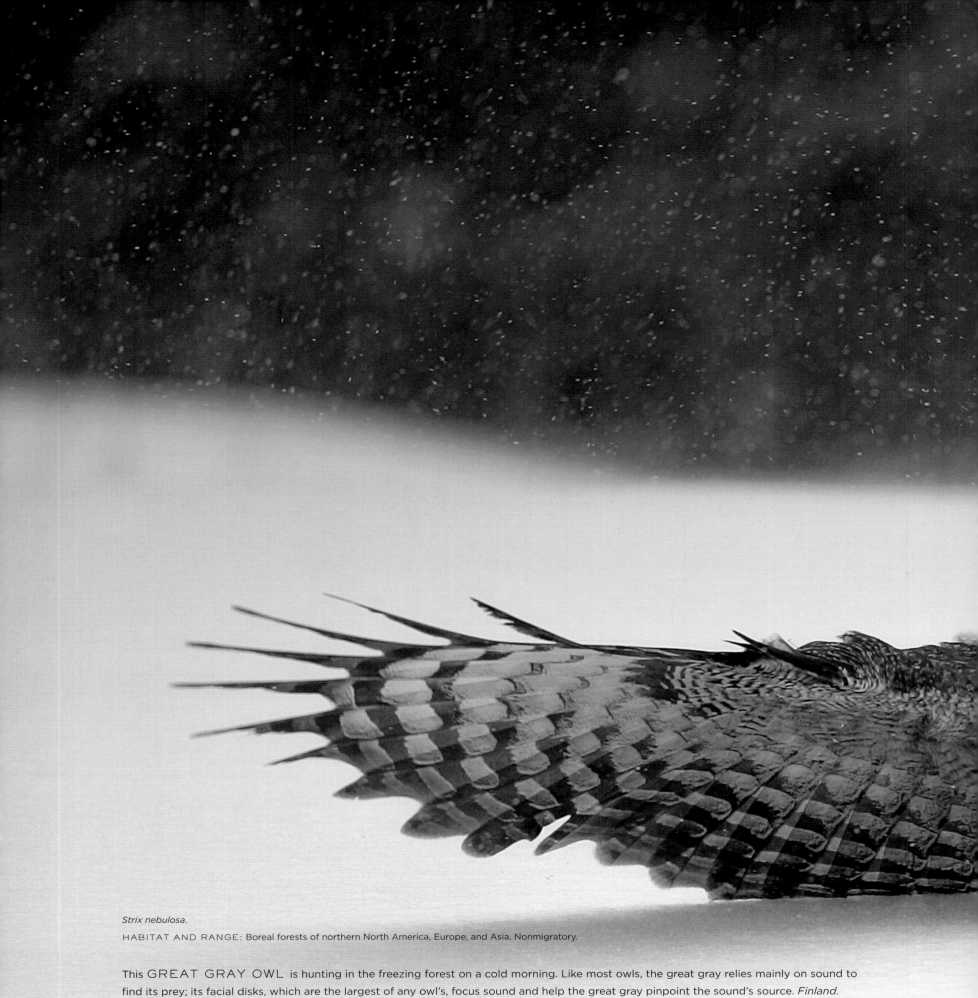

Strix nebulosa.

HABITAT AND RANGE: Boreal forests of northern North America, Europe, and Asia. Nonmigratory.

This GREAT GRAY OWL is hunting in the freezing forest on a cold morning. Like most owls, the great gray relies mainly on sound to find its prey; its facial disks, which are the largest of any owl's, focus sound and help the great gray pinpoint the sound's source. *Finland.*

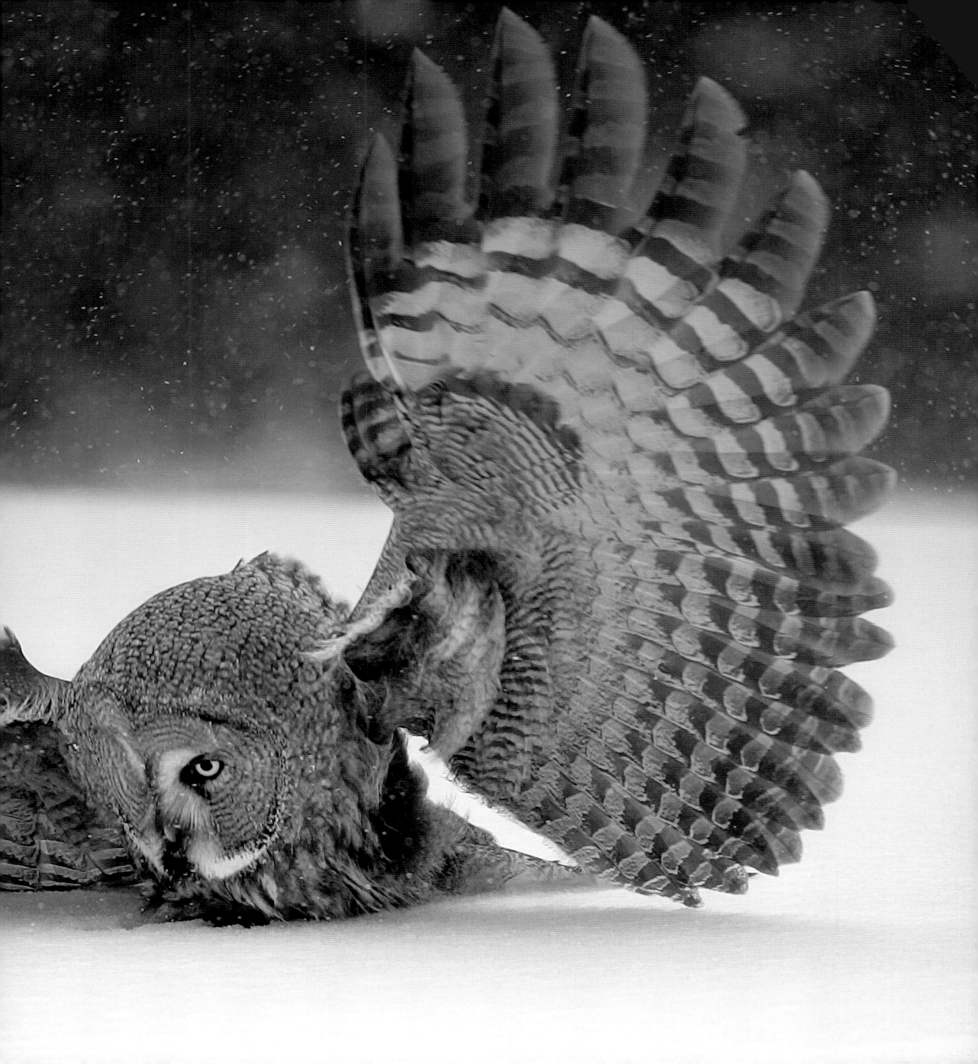

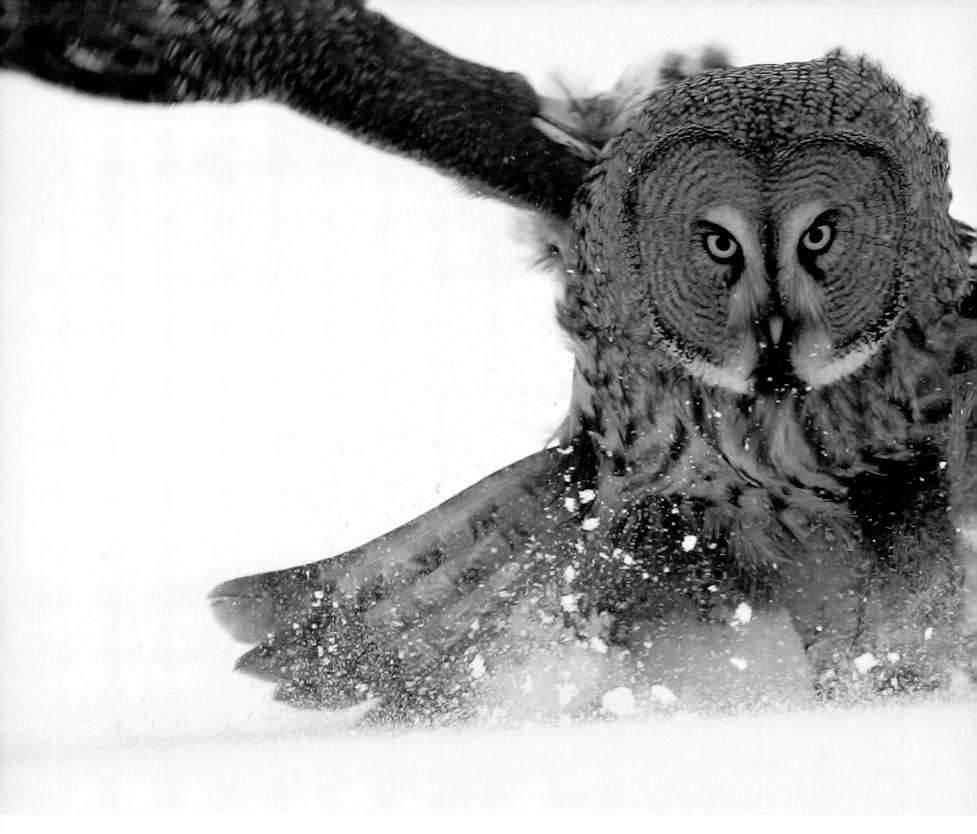

Strix nebulosa.

HABITAT AND RANGE: Boreal forests of northern North America, Europe, and Asia. Nonmigratory.

Just after swooping down from its perch on a nearby tree, a GREAT GRAY OWL catches a vole on the snow-covered ground below. The owl's hearing is so precise that the vole had no chance to escape. *Finland.*

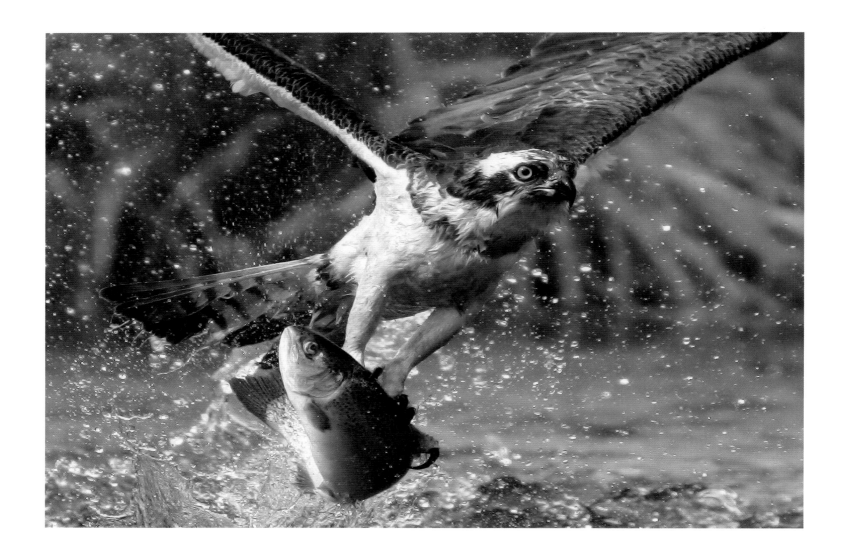

ABOVE: *Pandion haliaetus*.

HABITAT AND RANGE: Forests and wetlands on every continent except Antarctica. Migratory.

OSPREYS are specialist hunters, relying on salt- and freshwater fish for the bulk of their diet. While most fish are medium-size at best, this osprey has bagged an enormous catch nearly as big as its own body. *Finland.*

OPPOSITE: *Falco naumanni*.

HABITAT AND RANGE: Forests, grasslands, and open areas of southern Europe, central Asia, and Africa. Migratory.

This LESSER KESTREL is almost a poster bird for aerodynamics. With long, thin, tapered wings and large tail feathers, this bird of prey is among the world's fastest flyers. Several kestrels were hunting mice to bring back to feed their newborn chicks when this photograph was taken. *Seville, Spain.*

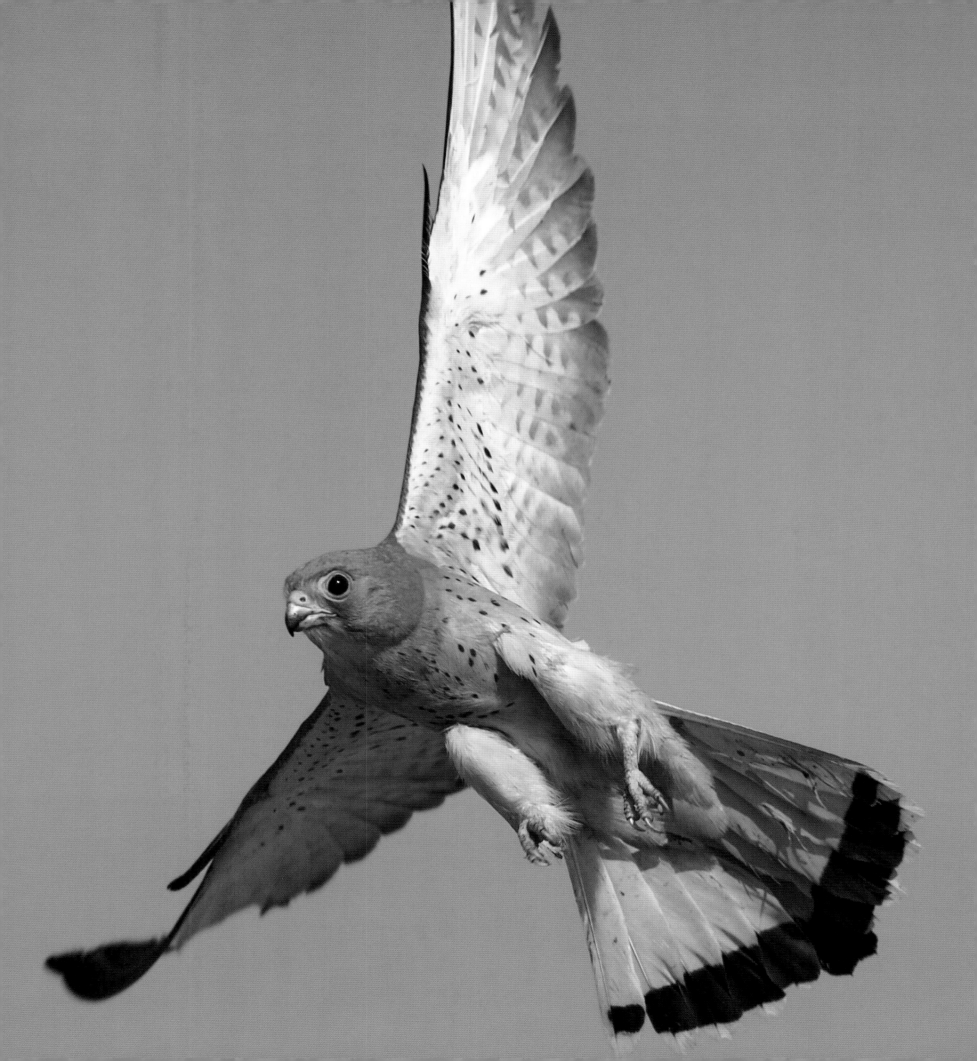

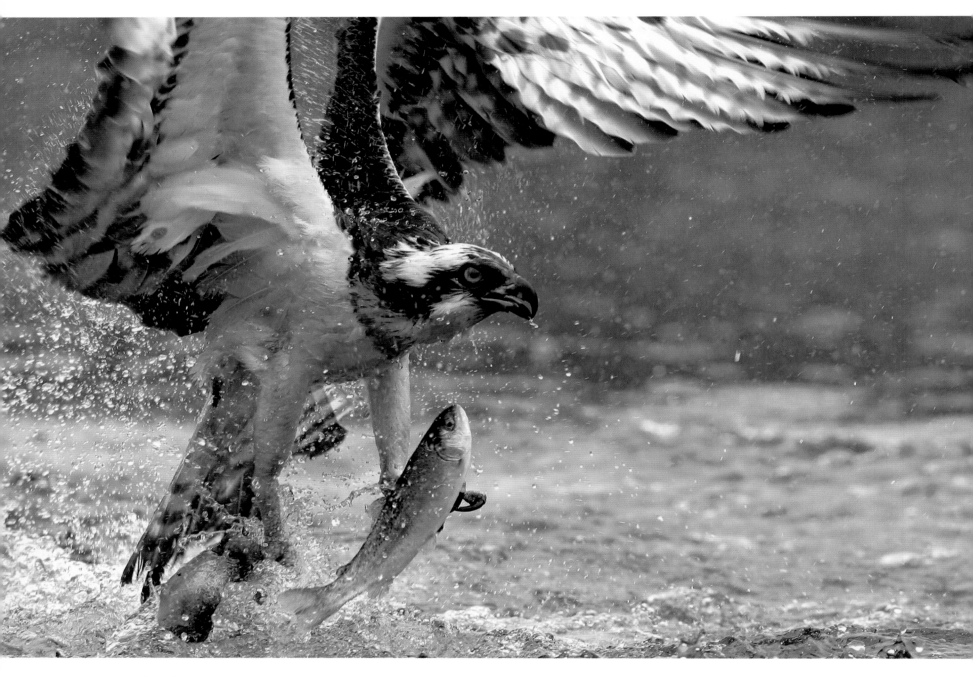

Pandion haliaetus.

HABITAT AND RANGE: Forests and wetlands on every continent except Antarctica. Migratory.

This OSPREY, clutching a pair of pink trout in its talons, eyes the horizon as it prepares to regain altitude. Unique among birds of prey, the osprey has been given its own taxonomic family (Pandionidae), and the four subspecies (*P. h. haliaetus, carolinensis, ridgwayi,* and *cristatus*) enjoy near-worldwide distribution. *Finland.*

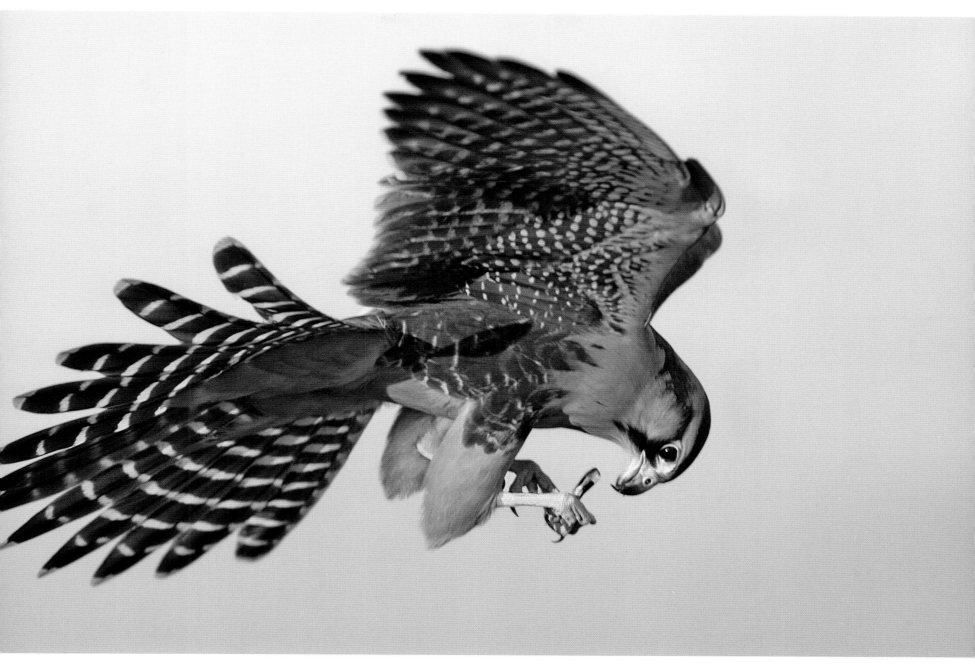

Falco femoralis.

HABITAT AND RANGE: Arid grasslands of North, Central, and South America. Migratory.

Looking as though it is about to do a midair somersault, this APLOMADO FALCON is flying straight ahead but craning its head so that it can focus its gaze on the grasshopper, helpless in its talons. *Colorado*.

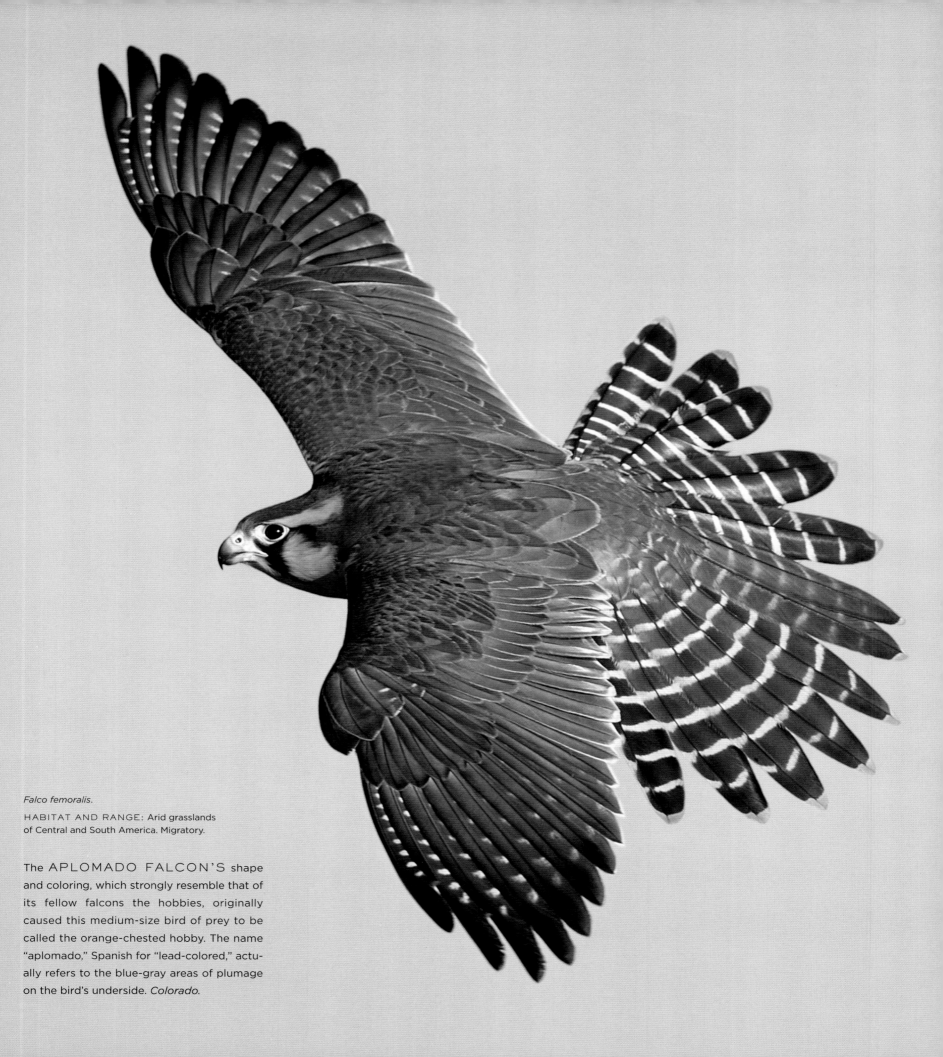

Falco femoralis.

HABITAT AND RANGE: Arid grasslands of Central and South America. Migratory.

The APLOMADO FALCON'S shape and coloring, which strongly resemble that of its fellow falcons the hobbies, originally caused this medium-size bird of prey to be called the orange-chested hobby. The name "aplomado," Spanish for "lead-colored," actually refers to the blue-gray areas of plumage on the bird's underside. *Colorado.*

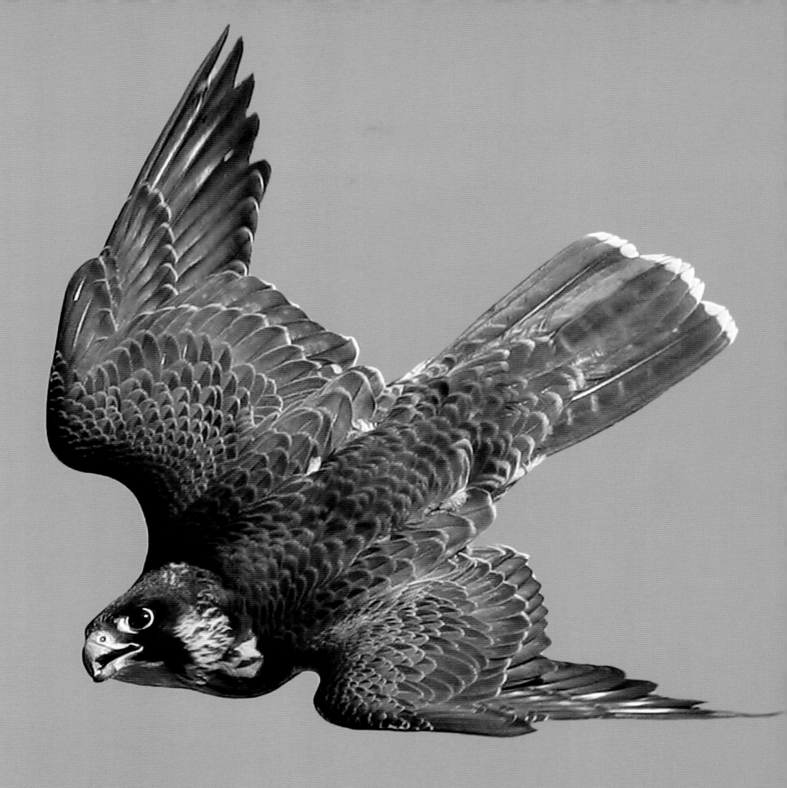

Falco peregrinus.

HABITAT AND RANGE: Forests, coastlines, and urban areas on every continent except Antarctica. Subspecies *tundrius* and *calidus* are migratory.

Assuming a slightly angled posture as it goes into a sharp dive, a PEREGRINE FALCON—occasionally called the duck hawk in North America—has spotted a duck below. The peregrine's hunting dive is the fastest on the planet, clocking in at more than 200 miles (322 kilometers) per hour. *Colorado*.

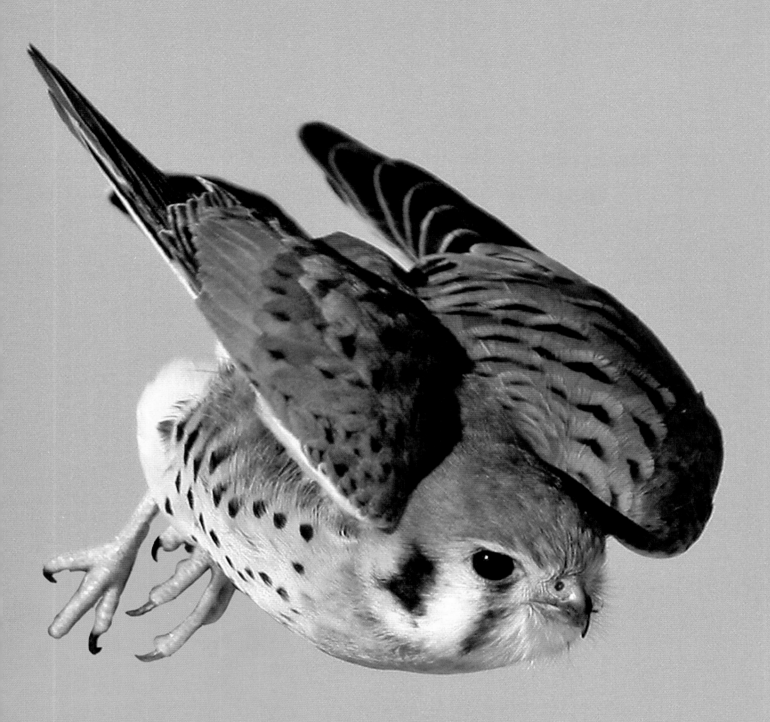

Falco sparverius.

HABITAT AND RANGE: Forests, grasslands, open country, and urban and suburban areas in North and South America. Migratory.

This AMERICAN KESTREL is in optimal diving position, its wings hunched and pointing straight as arrows backward, its black eye trained on a mouse on the ground. The black ear patches on the sides of the head and the extensively gray wings of the male, clearly visible here, reveal that this North American falcon species is not a true kestrel, but rather a hobby. *Colorado.*

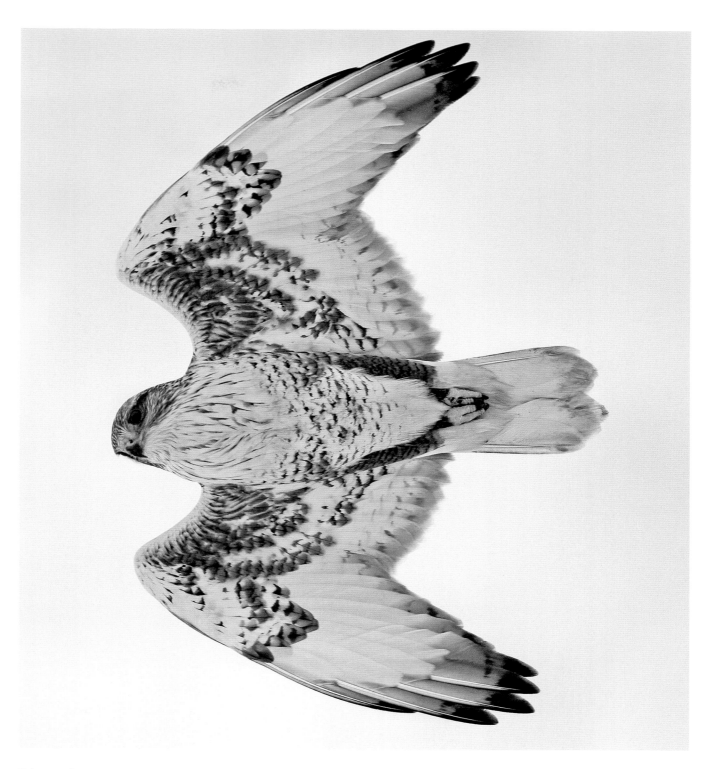

Buteo regalis.

HABITAT AND RANGE: Grasslands and deserts of western North and Central America. Migratory.

Here we see a FERRUGINOUS HAWK with its wings fully spread and its talons neatly tucked under its tail, nearly blocking out the winter sky. This is precisely the view of a great hunting bird that its prey will get—and usually the last thing it will see. *Colorado.*

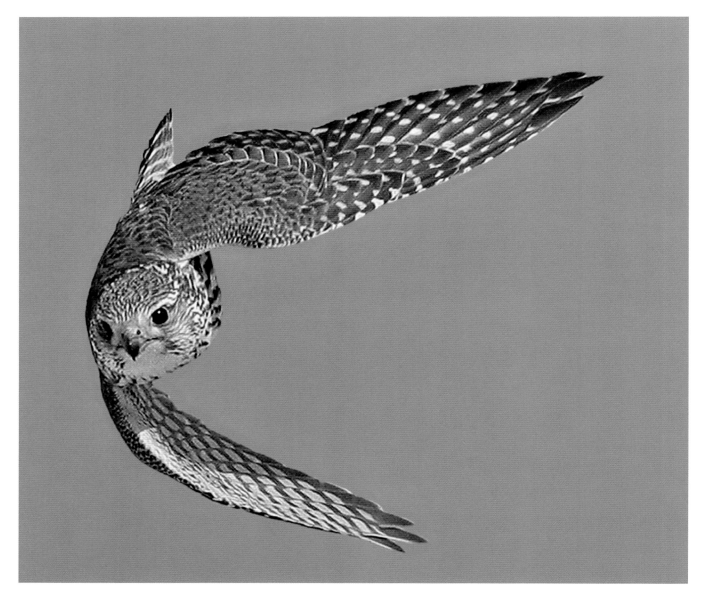

ABOVE: *Falco columbarius.*

HABITAT AND RANGE: Open country of North America, Europe, and Asia. Migratory.

The gleaming gold and white MERLIN here is on a dive through the deep blue sky, its body arched into a C shape and its eyes fixed straight ahead. This falcon is a captive that is being exercised and loving every minute of it. *Colorado.*

OPPOSITE: *Haliaeetus leucocephalus.*

HABITAT AND RANGE: Forests, river valleys, and coastlines across North America and Mexico. Partially migratory.

This is about as majestic as wildlife can be: an adult BALD EAGLE taking off from its perch in a cottonwood field. One cannot help but be drawn to its sense of strength, power, and grace, though for the eagle it's just another routine hunting flight. *Colorado.*

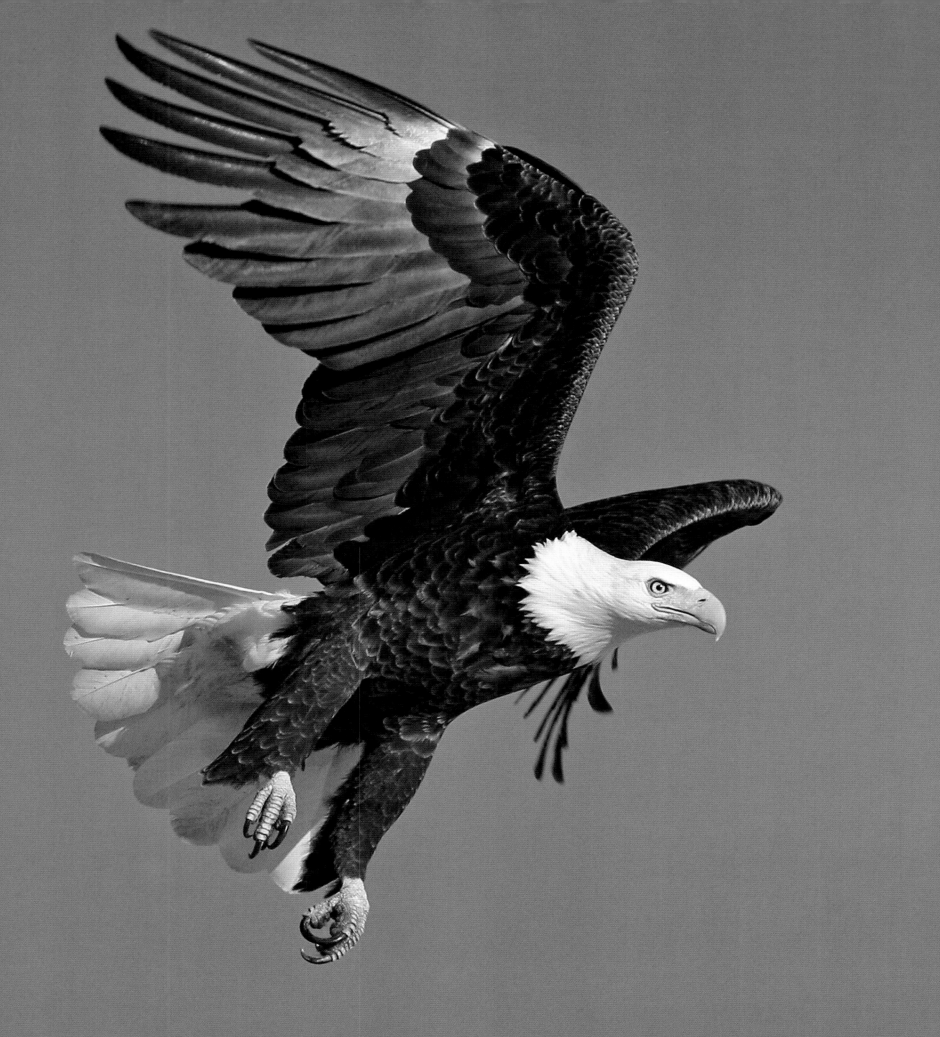

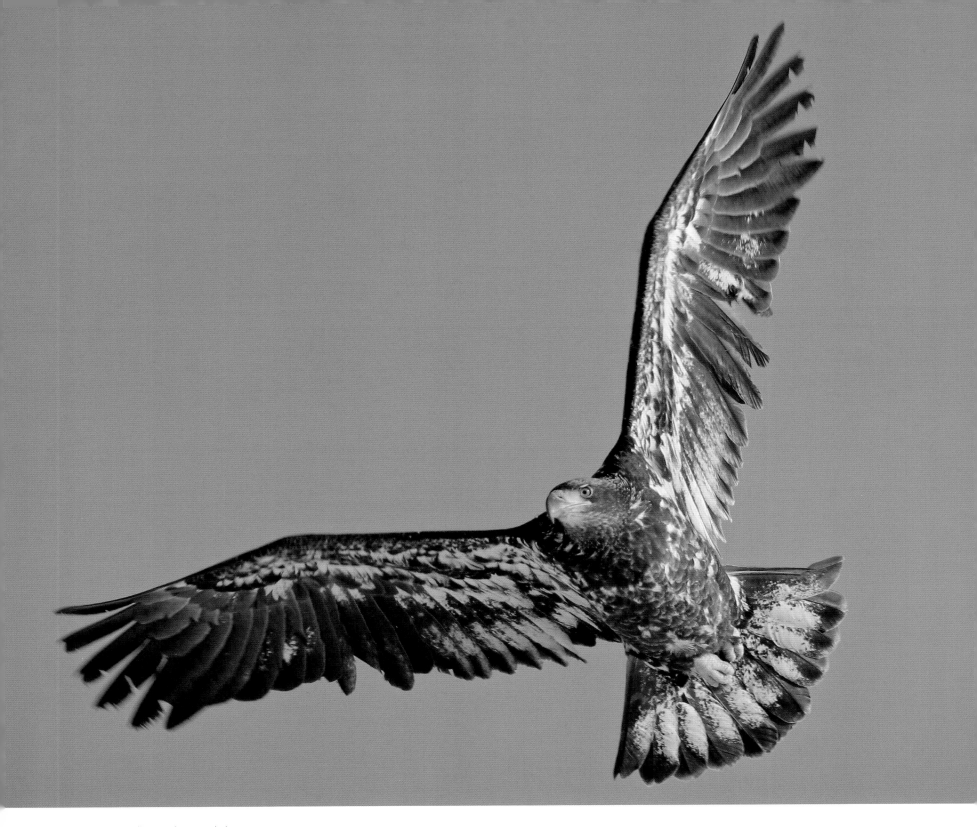

Haliaeetus leucocephalus.

HABITAT AND RANGE: Forests, river valleys, and coastlines across North America and Mexico. Partially migratory.

Even if this immature BALD EAGLE looks a bit mousy and unpolished, it won't be long before it develops its own impressive feathers and attitude. Already, it has the keen look of an airborne hunter. *Colorado.*

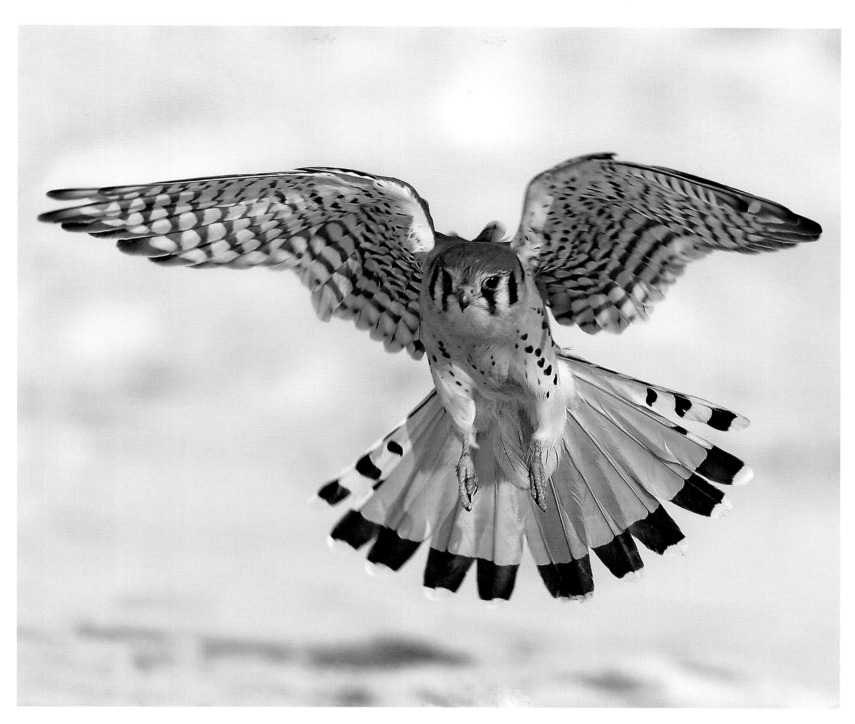

Falco sparverius.

HABITAT AND RANGE: Forests, grasslands, open country, and urban and suburban areas in North and South America. Migratory.

The smallest falcon in North America, the AMERICAN KESTREL is just about the size of a robin. In spite of their diminutive size, these birds have been known to harass other hawks and even golden eagles in flight. *Colorado.*

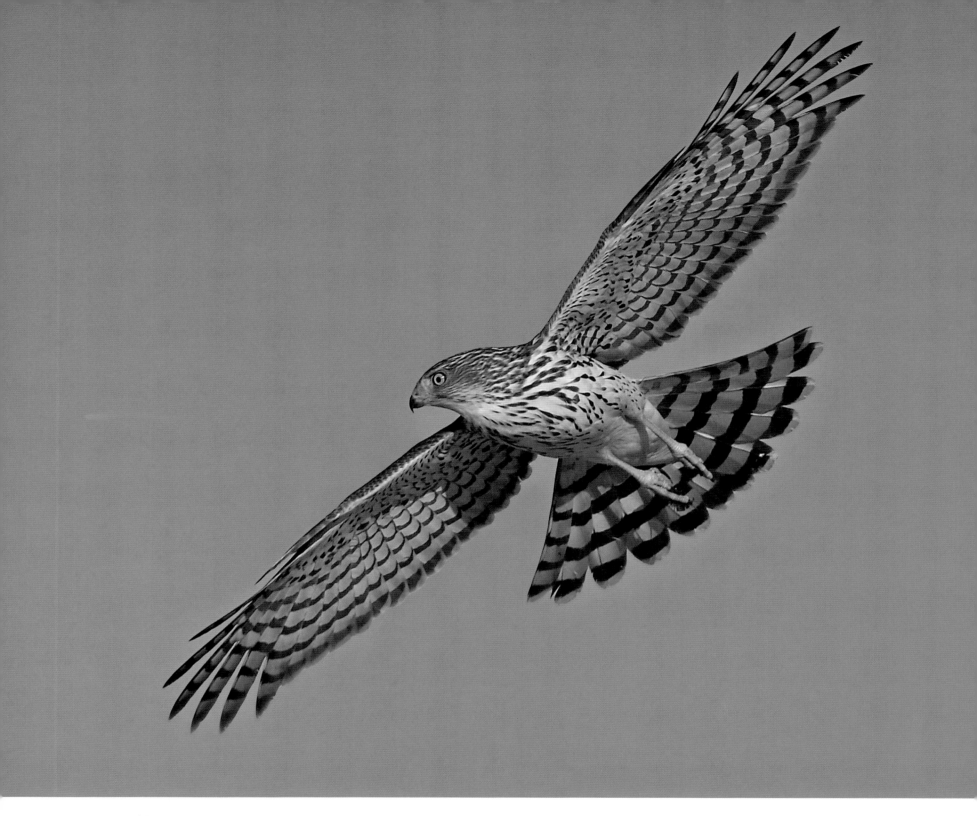

Accipiter cooperii.

HABITAT AND RANGE: Forests from southern Canada to northern Mexico. Northern populations are migratory.

This COOPER'S HAWK was on its customary migration to the warmer parts of its range. *Jones Beach, New York.*

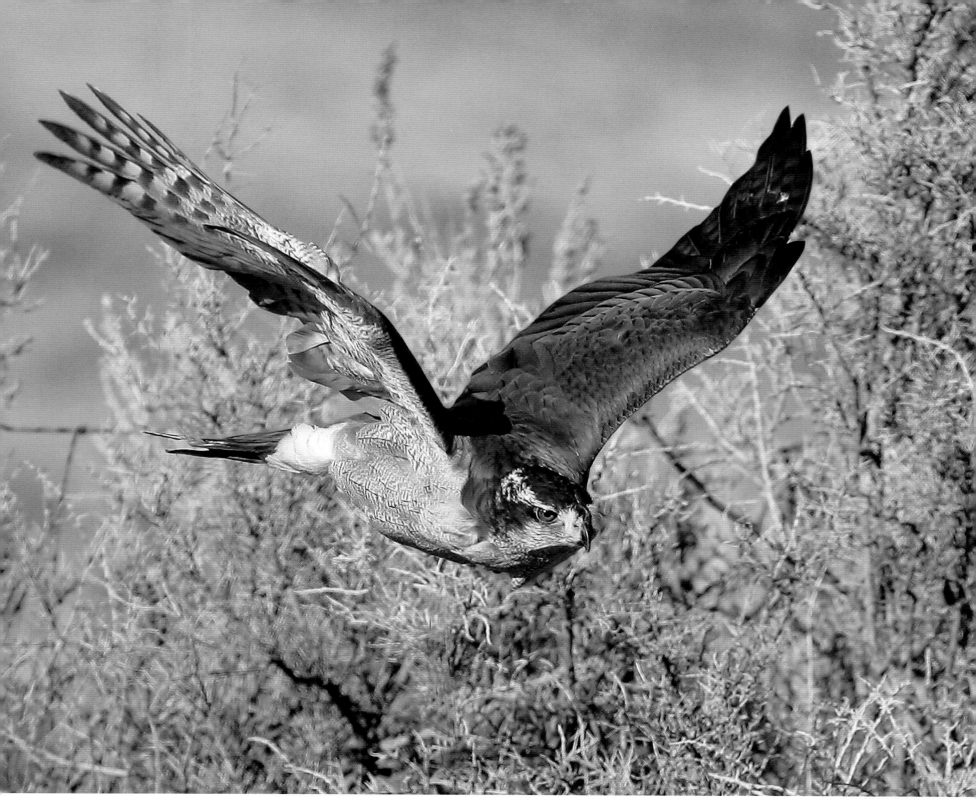

Accipiter gentilis.

HABITAT AND RANGE: Forests of North America, northern Europe, and Asia. Migratory.

A business-minded GOSHAWK attacks! Although a captive, this bird is taking advantage of its time outdoors by chasing rabbits. Wild goshawks have been known to hunt everything from squirrels to pheasants to great gray owls. *Utah.*

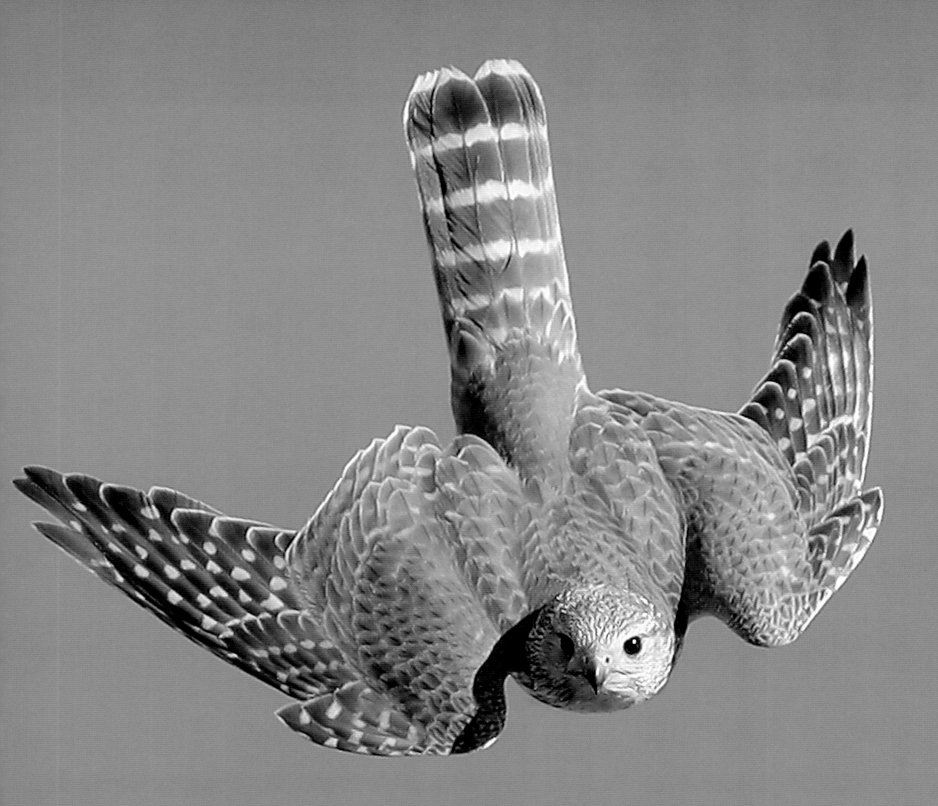

Falco columbarius.

HABITAT AND RANGE: Open country of North America, Europe, and Asia. Migratory.

The angle may look awkward, but this diving MERLIN is in perfect position to nail its prey, its thick tail and the tips of its golden wings perpendicular to gain more and more speed. This one is working alone, but breeding pairs of merlins often hunt together. *Utah.*

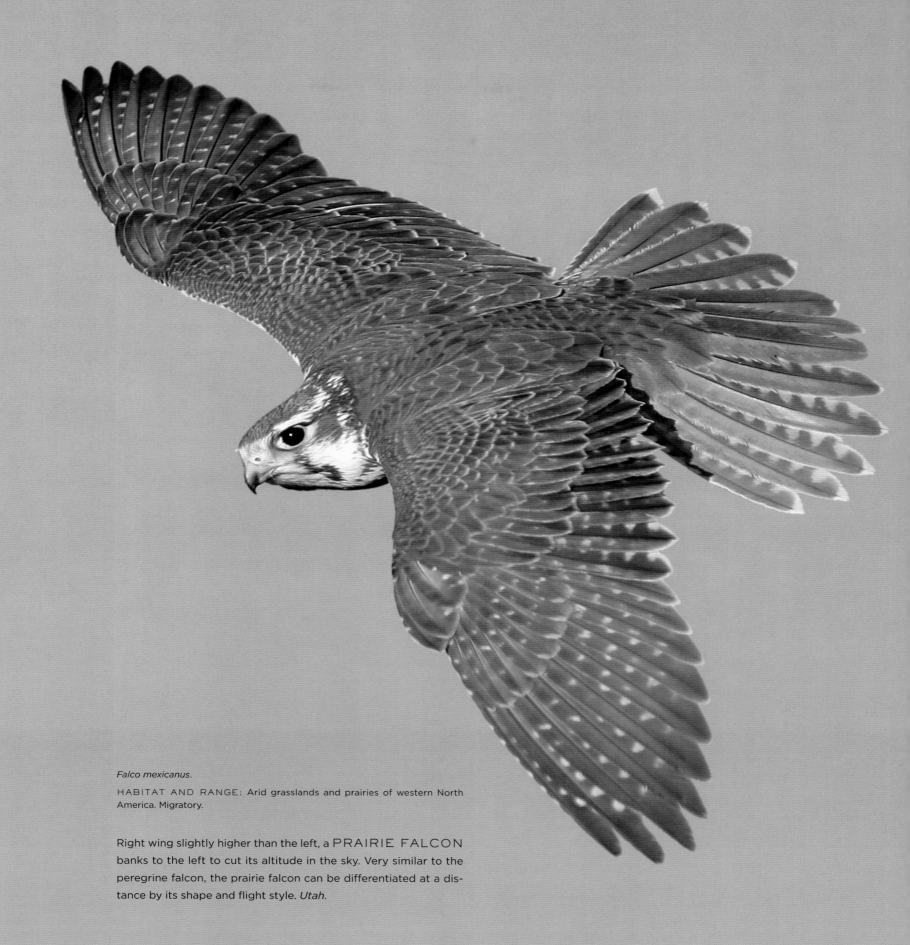

Falco mexicanus.

HABITAT AND RANGE: Arid grasslands and prairies of western North America. Migratory.

Right wing slightly higher than the left, a PRAIRIE FALCON banks to the left to cut its altitude in the sky. Very similar to the peregrine falcon, the prairie falcon can be differentiated at a distance by its shape and flight style. *Utah.*

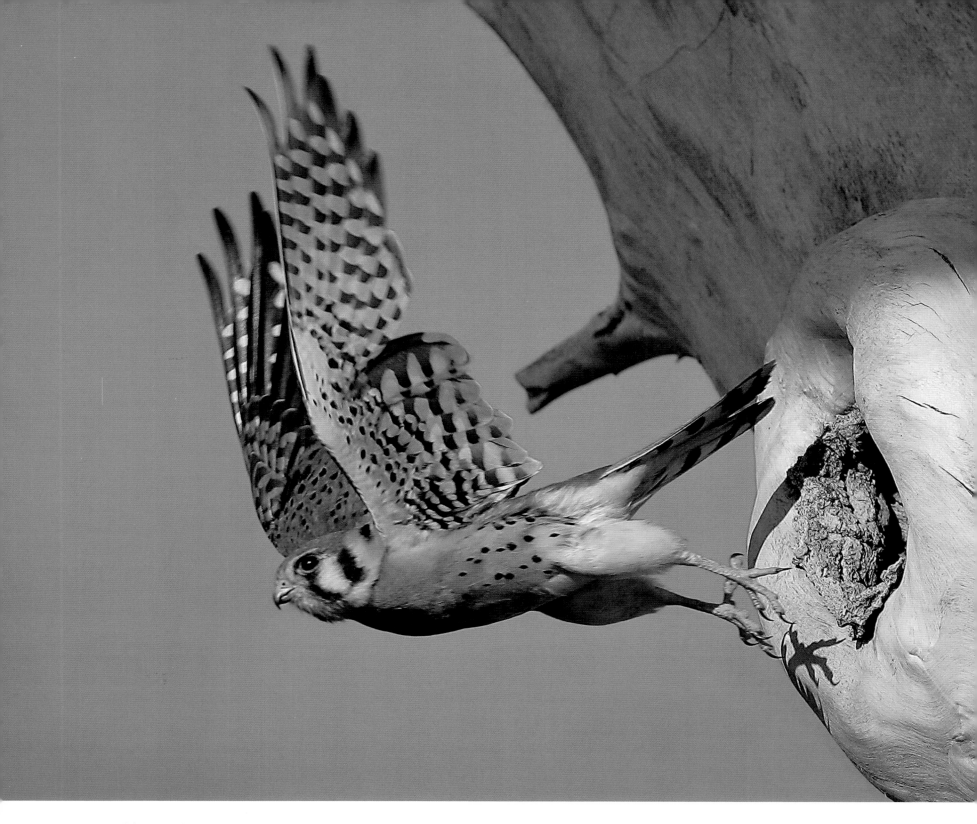

Falco sparverius.

HABITAT AND RANGE: Forests, grasslands, open country, and urban and suburban areas in North and South America. Migratory.

This ruddy AMERICAN KESTREL with "war paint" on its face has just emerged from its nest hole, unfurling its spotted wings. These birds are cavity nesters, typically using crevices in cliffs, artificial nest boxes, or even small holes in buildings. *Colorado.*

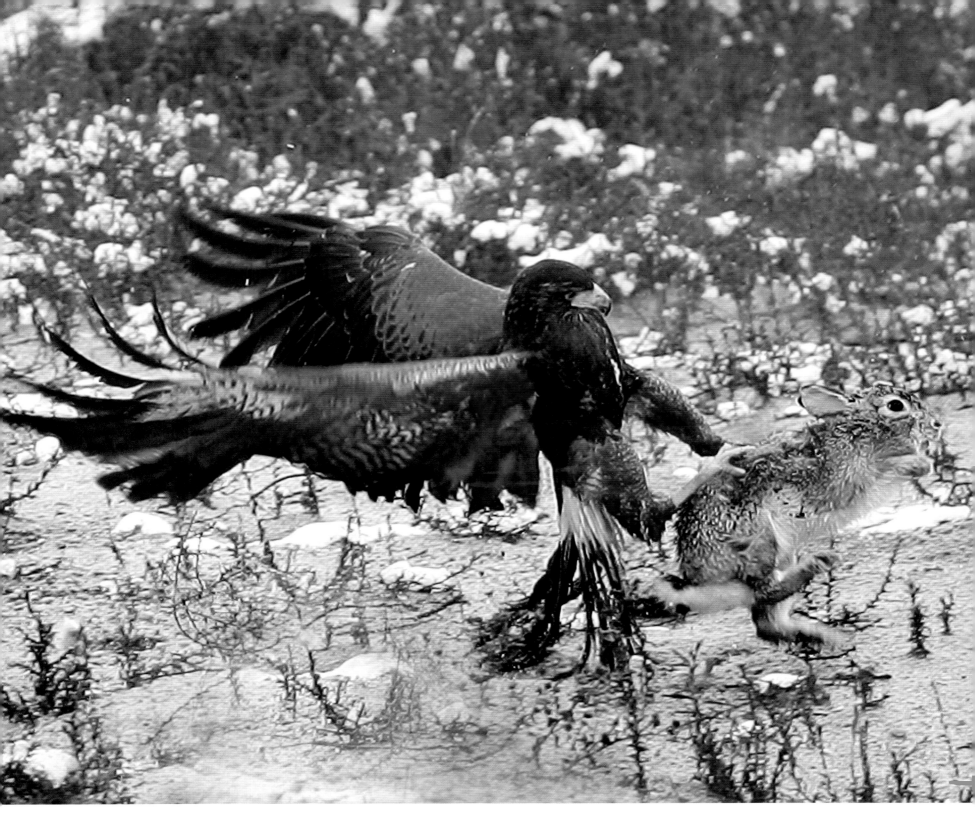

Parabuteo unicinctus.

HABITAT AND RANGE: Forests, arid open country, seasonally wet grasslands, and suburban areas of Central and South America. Nonmigratory.

All the fury and brutality of the kill is evident as this HARRIS'S HAWK gets its clutches on a wild rabbit in a snow-covered field. One can almost feel the tensile strength of the hawk's talons as they bore into the rabbit and lift it from the field, the hawk's wings pumping wildly to keep it hovering mere inches off the ground. *Utah.*

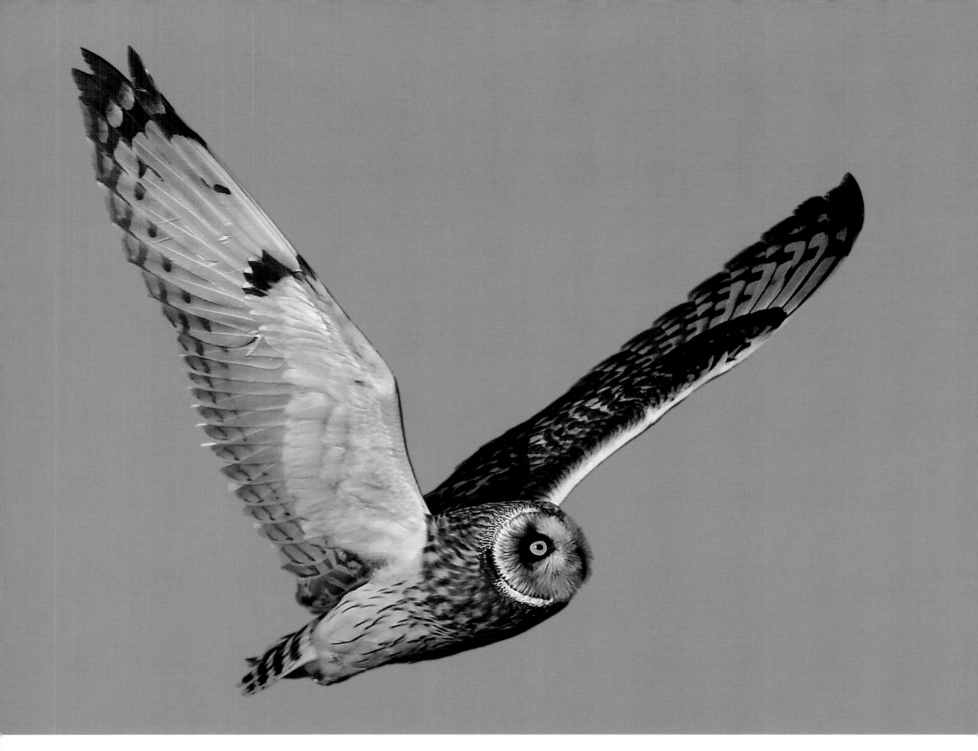

ABOVE: *Asio flammeus.*

HABITAT AND RANGE: Open fields on every continent except Australia and Antarctica. Northern populations are migratory.

The SHORT-EARED OWL comes down from the northern reaches of its range in the late winter months to hunt for new sources of food. This specimen was photographed circling Floyd Bennett Field, probably in search of a lingering mouse on the ground below. *Brooklyn, New York.*

OPPOSITE: *Falco rusticolus.*

HABITAT AND RANGE: Tundra of North America. Migratory.

A captive GRAY GYRFALCON, out on an exercise jaunt, lifts off with a rush of flapping wings and a spring of its long, powerful legs, generating immense thrust and speed. In medieval times, the gyrfalcon was considered a royal bird and could only be owned by kings and nobles.

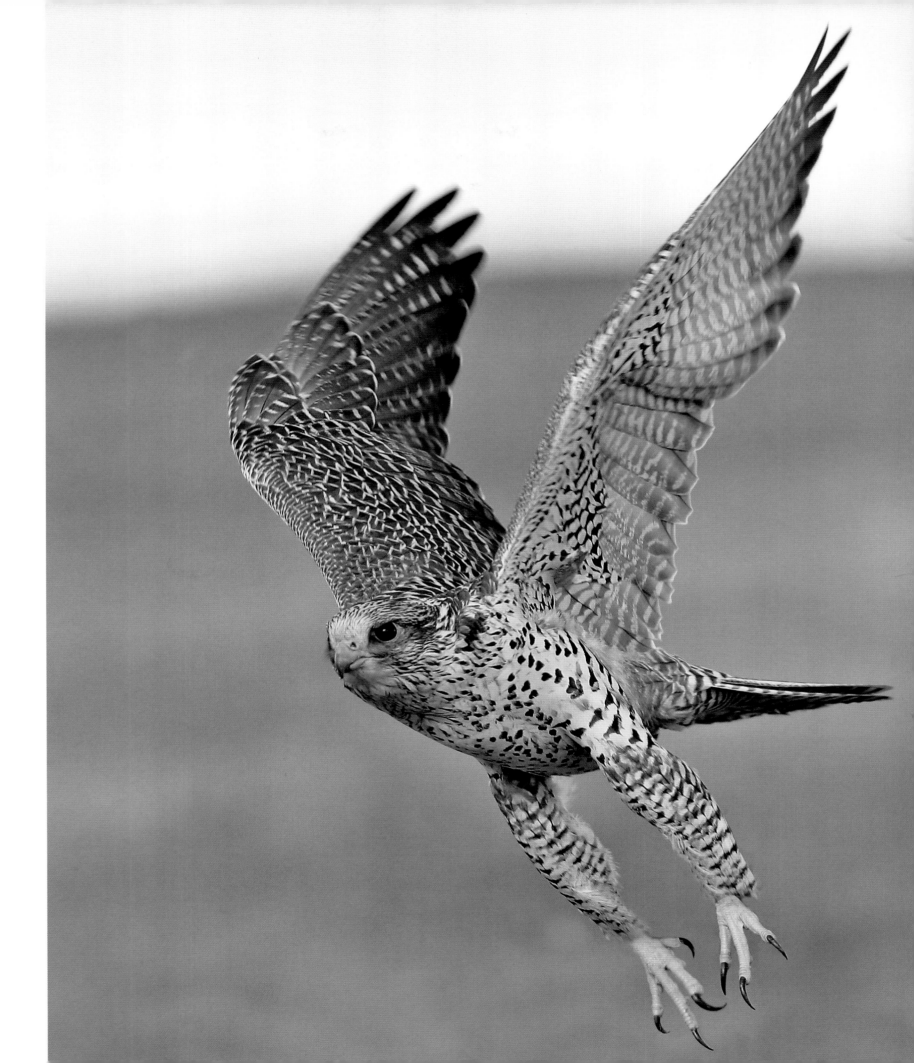

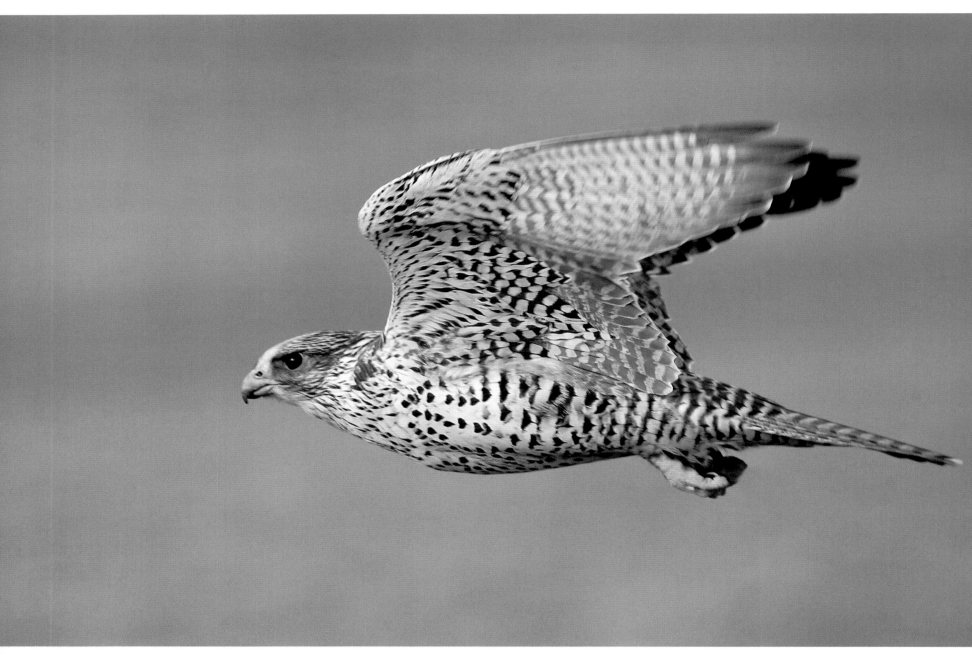

Falco rusticolus.

HABITAT AND RANGE: Tundra of North America. Migratory.

This GRAY GYRFALCON, throttled up to top speed, is seeking smaller birds and mammals to catch. Tenacious hunters, these falcons are threatened mainly by golden eagles in the wild, but their own harassment of other animals knows few bounds. Even brown bears have been dive-bombed by protective gyrfalcons defending a nest.

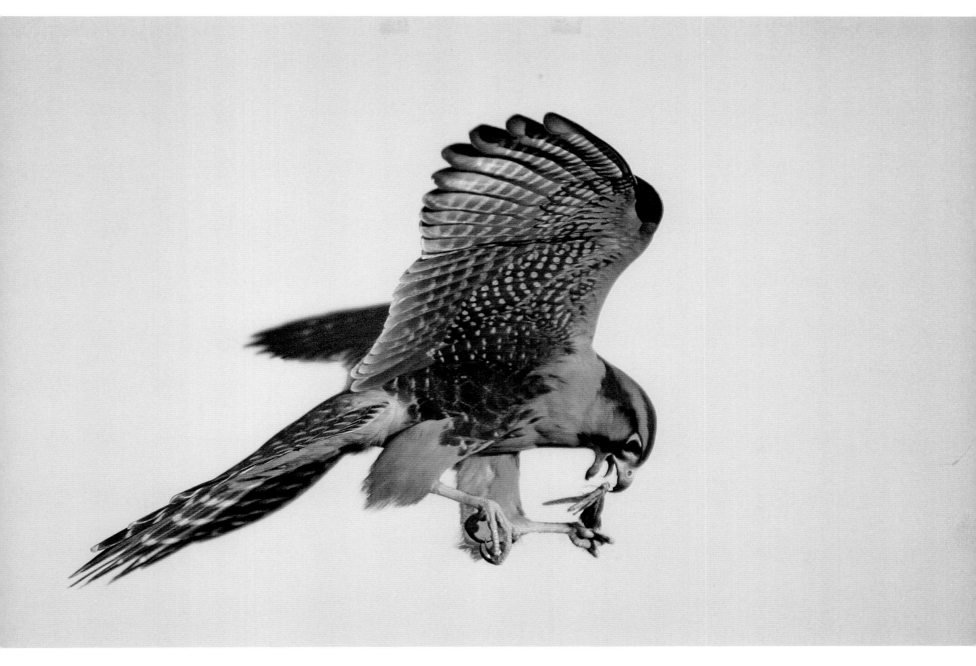

Falco femoralis.

HABITAT AND RANGE: Arid grasslands of Central and South America. Migratory.

Talk about eating on the go! This APLOMADO FALCON can't wait before landing to begin gnawing on its captive grasshopper, not missing a beat in full flight.

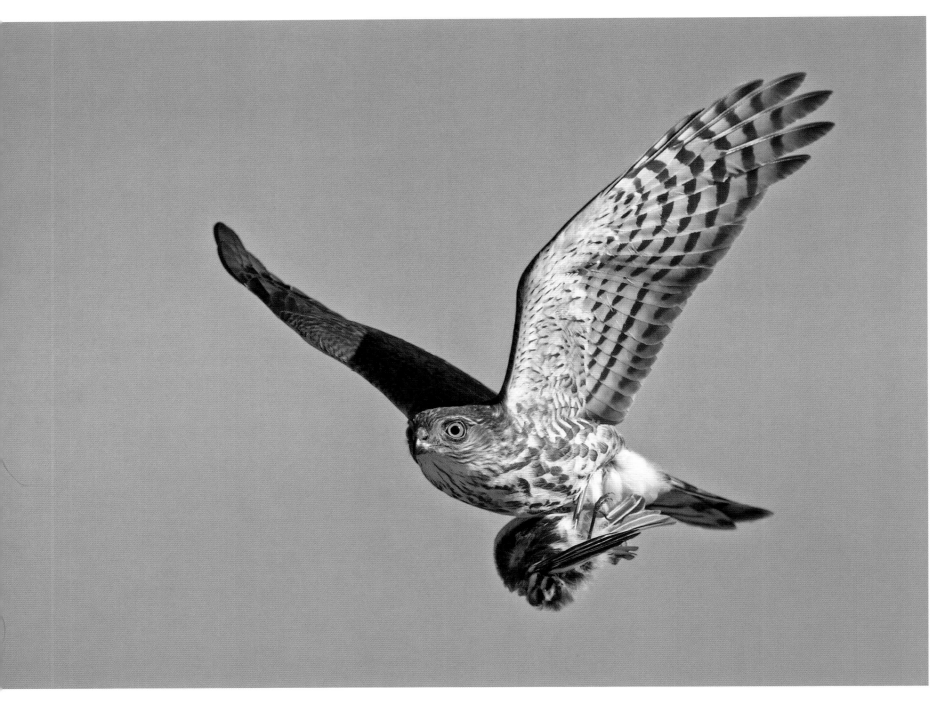

Accipiter striatus.

HABITAT AND RANGE: Forests of North America. Migratory.

This young SHARP-SHINNED HAWK, on one of its first fall migrations, has just captured a prize: a small songbird. In spite of their small size, sharp-shinned hawks often make off with larger kills than this one. *Jones Beach, New York.*

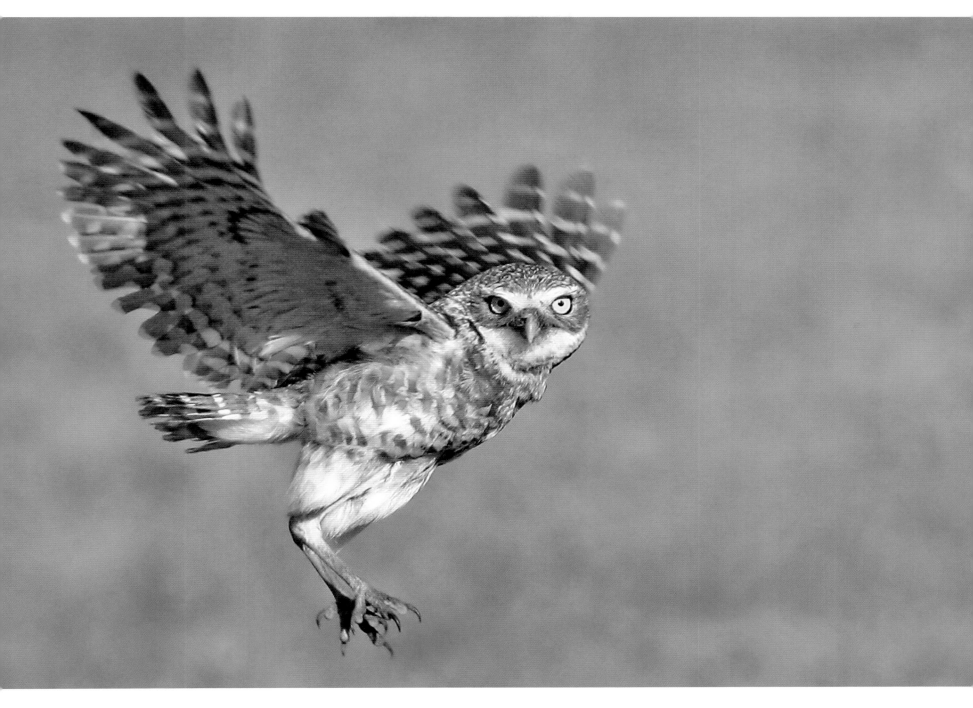

Athene cunicularia.

HABITAT AND RANGE: Grasslands and urban and suburban areas in North and Central America and parts of South America. Northern populations are migratory.

BURROWING OWLS, like this inquisitive female engaged in a midair maneuver, are becoming an increasingly rare sight in the United States. Although there are stable populations in South America, the bird is considered a species of special concern in Florida and most of the western states in its range.

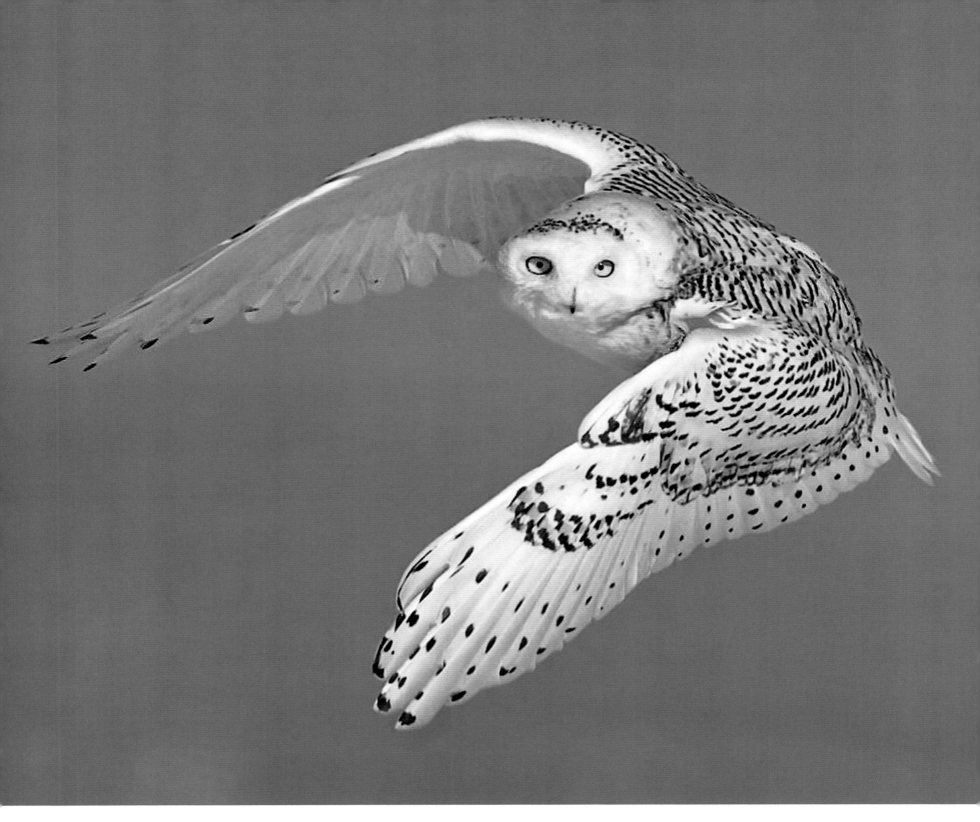

Nyctea scandiaca.

HABITAT AND RANGE: Open tundra of North America. Migratory.

In this photograph, the SNOWY OWL is so sharp and clear that the individual feathers make up its pleated wing patterns can be counted. The heavy barring on the plumage of young snowy owls eventually fades, and in some males it vanishes altogether.

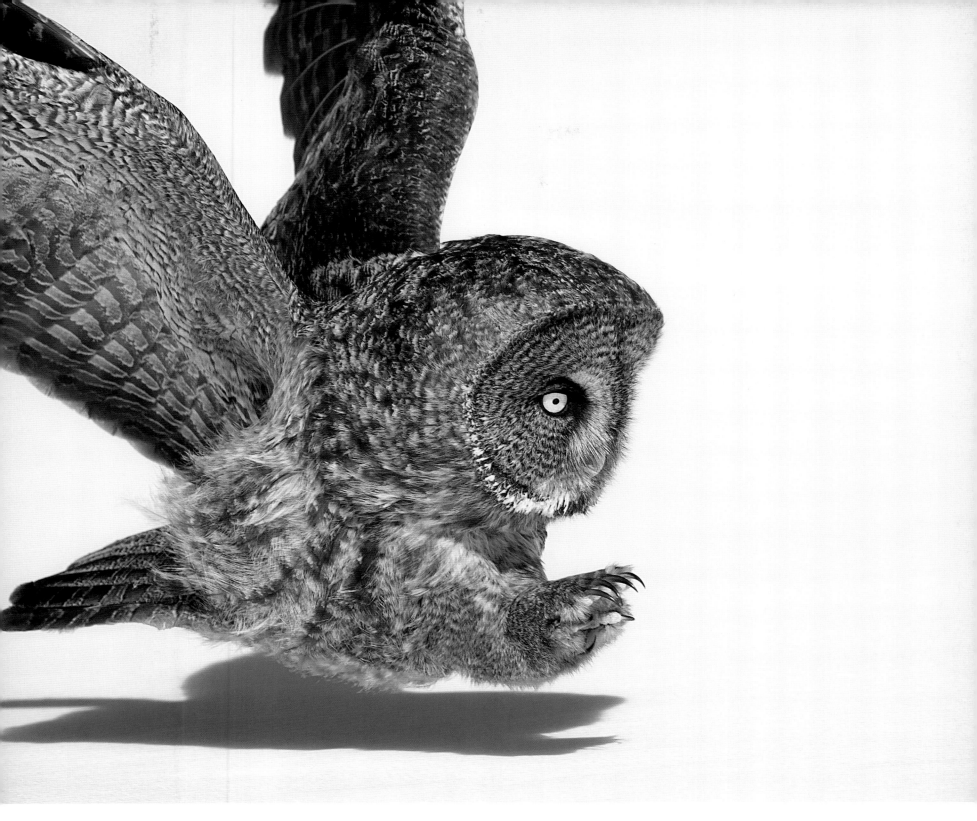

Strix nebulosa.

HABITAT AND RANGE: Boreal forests of northern North America, Europe, and Asia. Nonmigratory.

This GREAT GRAY OWL almost looks cuddly, but looks are deceiving: The impact of its landing can break through snow banks that would support a 180-pound (82-kilogram) human. Among North American owls, this species measures the largest in size; however, much of its bulk is accounted for in those deceptively puffy feathers, and the bird is actually rather lightweight.

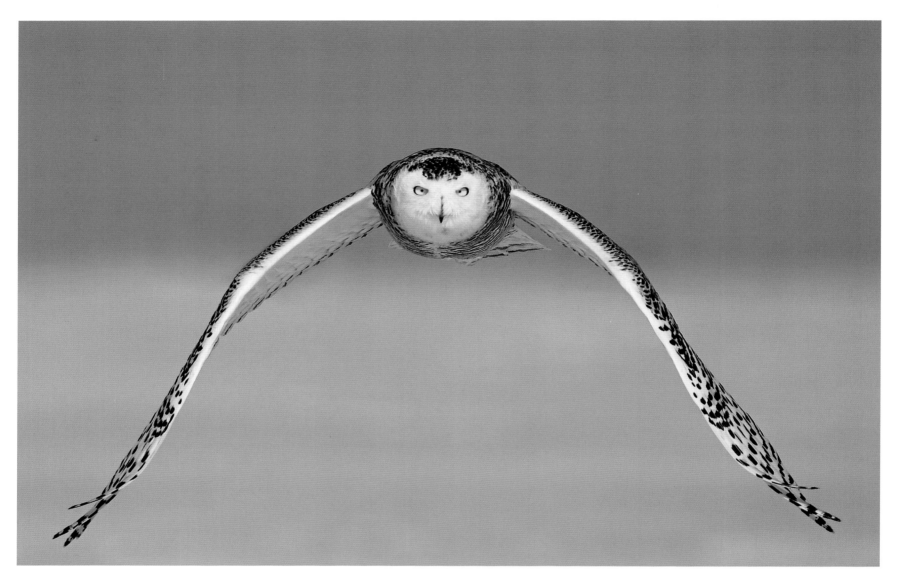

ABOVE: *Nyctea scandiaca.*

HABITAT AND RANGE: Open tundra of North America. Migratory.

This particularly fascinating shot of a SNOWY OWL in flight captures the awesome symmetry of its wings at the very bottom of the downstroke—almost making it appear that the owl is walking on legs! *Canada.*

OPPOSITE: *Buteo lagopus.*

HABITAT AND RANGE: Forests and tundra of North America, Europe, and Asia. Migratory.

This magnificent overhead shot of a ROUGH-LEGGED HAWK was taken as it soared over a large cornfield. Note how the lavender top feathers of its wings are so diaphanous that they are almost set apart from the shorter bottom feathers, making it appear as if the hawk has two sets of wings. *Canada.*

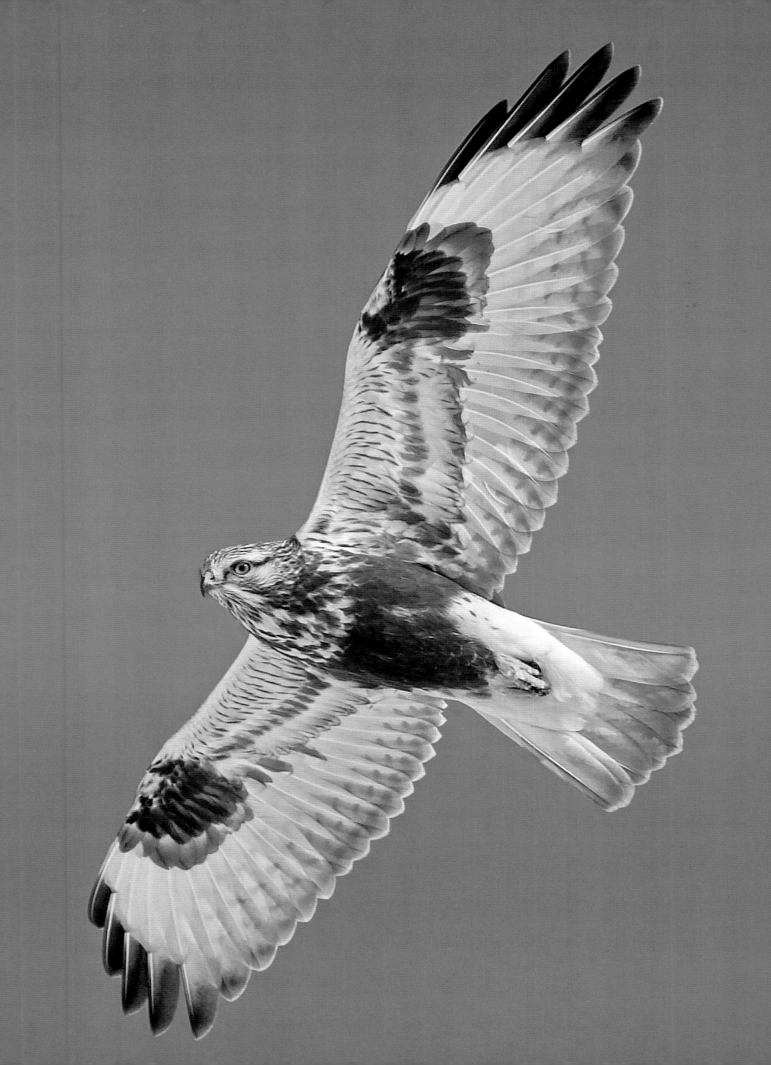

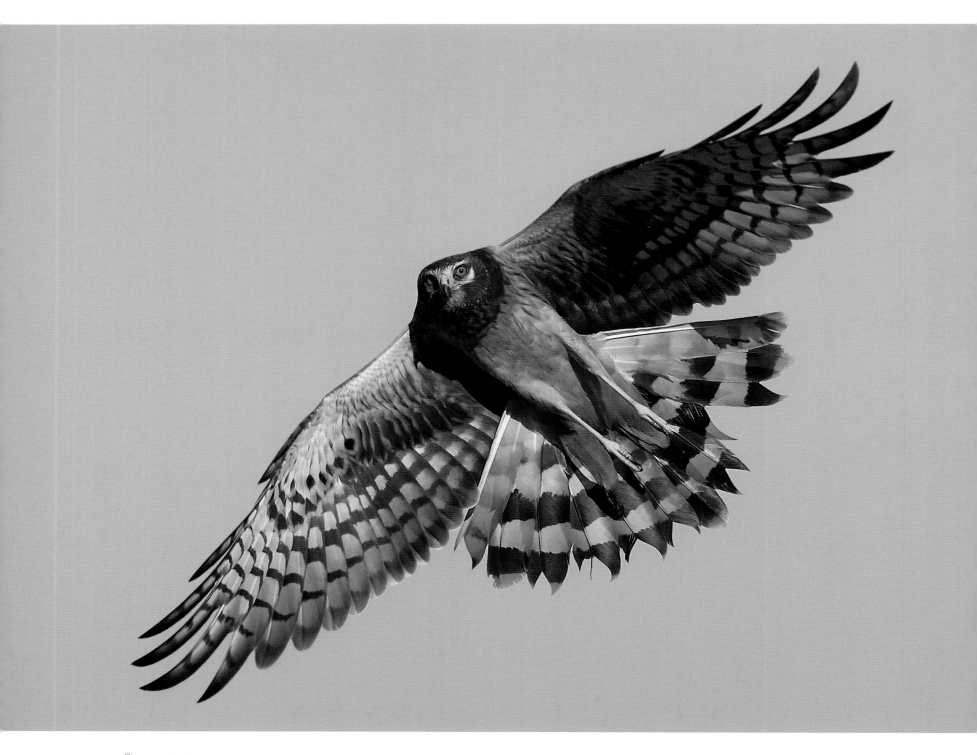

Circus cyaneus.

HABITAT AND RANGE: Forests, grasslands, wetlands, and open country of North America, parts of South America, Europe, and Asia. Migratory.

A beautiful copper and gray female NORTHERN HARRIER surveys the ground below for a possible meal with a tip of the head, as if checking out any competition. Unlike other harrier species, northern harriers have a great deal of differentiation between the plumages of the two sexes. The male is gray on its back and white below, with black wing tips. *Jones Beach, New York.*

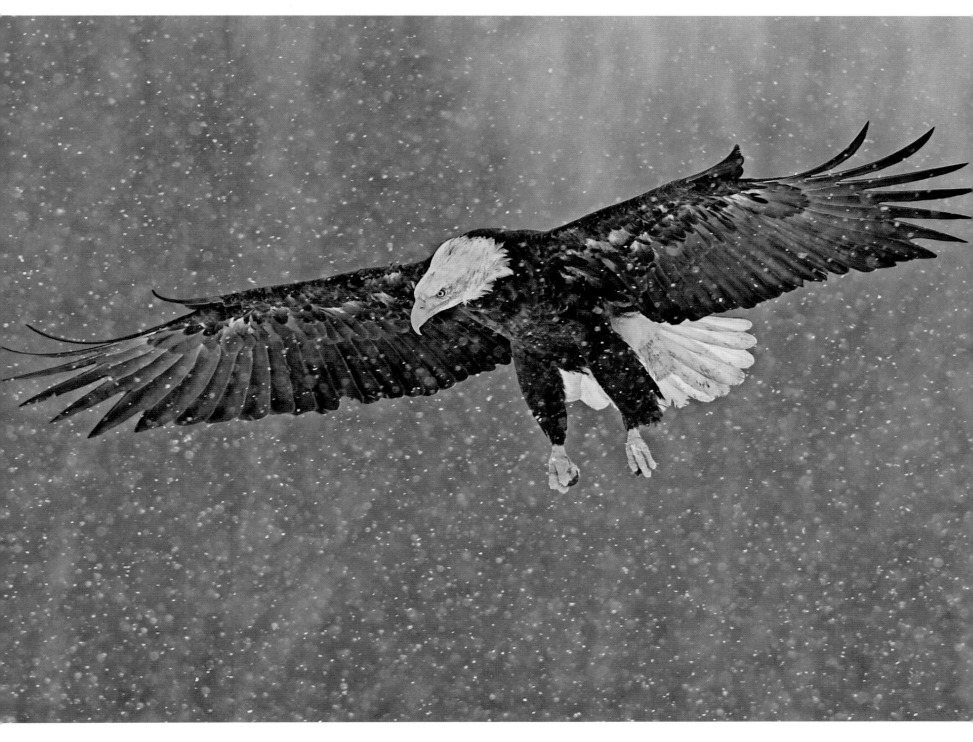

Haliaeetus leucocephalus.

HABITAT AND RANGE: Forests, river valleys, and coastlines across North America and Mexico. Partially migratory.

Even a tough old bird like the BALD EAGLE can't get the better of Mother Nature. This eagle is seen, no doubt reluctantly, coming down from the sky in the teeth of a driving snowstorm with temperatures that fell to –28° Farenheit (–33° Celsius). *Nova Scotia, Canada.*

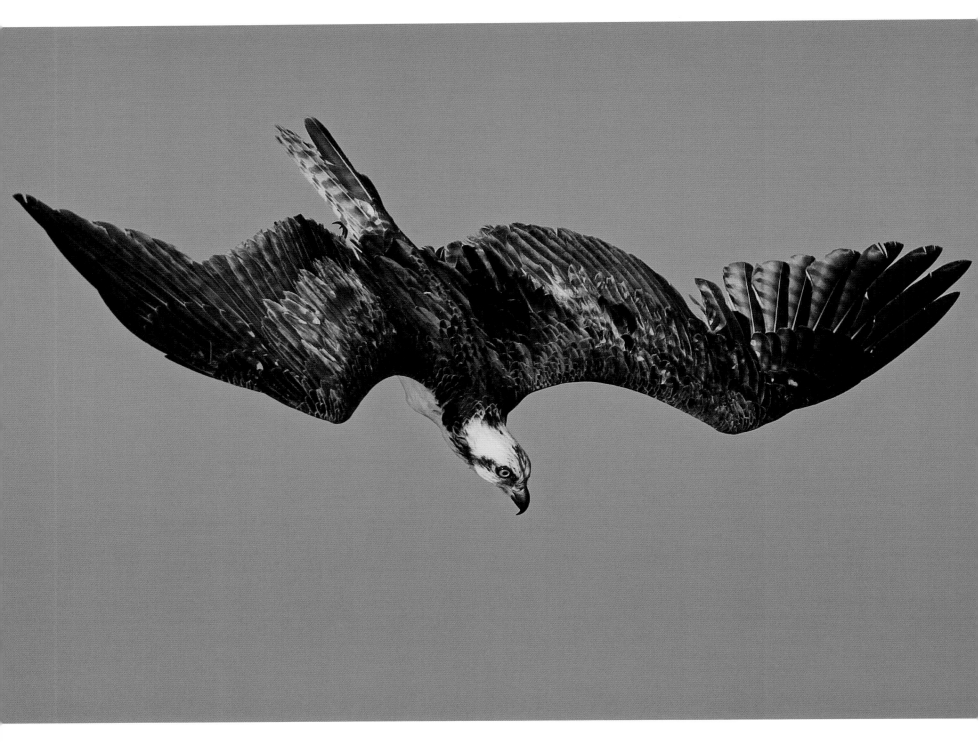

Pandion haliaetus.

HABITAT AND RANGE: Forests and wetlands on every continent except Antarctica. Migratory.

This OSPREY is about two seconds from impact with the water, its eyes trained on the fish below. With incredible agility, the osprey will turn its body upward at the last moment to hit the water feet-first and snap its prey up into the air.

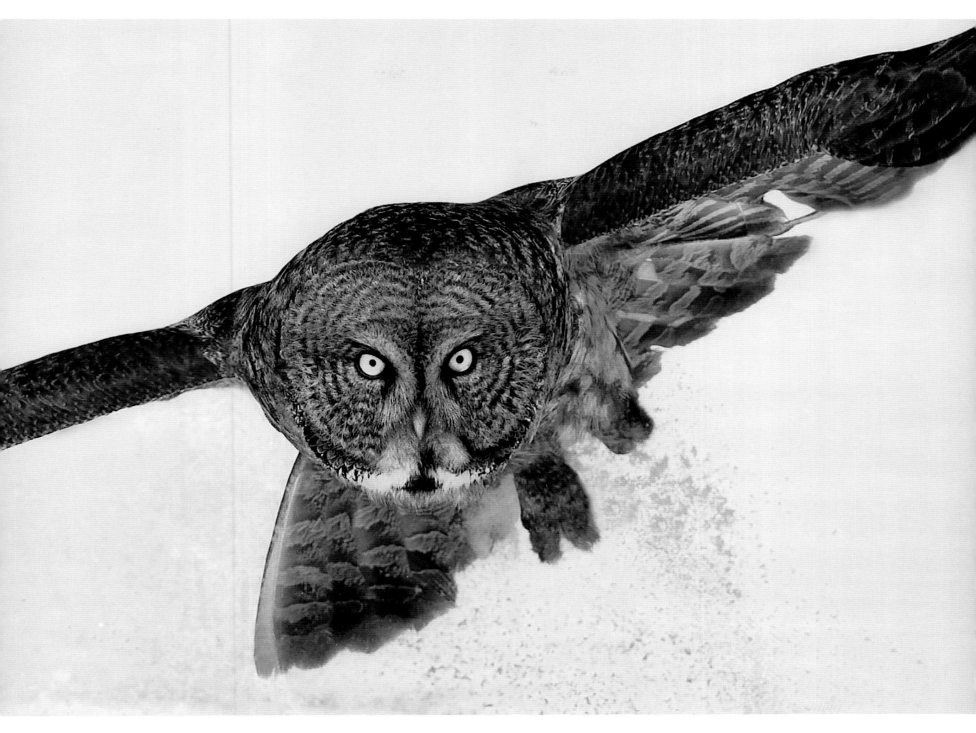

Strix nebulosa.

HABITAT AND RANGE: Boreal forests of northern North America, Europe, and Asia. Nonmigratory.

A female GREAT GRAY OWL is on the prowl, making a beeline for her prey in the snow. Apart from hunting at dawn and dusk, the great gray owl is almost entirely nocturnal. *Nova Scotia, Canada.*

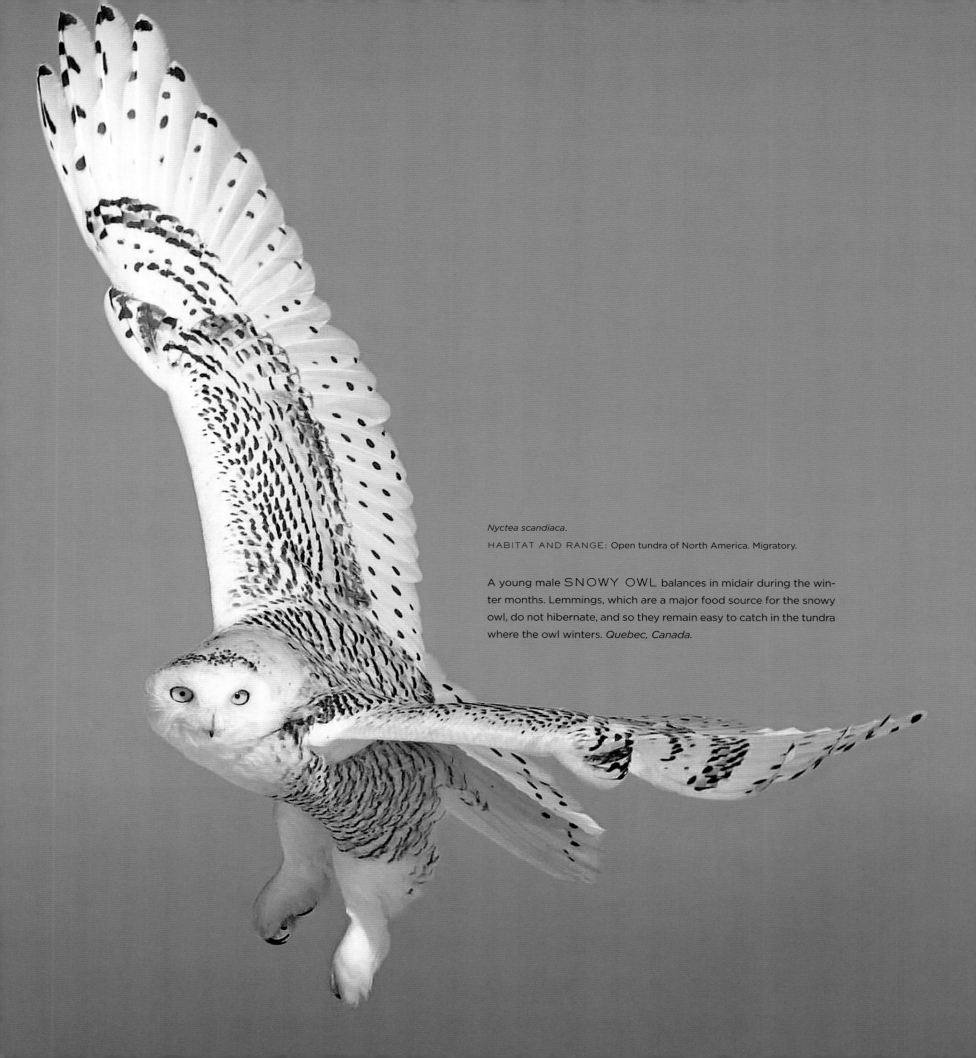

Nyctea scandiaca.

HABITAT AND RANGE: Open tundra of North America. Migratory.

A young male SNOWY OWL balances in midair during the winter months. Lemmings, which are a major food source for the snowy owl, do not hibernate, and so they remain easy to catch in the tundra where the owl winters. *Quebec, Canada.*

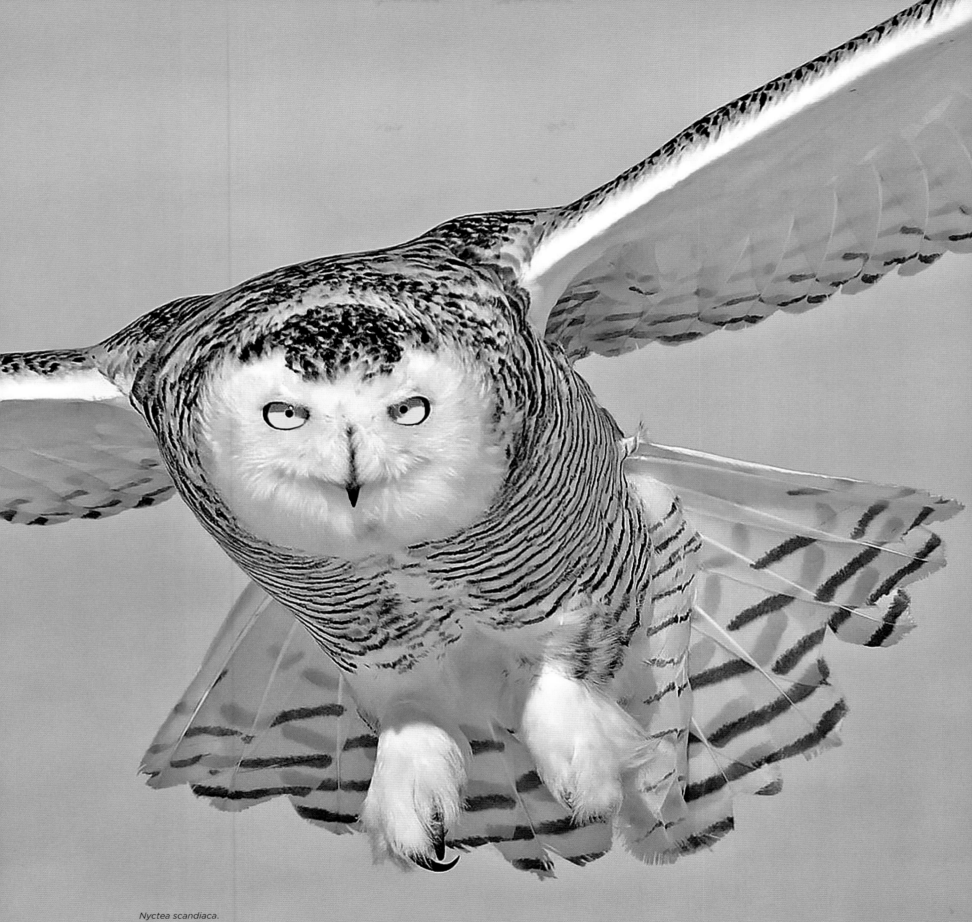

Nyctea scandiaca.

HABITAT AND RANGE: Open tundra of North America. Migratory.

Here's looking at you, kid! The piercing yellow eyes of the SNOWY OWL
at close range give new meaning to the phrase "focused like laser beams."

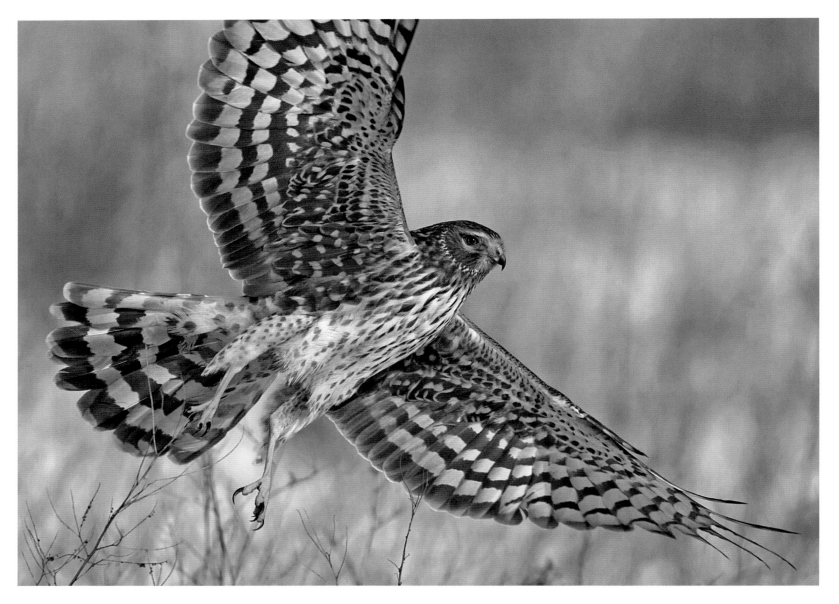

ABOVE: *Circus cyaneus.*

HABITAT AND RANGE: Forests, grasslands, wetlands, and open country of North America, parts of South America, Europe, and Asia. Migratory.

The interwoven spots, stripes, and other patterns that mark this female NORTHERN HARRIER from head to toe make her seem almost like a flying checkerboard. This agile hunting bird made an unsuccessful attempt to find prey in a field and is taking off for higher ground.

OPPOSITE: *Haematopus palliatus.*

HABITAT AND RANGE: Atlantic and Gulf Coasts of North America. Migratory.

This three-quarter view of an AMERICAN OYSTER-CATCHER in full flight shows the hardy flyer's intense red-orange eyes and matching beak as it cruises over the Atlantic Ocean. *Lido Beach, New York.*

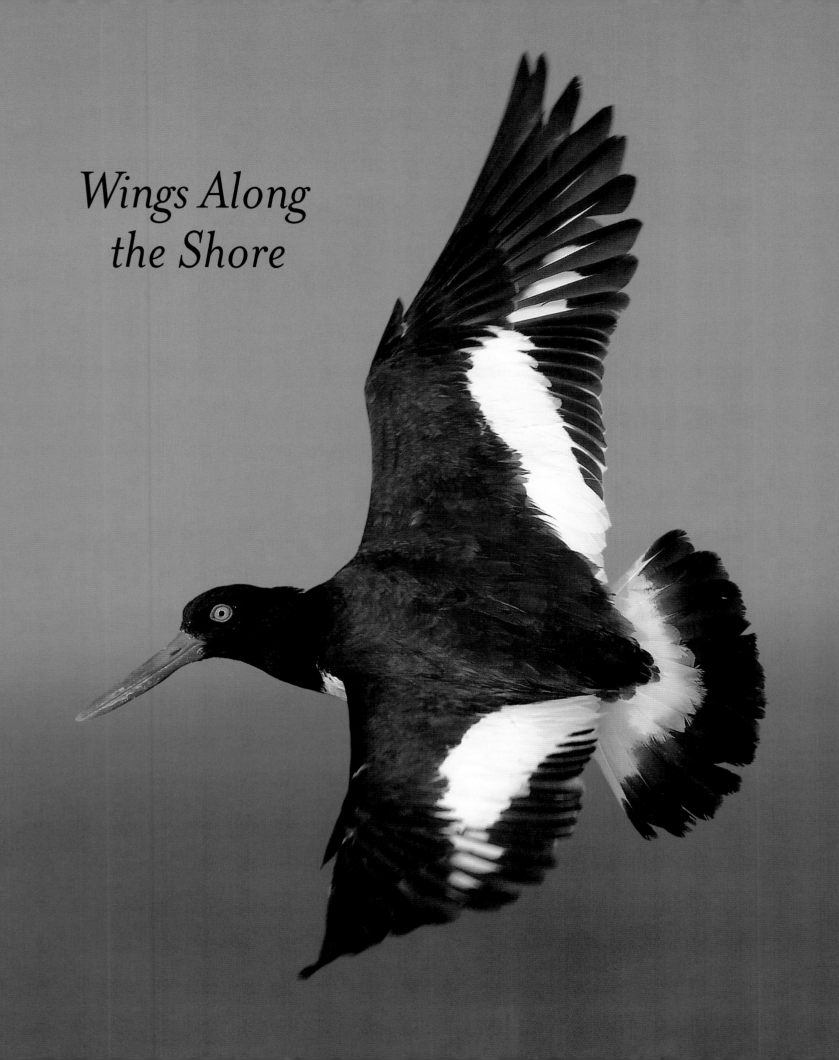

*Wings Along
the Shore*

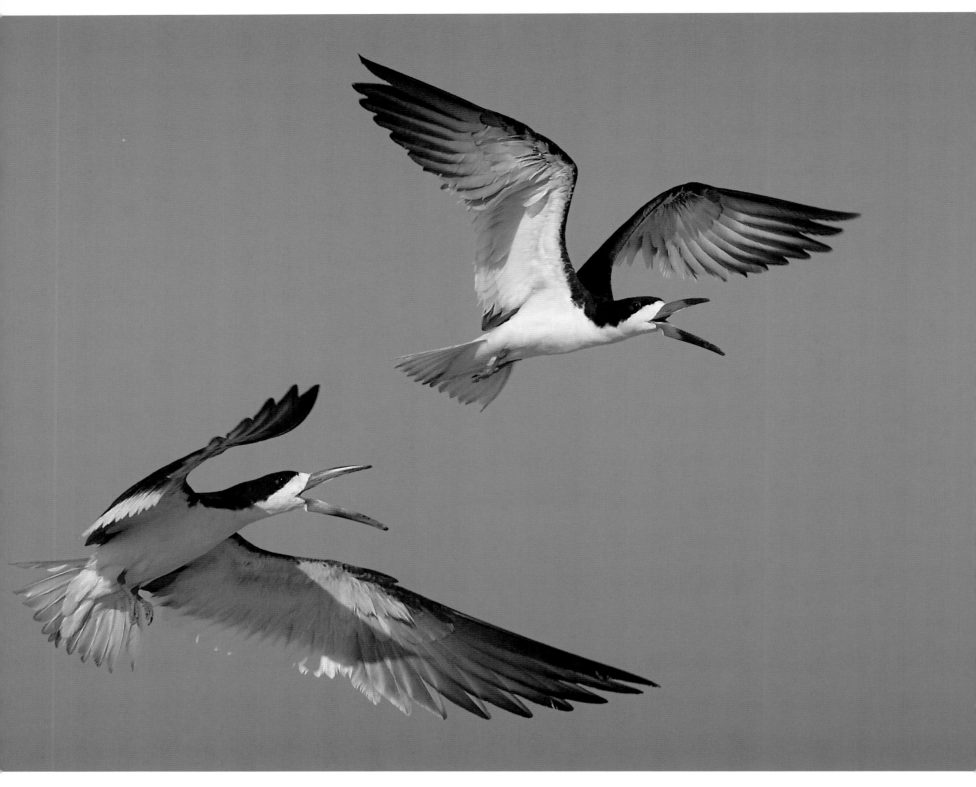

Rynchops niger.

HABITAT AND RANGE: Wetlands and coastlines of North and South America. Migratory.

A tumbling, soaring pair of BLACK SKIMMERS were captured in high-speed chase during nesting season at Nickerson Beach Park. Calling to each other, these two seabirds show the uneven mandibles that make their species unique among avians. *Lido Beach, New York.*

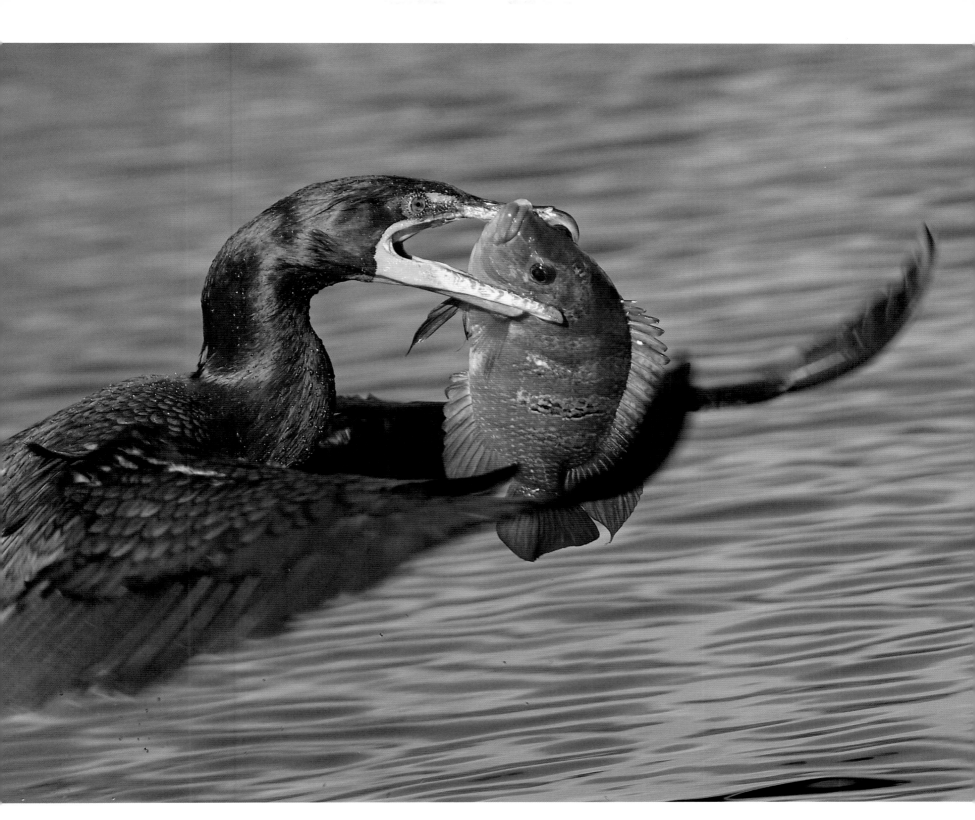

Phalacrocorax auritus.

HABITAT AND RANGE: Coastlines and inland waterways of North and Central America. Migratory.

The DOUBLE-CRESTED CORMORANT pictured here was just coming up from the water with an enormous fish in its beak, when suddenly two of its hungry companions dove after it. Picking up speed to escape, the cormorant secured the brightly colored catch in its powerful jaws. Not shown here are the twin white plumes that give the species its name; those appear only during breeding season. *Everglades, Florida.*

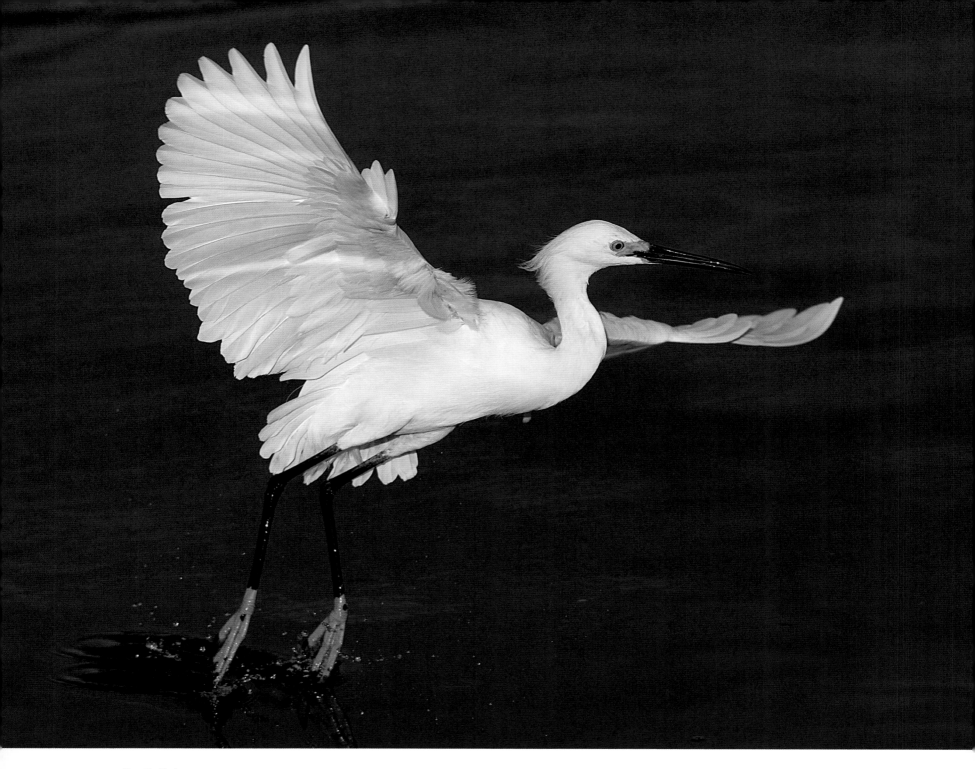

Egretta thula.

HABITAT AND RANGE: Large coastal and inland wetlands from the lower Great Lakes to South America. Northern populations are migratory.

You didn't know birds can dance? This powder-white SNOWY EGRET with a sense of rhythm trips lightly on the surface of the water at the J. N. "Ding" Darling National Wildlife Preserve, scanning for fish swimming in the shallows. Any fish unlucky enough to be spotted will quickly be snapped up in the egret's beak. Even the cleverest hunter can become prey, however; the characteristic tufted plume, just visible at the back of the bird's head, nearly extinguished the snowy egret at the turn of the twentieth century, so great was the demand for its feathers as ornaments on ladies' hats. *Sanibel Island, Florida.*

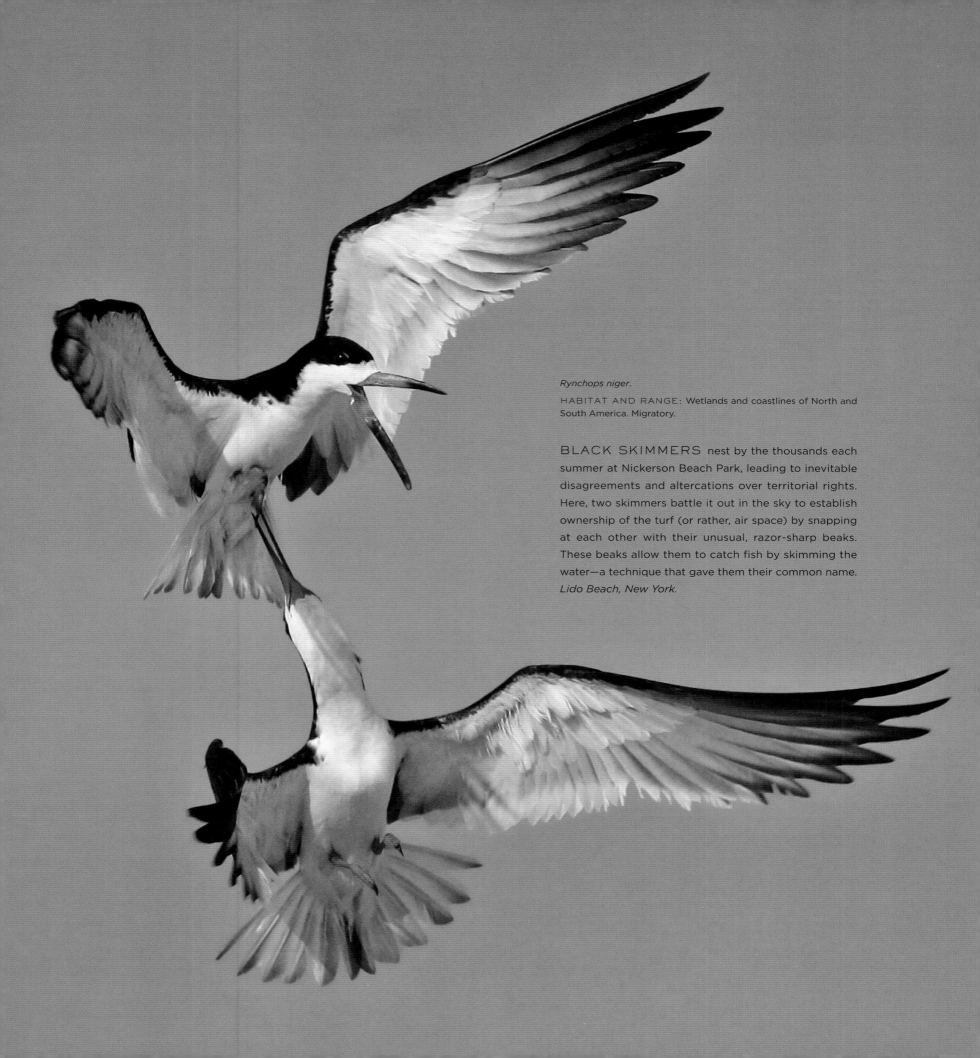

Rynchops niger.

HABITAT AND RANGE: Wetlands and coastlines of North and South America. Migratory.

BLACK SKIMMERS nest by the thousands each summer at Nickerson Beach Park, leading to inevitable disagreements and altercations over territorial rights. Here, two skimmers battle it out in the sky to establish ownership of the turf (or rather, air space) by snapping at each other with their unusual, razor-sharp beaks. These beaks allow them to catch fish by skimming the water—a technique that gave them their common name. *Lido Beach, New York.*

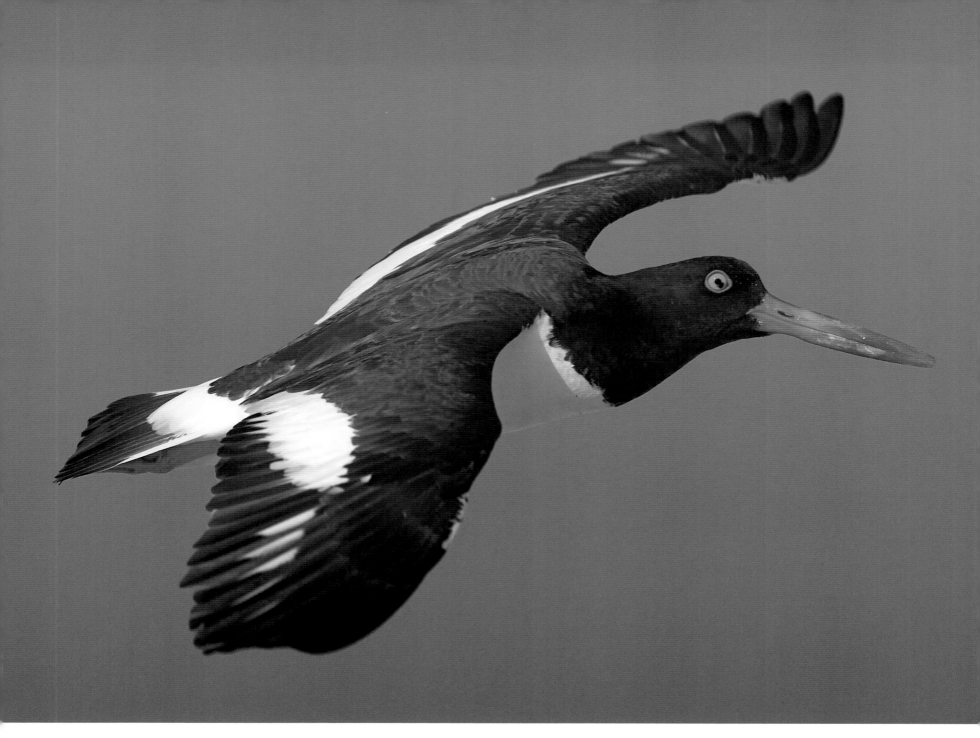

Haematopus palliatus.

HABITAT AND RANGE: Atlantic and Gulf Coasts of North America. Migratory.

This AMERICAN OYSTERCATCHER has seen better days. Note the discoloration on its bright orange bill, wear and tear caused by prying open and eating its prey, primarily bivalves, over the years. *Lido Beach, New York.*

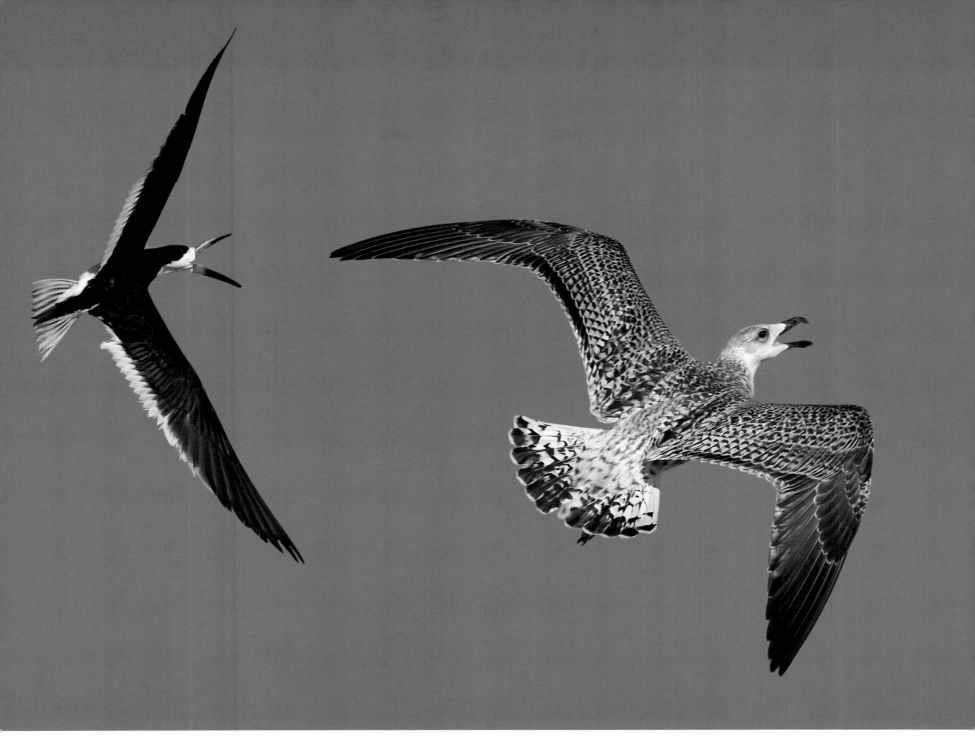

Rynchops niger.

HABITAT AND RANGE: Wetlands and coastlines of North and South America. Migratory.

Larus marinus.

HABITAT AND RANGE: North Atlantic coastlines and islands of North America and Europe. Nonmigratory.

It may appear as though the pint-size BLACK SKIMMER on the left has the great BLACK-BACKED GULL on the run, but looks are deceiving. The young gull is merely biding its time before it went on to grab the skimmer in its beak and devour the smaller bird—which the gull did right after this photograph was taken. Far from being picky eaters, gulls will swallow larger prey whole, steal other gulls' catches, and even eat garbage. *Lido Beach, New York.*

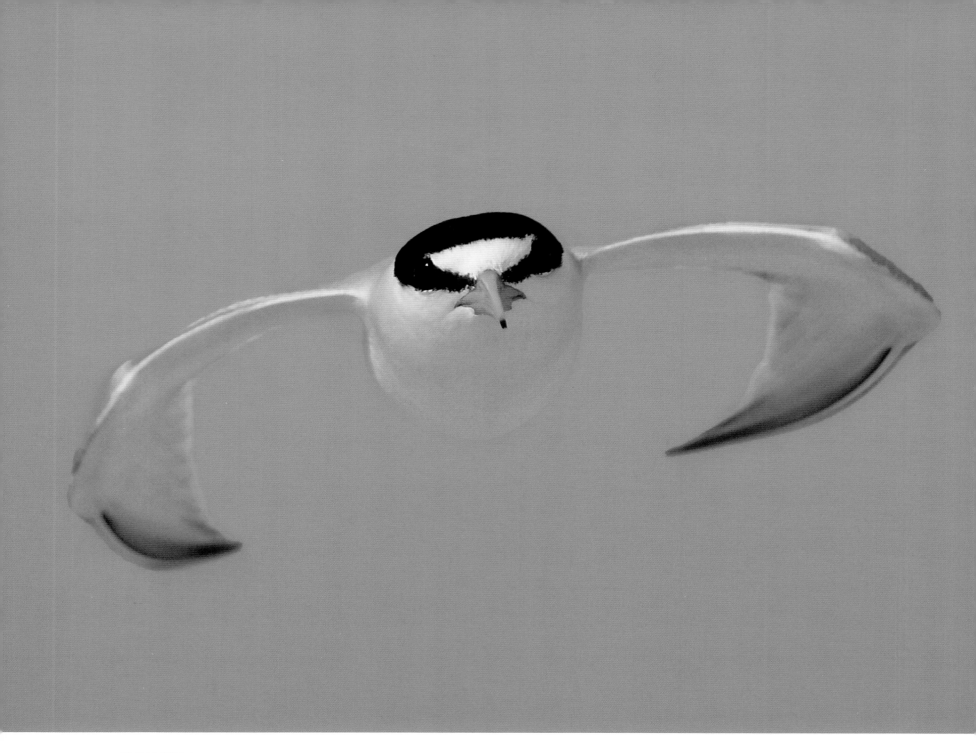

Sterna antillarum.

HABITAT AND RANGE: Coastlines in North America and parts of South America. Migratory.

The raccoon-faced LEAST TERNS are notorious for being very aggressive, and this bird at Nickerson Beach State Park came flying toward the photographer at a very high speed. Attacks like this one can happen without warning, as terns often hover before plunging down to their quarry. *Lido Beach, New York.*

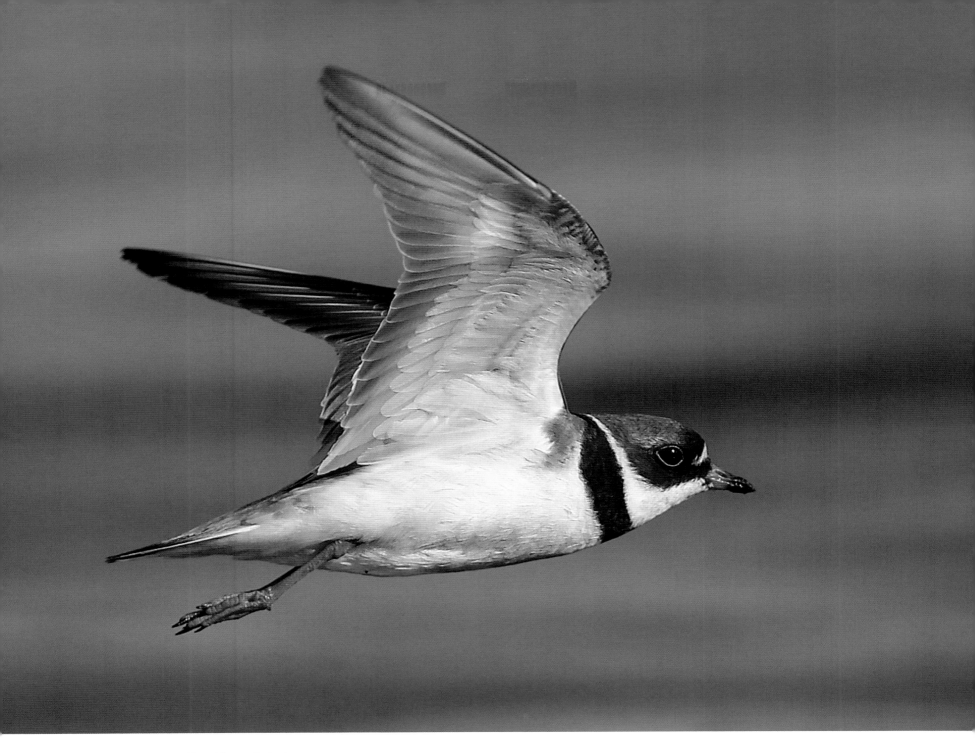

Charadrius semipalmatus.

HABITAT AND RANGE: Open coastal ground across North America. Migratory.

Zipping across the eastern seaboard during a late-August migration, this SEMIPALMATED PLOVER glides along on its muscular, compact wings. Plovers are relatively unassuming, content mainly to forage for insects, worms, and small crustaceans on the shorelines of North America, but after the breeding season every year, they make a great pilgrimage from Alaska and northern Canada to their wintering grounds on the East and West Coasts. *Jones Beach, New York.*

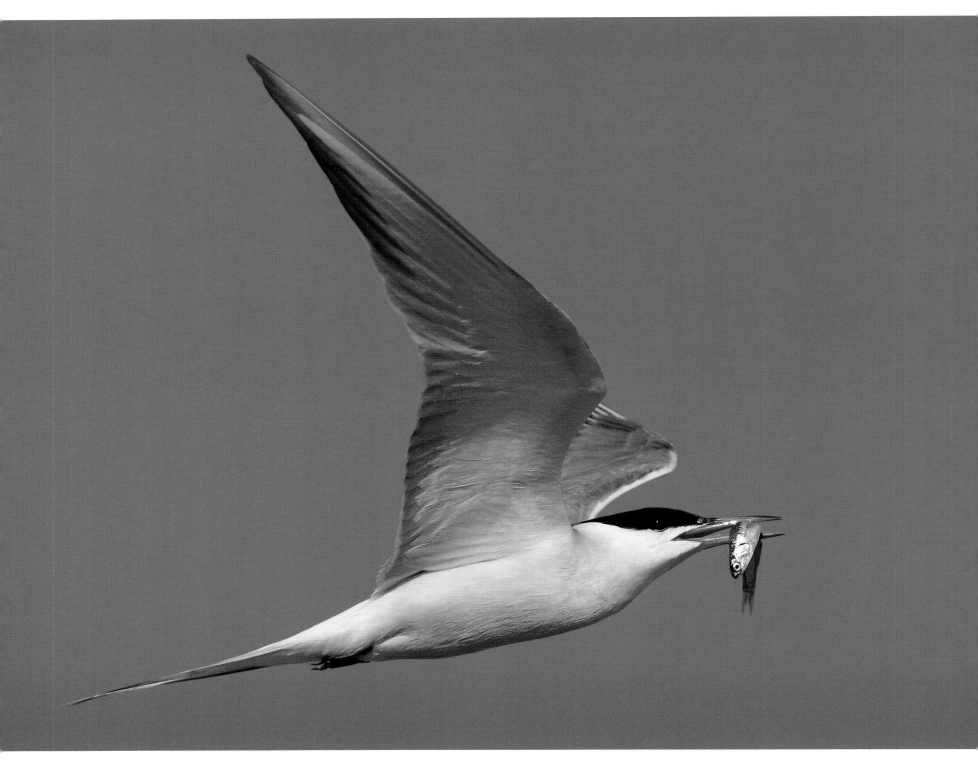

Sterna hirundo.

HABITAT AND RANGE: Coastlines of North and South America, Europe, Asia, and Australia. Migratory.

With the unequivocal surrender of its prey, a small sardine, this COMMON TERN is off again. When fishing in the ocean or other marine areas, as this tern is, the birds will often drink saltwater rather than seek out a source of freshwater. *Lido Beach, New York.*

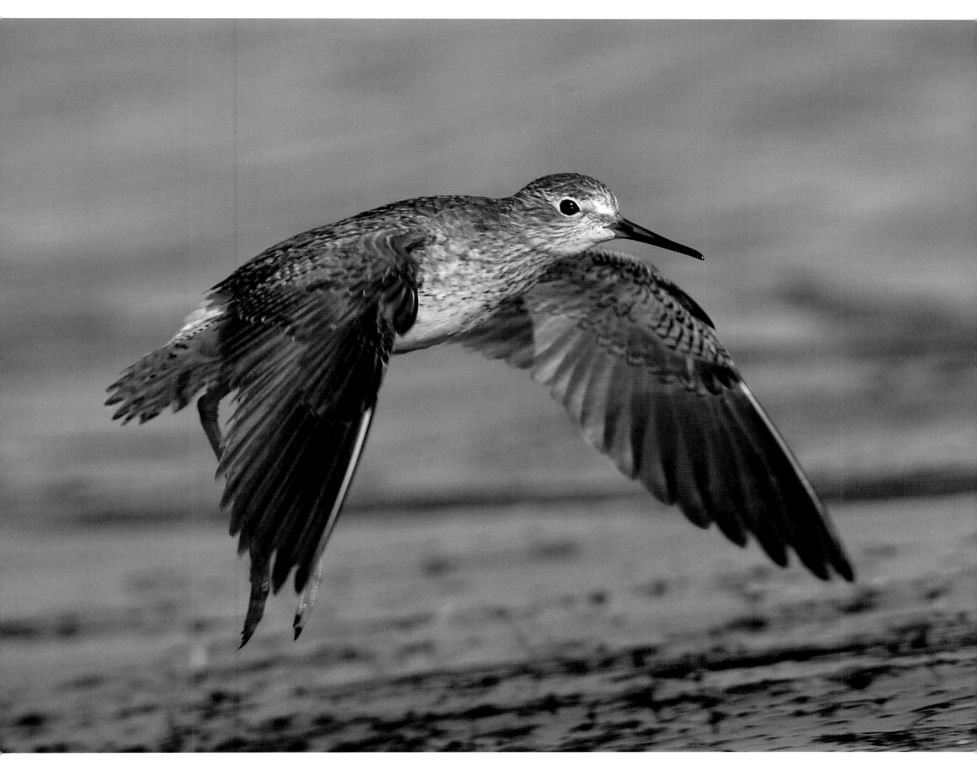

Tringa flavipes.

HABITAT AND RANGE: Coastlines of North and South America, Europe, Asia, and Australia. Migratory.

Despite the similarities in name and appearance, the LESSER YELLOWLEGS is not closely related to the greater yellowlegs; rather, its nearest relative is the willet. Lesser yellowlegs will often "run" along the surface of the water to skim for food, which includes insects, small fish, and crustaceans. *Jamaica Bay, New York.*

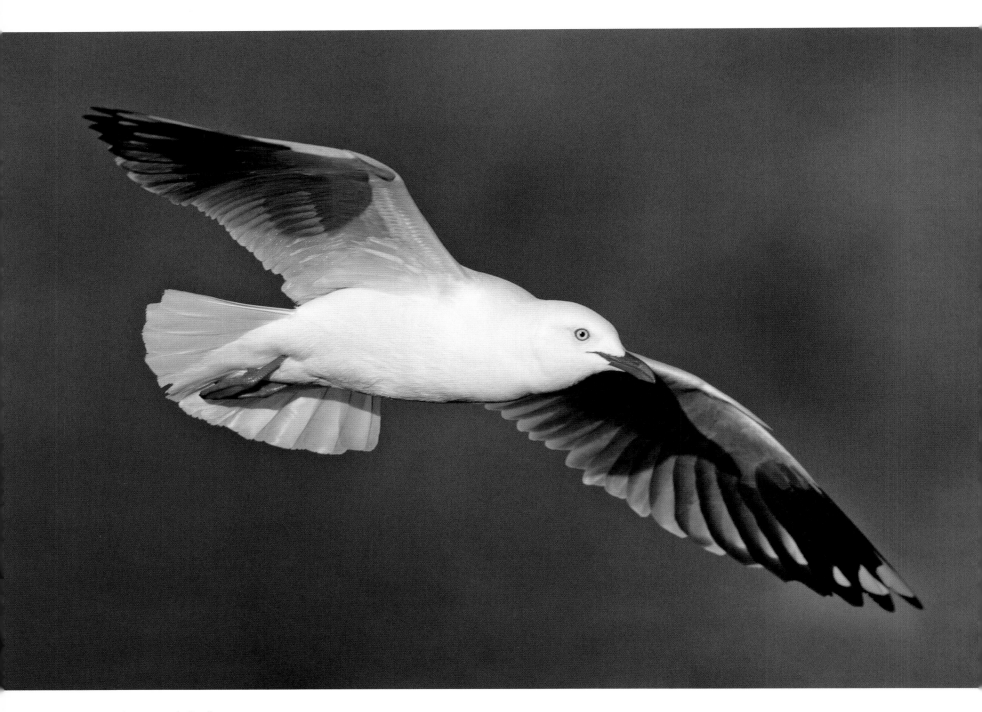

Larus novaehollandiae.

HABITAT AND RANGE: Coastlines of Australia. Nonmigratory.

SILVER GULLS, which are called simply "seagulls" in their native Australia, are great adapters. Found throughout the continent, the birds are not only fishers but also Dumpster divers, often thriving around shopping centers and garbage dumps. *Sydney, Australia.*

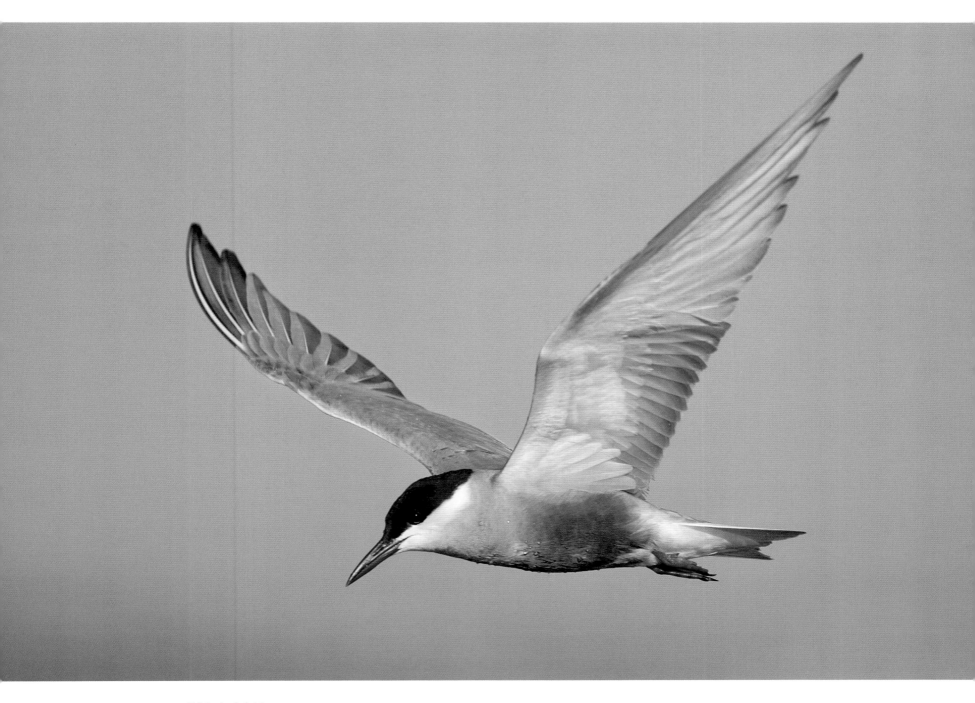

Chlidonias hybrida.

HABITAT AND RANGE: Inland marshes of Europe, Asia, Australia, and Africa. European and Asian populations are migratory.

This masked flier is a WHISKERED TERN, eying prey in a commercial fishpond. Whiskered terns hunt by hovering and then diving to snatch fish, amphibians, small crustaceans, insects, and insect larvae. *Israel.*

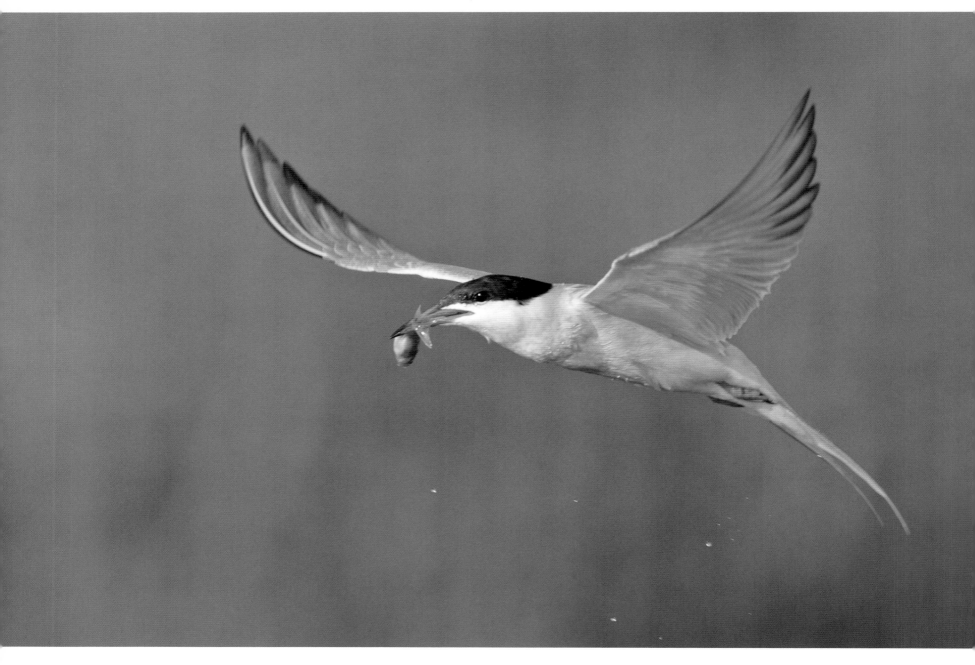

Sterna hirundo.

HABITAT AND RANGE: Coastlines of North and South America, Europe, Asia, and Australia. Migratory.

A COMMON TERN clutches its prize, a glistening fish just pulled from a commercial fishpond—easy pickings. During courtship rituals, the male tern will offer a fish to his prospective mate. *Israel.*

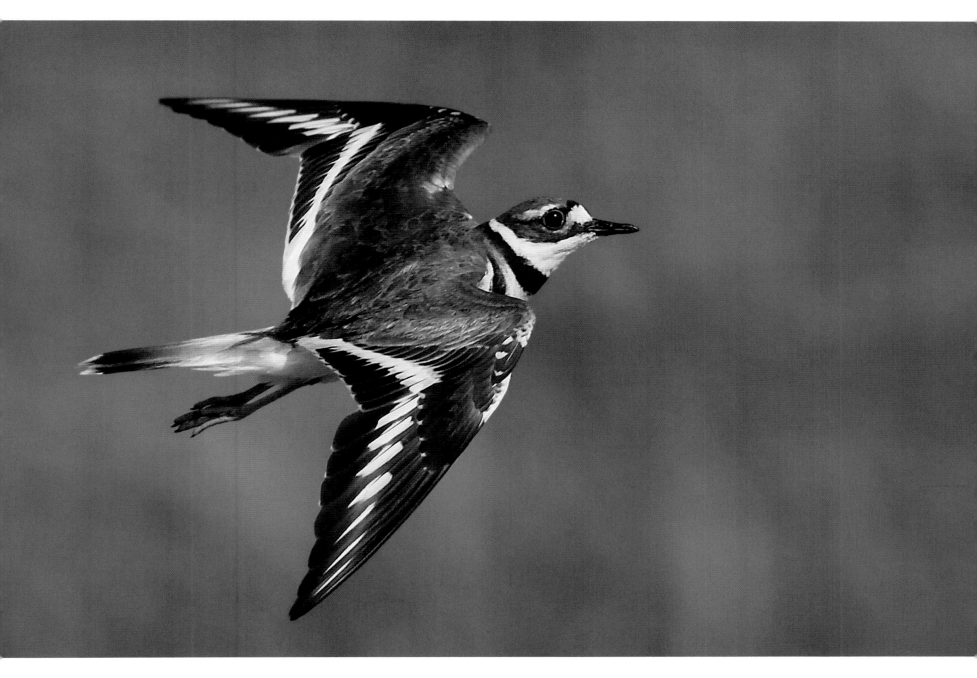

Charadrius vociferus.

HABITAT AND RANGE: Open fields in North and South America. Migratory.

A speedy little shore bird, the KILLDEER zips up and down, picking up and swallowing earthworms in the springtime. *Lido Beach, New York.*

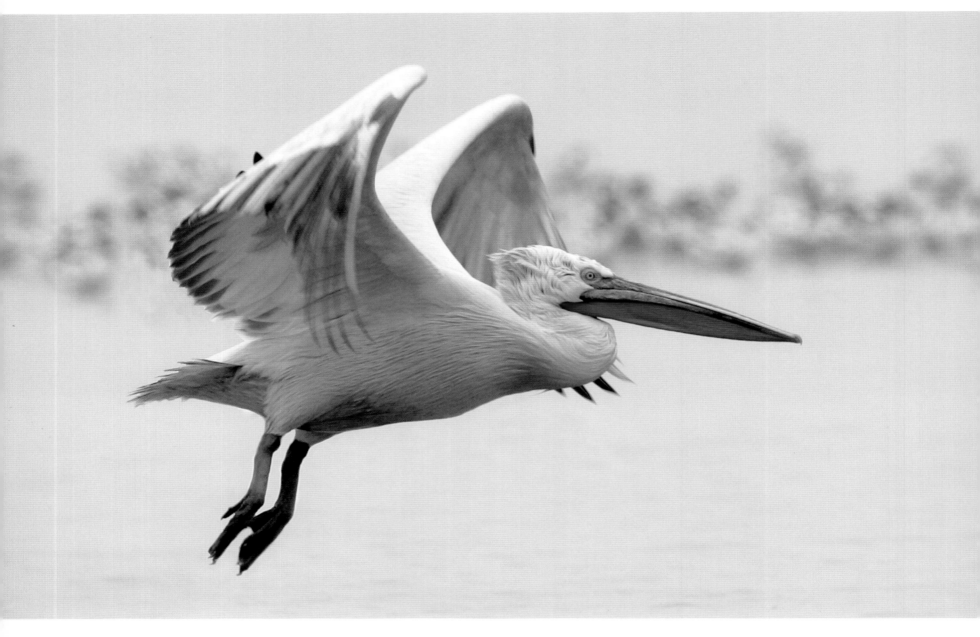

ABOVE: *Pelecanus crispus.*

HABITAT AND RANGE: Swamps and shallow lakes of southern Europe and Asia. Migratory.

A beautiful and endangered bird, the DALMATIAN PELICAN displays the distinctive curly crest on its nape and bright orange gular pouch with matching orange around its eye, its breeding-season coloration. Like the heron, the Dalmatian pelican retracts its neck into an S shape in flight. *Hong Kong, China.*

OPPOSITE: *Recurvirostra avosetta.*

HABITAT AND RANGE: Shallow lakes of Europe, Asia, and Africa. Migratory.

Flocks of several hundred PIED AVOCETS winter annually in Deep Bay. Here, a snow-white avocet makes a fast-flying display close to the surface of the water. The upturned bill isn't a trick of the water's reflection, either; avocets sweep their strange, curved bills like scythes through the water when feeding. *Hong Kong, China.*

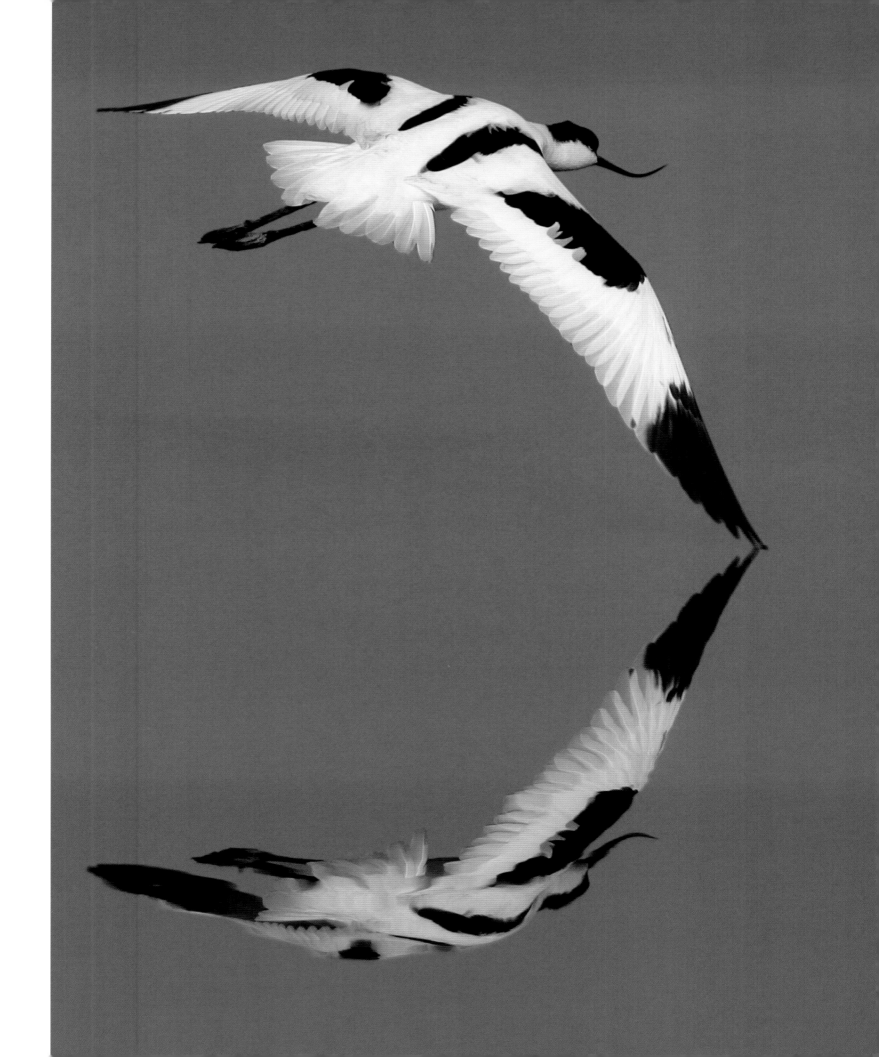

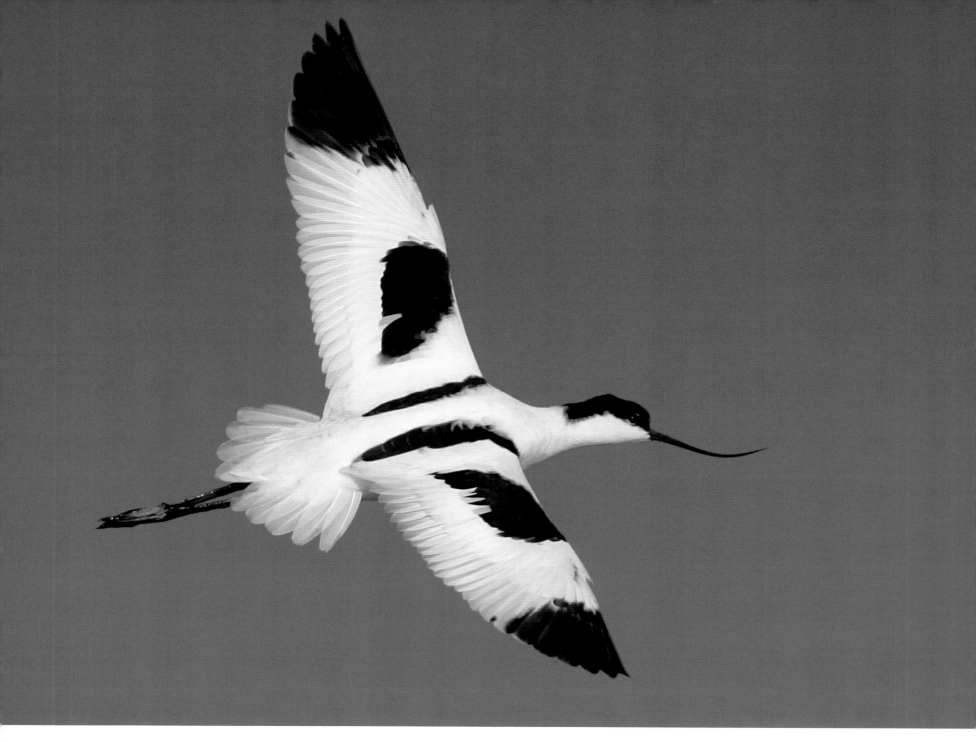

Recurvirostra avosetta.

HABITAT AND RANGE: Shallow lakes of Europe, Asia, and Africa. Migratory.

This PIED AVOCET has some incredibly distinct racing stripe wing patterns. This species of avocet gave the rest of the genus its common name, as the black cap on its head is reminiscent of the head coverings once worn by European lawyers—or advocates. *Hong Kong, China.*

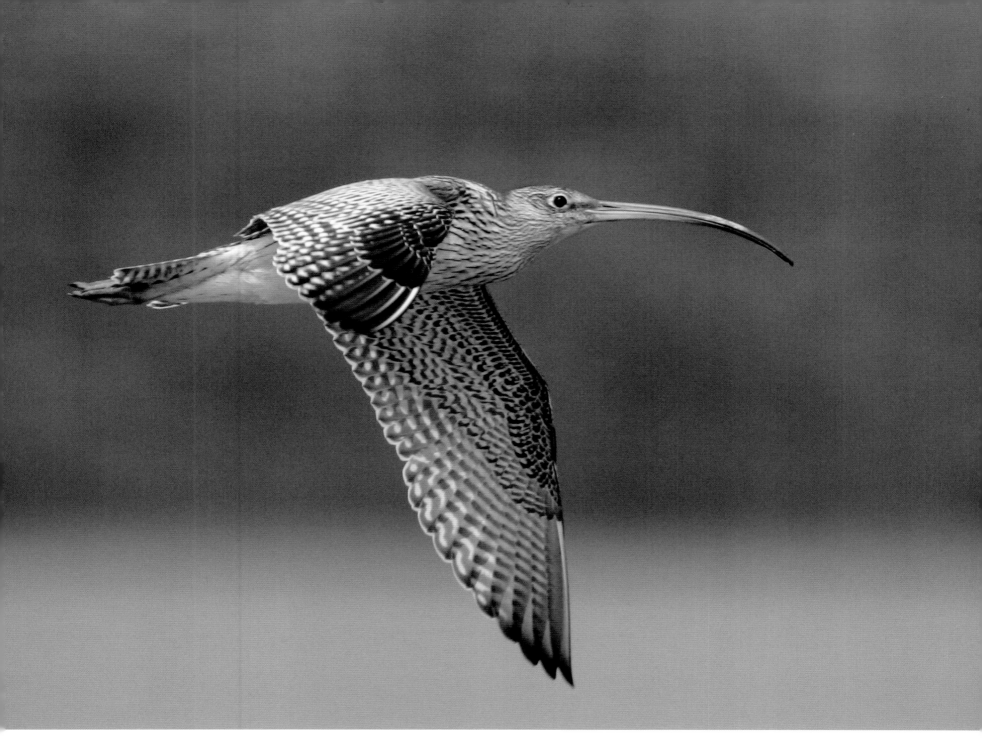

Numenius madagascariensis.

HABITAT AND RANGE: Boreal forests, marshes, swamps, and coastlines of Asia and Australia. Migratory.

The long, curved bill of the FAR EASTERN CURLEW seems to announce its presence as it makes a low-flying pass along the mud flat of Deep Bay. It uses this bill to probe for insects, crustaceans, and other small invertebrates in the sand on the shore. *Hong Kong, China.*

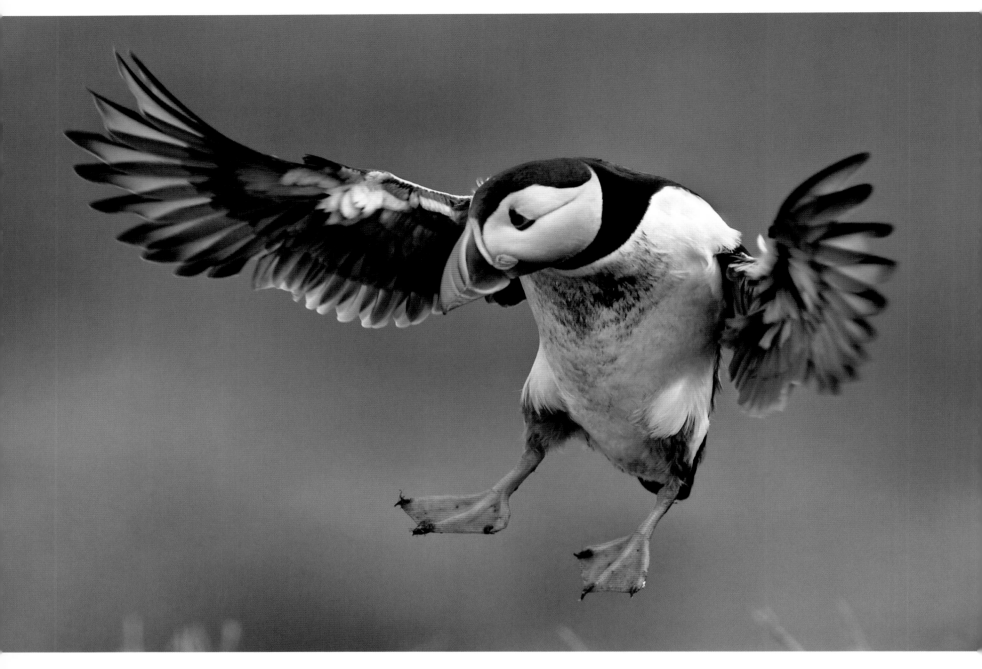

ABOVE: *Fratercula arctica*.

HABITAT AND RANGE: Coastlines of eastern North America and northern Europe. Migratory.

Great flocks of ATLANTIC PUFFINS come to shore every spring to breed off the coast of Northumberland. Here a delightfully nimble character, with distinguishing orange and black bill and webbed feet, comes in for a landing. The orange bill plates grow in before breeding season and then fall off when winter comes. *Farne Islands, England.*

OPPOSITE: *Fratercula arctica*.

HABITAT AND RANGE: Coastlines of eastern North America and northern Europe. Migratory.

ATLANTIC PUFFINS fly at terrifically high speeds, making them difficult to photograph in flight. These puffins in the air over Northumberland were incredibly intent on coming out of the burrows to bring back eels to feed to their chicks. *Farne Islands, England.*

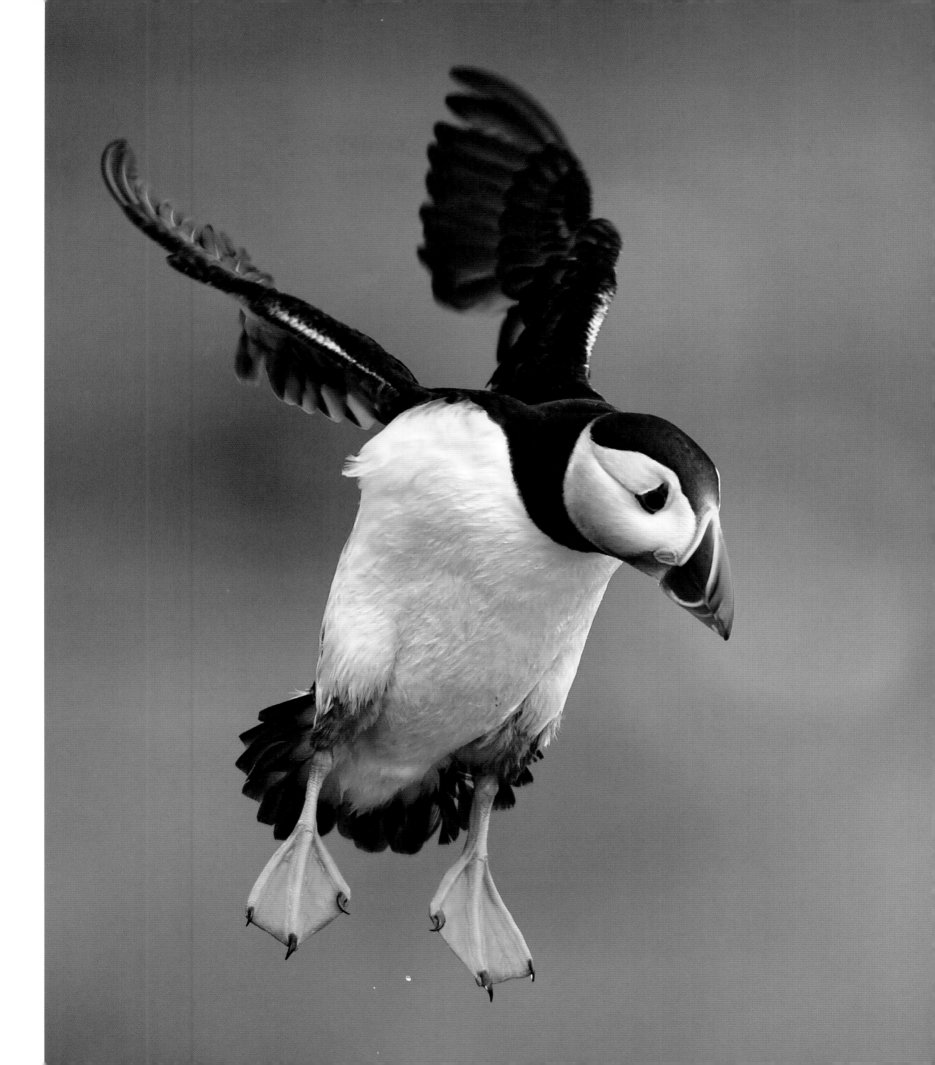

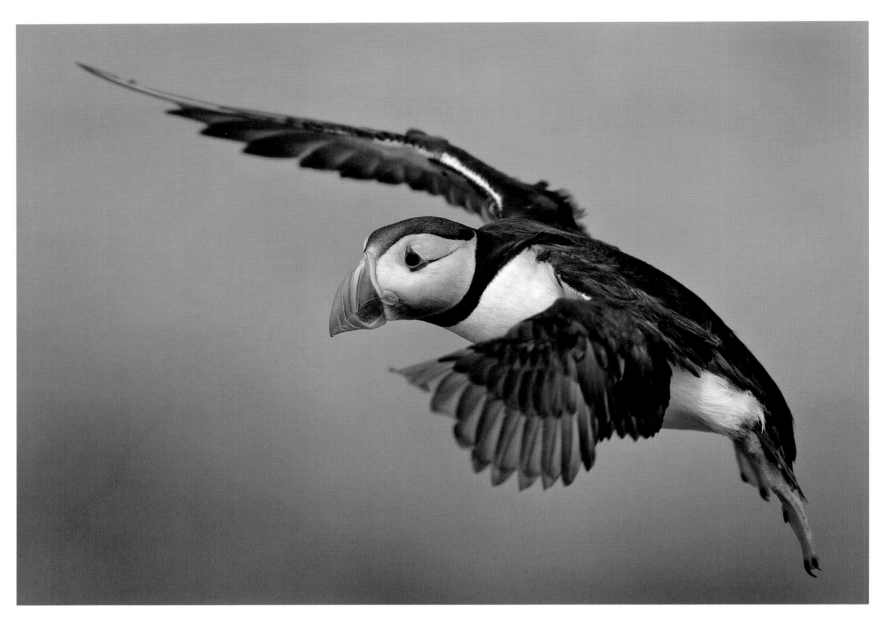

ABOVE: *Fratercula arctica.*

HABITAT AND RANGE: Coastlines of eastern North America and northern Europe. Migratory.

Back in the air, the ATLANTIC PUFFIN increases its altitude over Northumberland. Puffins spend the entire winter far from land over the open ocean, so they are very powerful fliers. Their light weight and long wings place puffins among the more graceful birds in the air. *Farne Islands, England.*

OPPOSITE: *Sterna paradisaea.*

HABITAT AND RANGE: Forests and open tundra of northern North America, Europe, and Asia; winters in Antarctica. Migratory.

An ARCTIC TERN feeds, just touching the surface of the calm seawater. This tern species is famous for its extremely long migration route, mostly along coastal waters, from one polar region to the other; round-trip, the annual journey is about the same distance as the Earth's circumference. *Norway.*

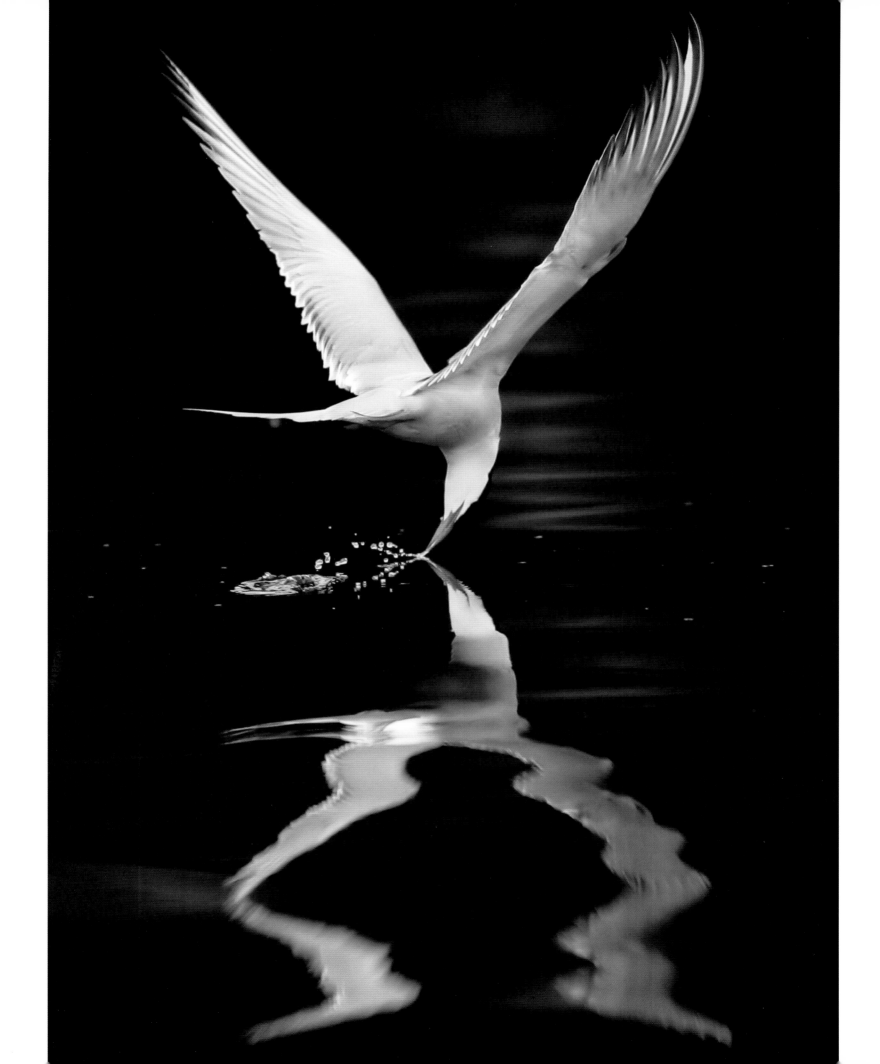

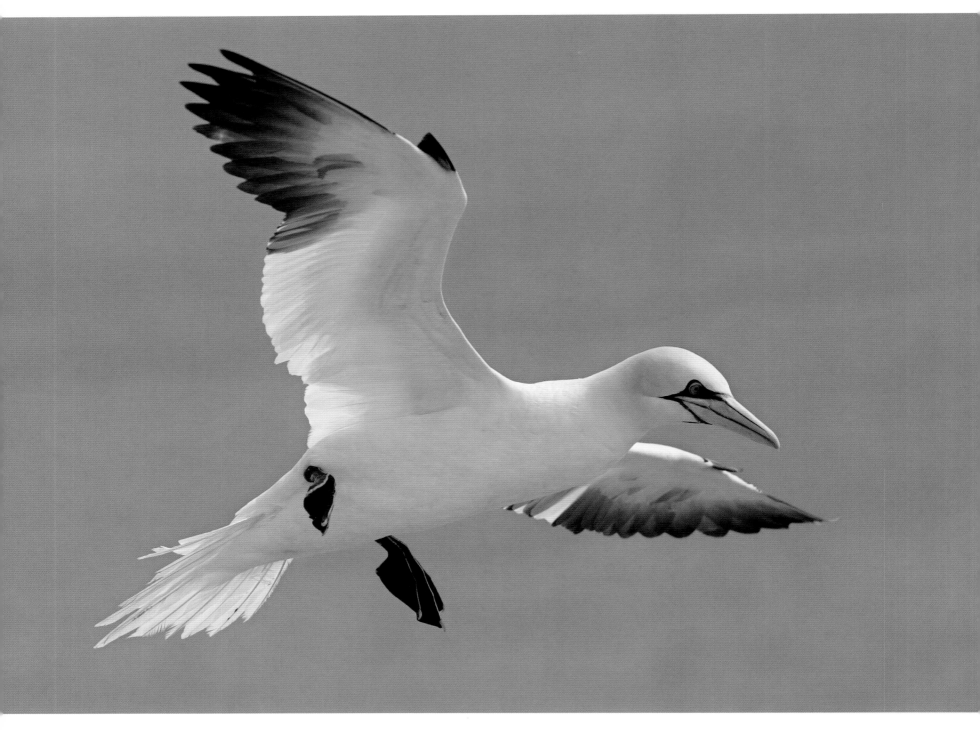

Morus bassanus.

HABITAT AND RANGE: Offshore islands and cliffs of eastern North America, northern Europe, and Africa. Migratory.

Bass Rock, a small island in the Firth of Forth off the coast of Britain, is home to thousands of NORTHERN GANNETS every year and is one of the biggest and best gannet colonies in the world. Bass Rock seems to turns white with the hundreds of gannets breeding atop and flying around the island. *Bass Rock, Scotland.*

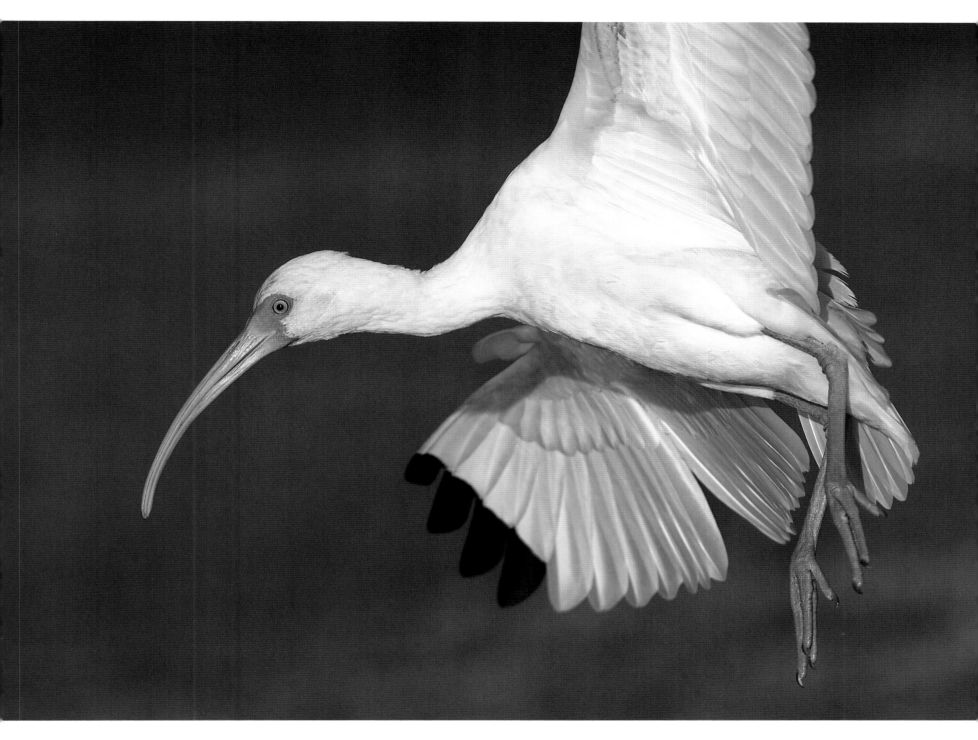

Eudocimus albus.

HABITAT AND RANGE: Forests and wetlands of southeastern North America, the Caribbean, and South America. Migratory.

An adult AMERICAN WHITE IBIS circles in for a landing to join a number of other ibis already foraging in a lagoon. The black wing tips of the American white ibis are only visible when the bird is on the wing.

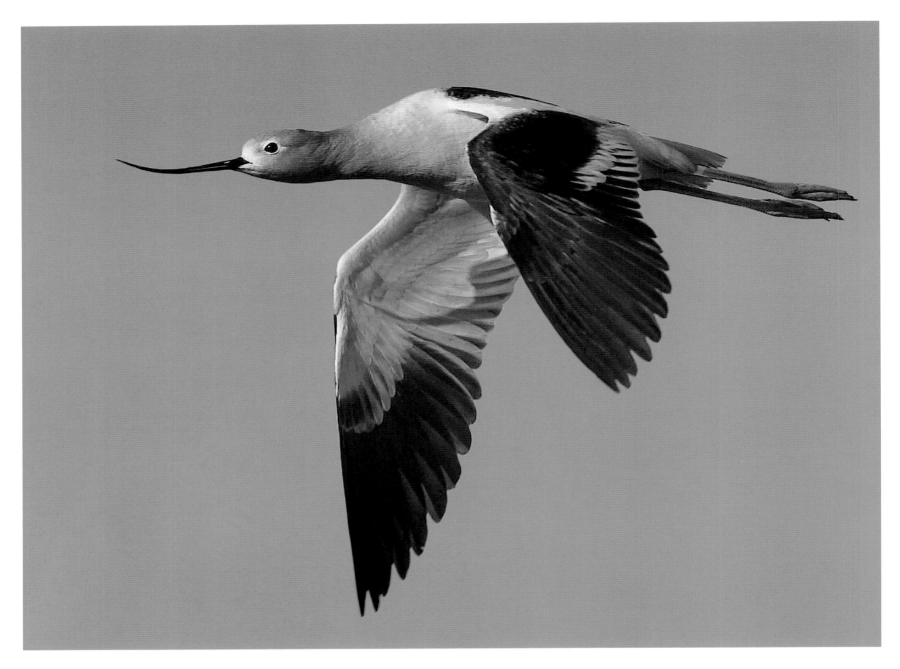

ABOVE: *Recurvirostra americana.*

HABITAT AND RANGE: Wetlands and coastlines of North America. Migratory.

This AMERICAN AVOCET was photographed in northern Ontario, a place where this bird seldom appears. *Ontario, Canada.*

OPPOSITE: *Ardea alba.*

HABITAT AND RANGE: Wetlands and coastlines of North, Central, and South America. Migratory.

All this distinguished and beautiful GREAT EGRET needs is a coat of arms to go with its pristine white plumage. An awesome flier, the bird was riding like the wind and making a turn toward land, the long breeding-season plumes of its back streaming behind it.

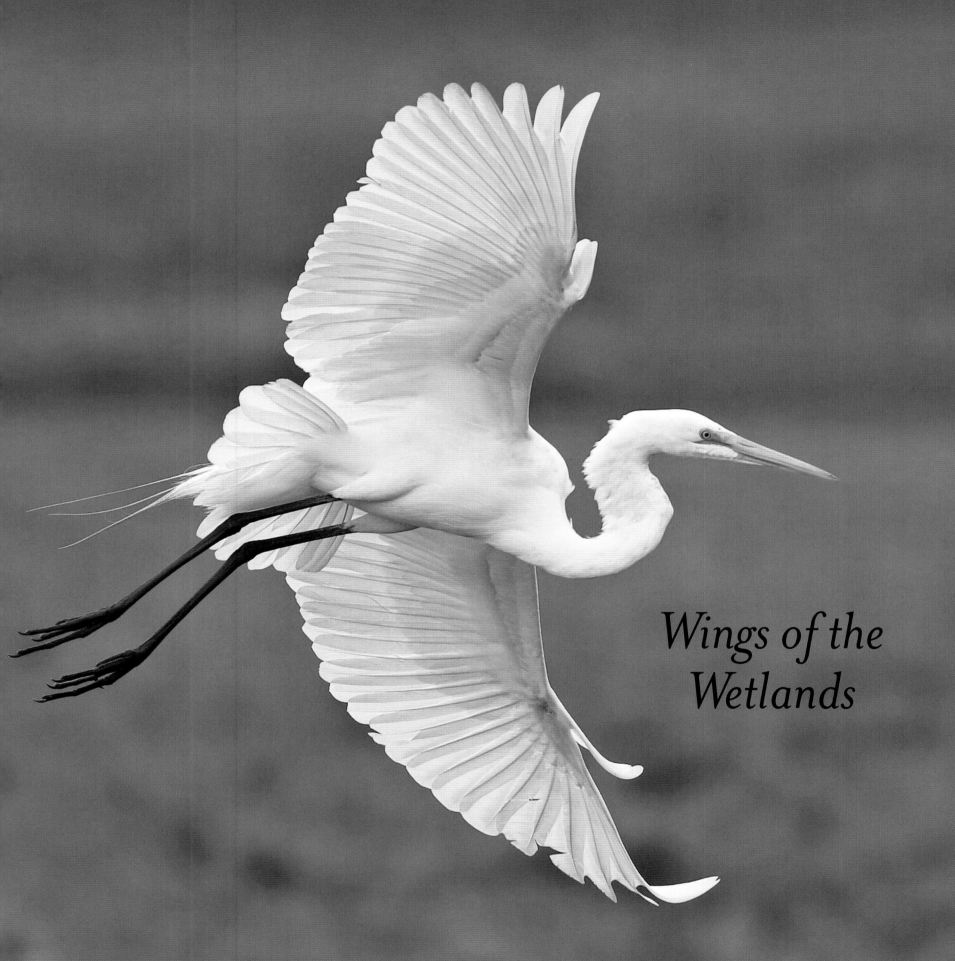

Wings of the
Wetlands

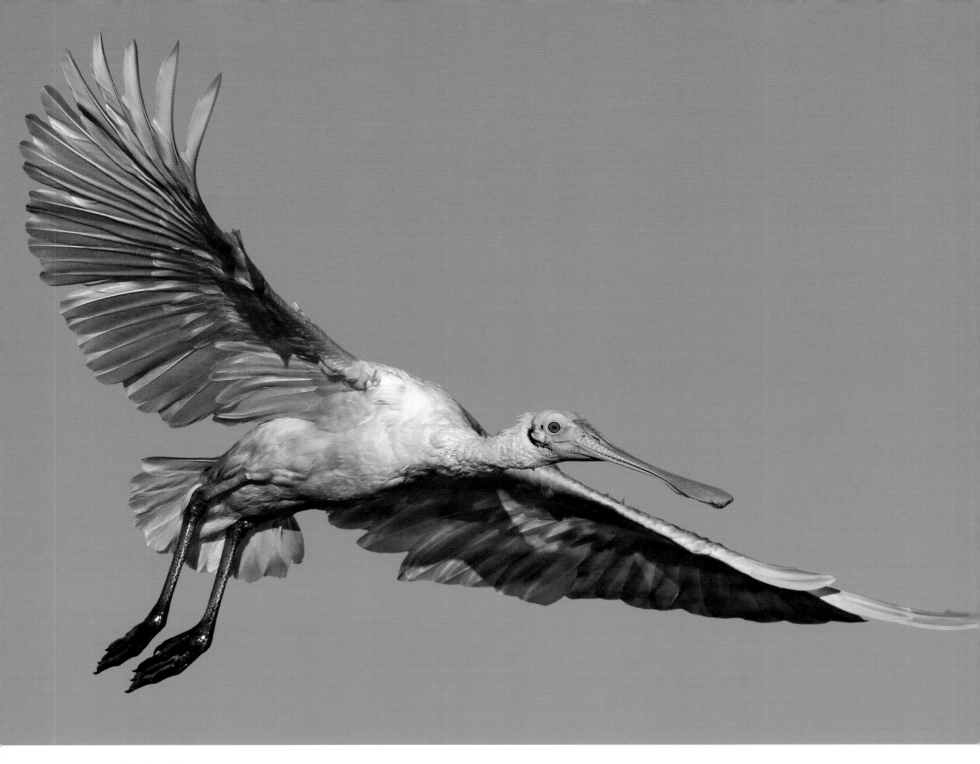

Platalea ajaja.

HABITAT AND RANGE: Wetlands of the southern United States and South America. Nonmigratory.

The ROSEATE SPOONBILL, no relation to the pink flamingo, is often mistaken in the southern United States for the less common—and less shy—wading bird. However, this spoonbill, captured in flight over the Estero Lagoon, is certainly difficult to miss: Its legs and bizarre, flattened bill are a shiny pink that catches the sunlight. *Fort Myers Beach, Florida.*

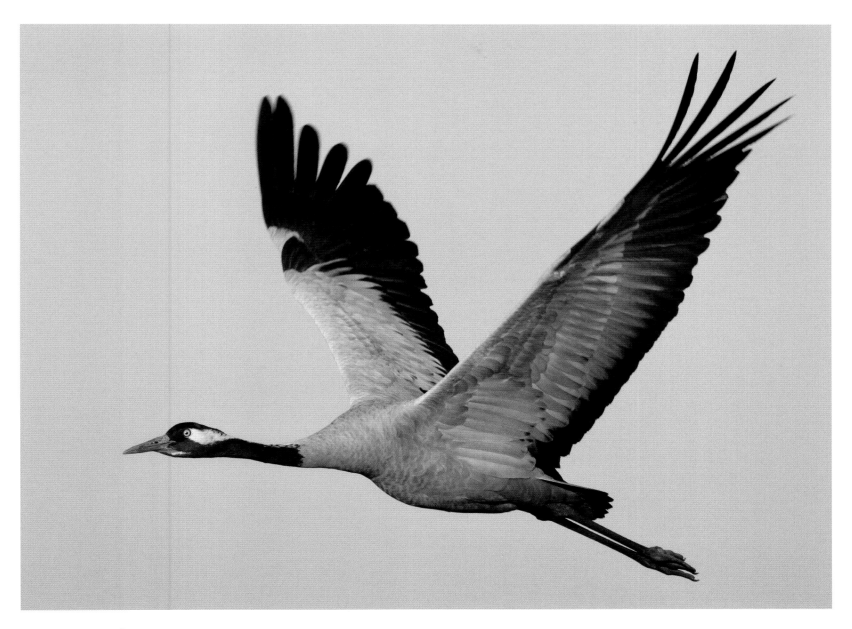

Grus grus.

HABITAT AND RANGE: Forests, grasslands, and wetlands of Europe and Asia; winters as far south as Africa. Migratory.

A typically sleek COMMON (EURASIAN) CRANE soars above the Hula Nature Reserve. Thousands of cranes winter there, forcing farmers to truck in corn for them to spare their crops from the cranes' voracious appetites. This species of crane is omnivorous and will even eat small birds and mammals, but if a plentiful grain supply is present, their gluttony can be devastating. *Hula Valley, Israel.*

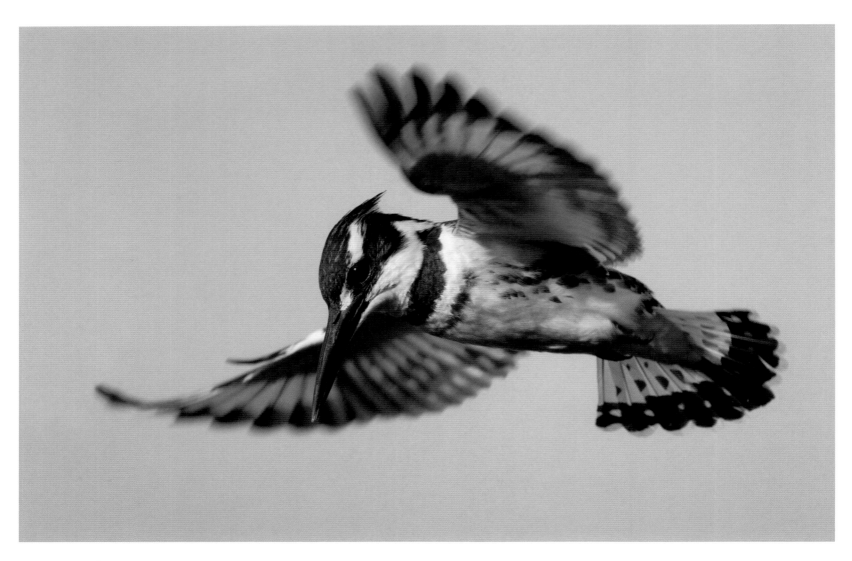

Ceryle rudis.

HABITAT AND RANGE: Wetlands and rivers of sub-Saharan Africa and southern Asia. Nonmigratory.

A PIED KINGFISHER hunts fish in a small commercial container that is being used to raise young fry in an agricultural fishpond. Shooting fish in a barrel isn't very good sport, but the pied kingfisher is no slouch when it comes to fishing: It can hunt in both fresh and salt water, and it can catch a second fish or eat small prey in flight without returning to a perch. *Israel.*

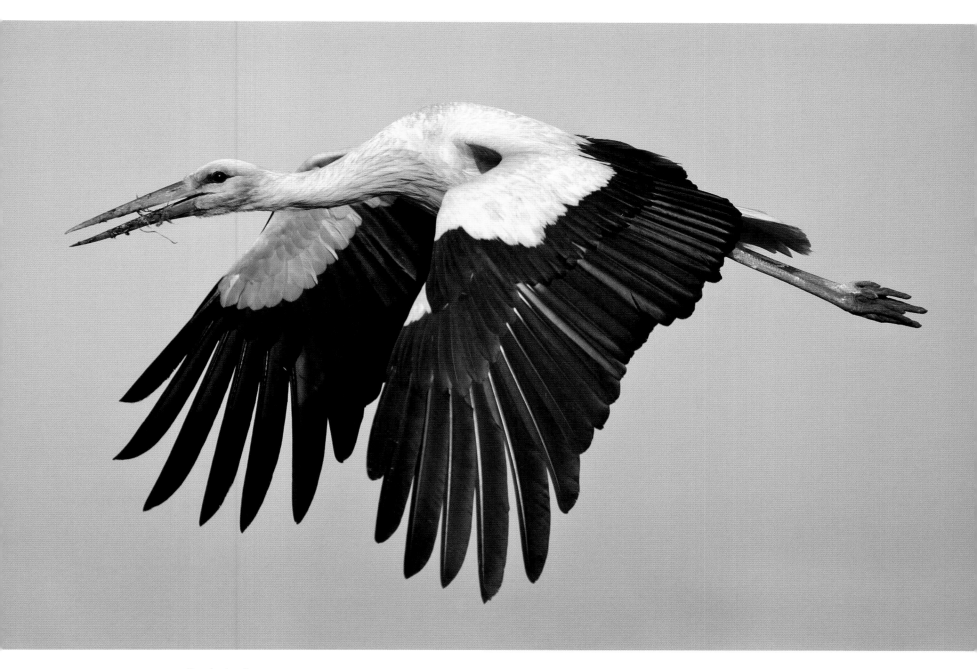

Ciconia ciconia.

HABITAT AND RANGE: Grasslands, wetlands, and urban and suburban areas throughout Europe, Asia, and Africa. Migratory.

This WHITE STORK flies high while keeping a trained eye on a field filled with rodents, insects, and reptiles hiding in the grass. Storks are viewed by most cultures as birds of good fortune and are often seen nesting near human settlements, though they breed primarily in open farmland. *Israel.*

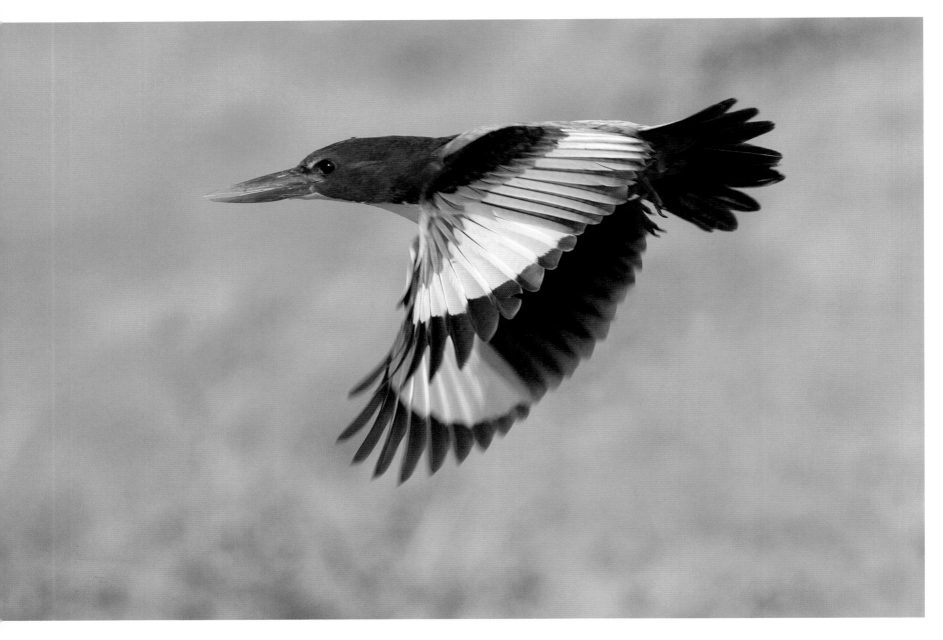

Halcyon smyrnensis.

HABITAT AND RANGE: Rural and suburban areas of southeast Asia and northern Africa. Nonmigratory.

A rainbow of colors in full flight, this WHITE-THROATED KINGFISHER is taking off from a perch not far from its nest. The kingfisher mainly hunts large insects, rodents, snakes, fish, and frogs, but it is reported to catch and eat tired migrators when the chance arises. *Israel.*

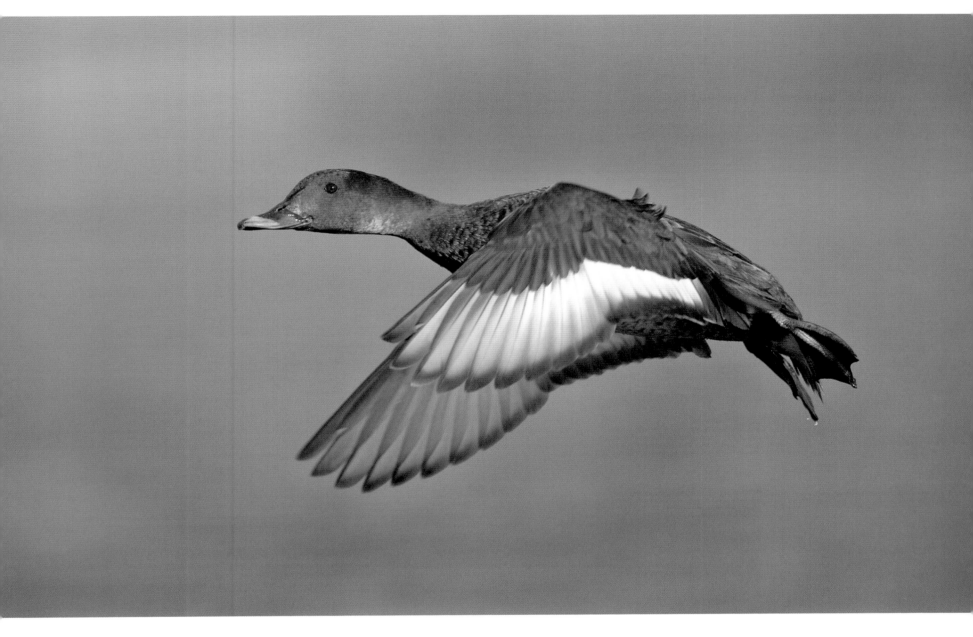

Aythya australis.

HABITAT AND RANGE: Swamps, lakes, and rivers of southeast Australia. Nonmigratory.

The relatively small HARDHEAD, formerly known as the white-eyed duck, is the only Australian diving duck. The species' characteristic white eyes are missing on this female duck, as only the male hardhead exhibits the trait (a biological phenomenon known as sexual dichromatism). *Sydney, Australia.*

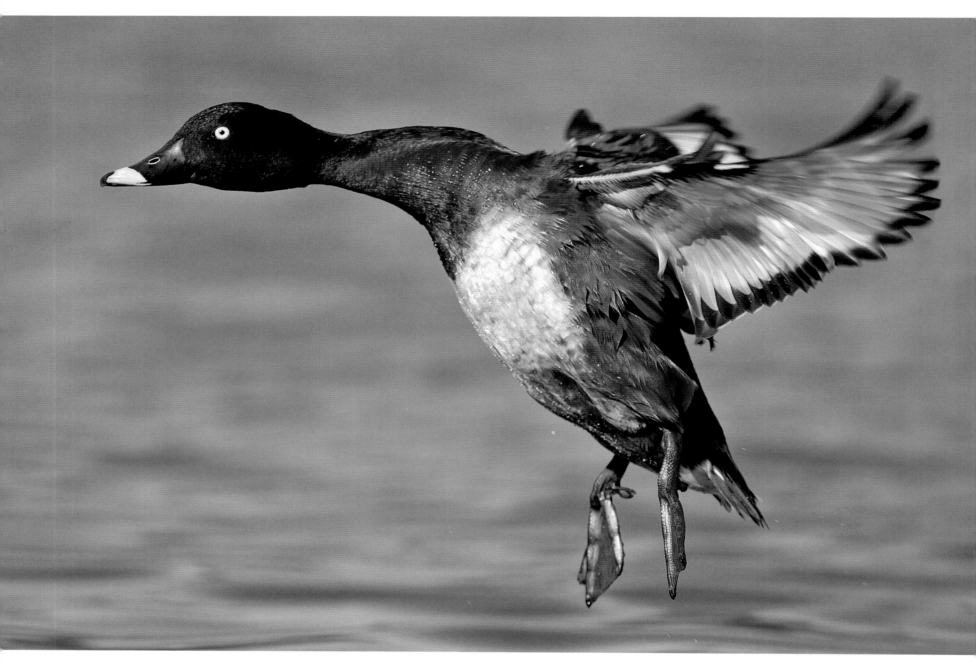

Aythya australis.

HABITAT AND RANGE: Swamps, lakes, and rivers of southeast Australia. Nonmigratory.

Here we see the striking white eye of the male HARDHEAD. The duck is taking off from the water, which is where hardheads spend nearly all their lives, rarely coming to land and favoring lakes and rivers to coastal waters. *Sydney, Australia.*

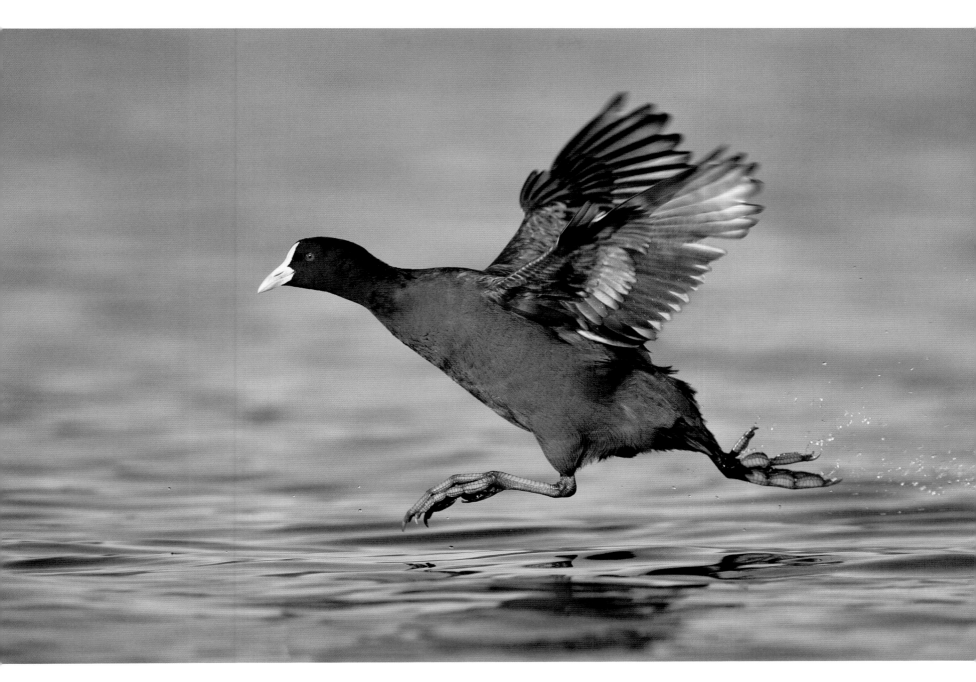

Fulica atra.

HABITAT AND RANGE: Freshwater lakes and ponds of Europe, Asia, and Africa. Migratory.

Walking on water? This remarkable shot seems to show just that, as this COMMON (EURASIAN) COOT, propelled just above the surface of the water by its wings, enjoys a fish-eye view of its prey on a pond. The coot is a weak and reluctant flier, and this running start is its preparation for becoming airborne. *Sydney, Australia.*

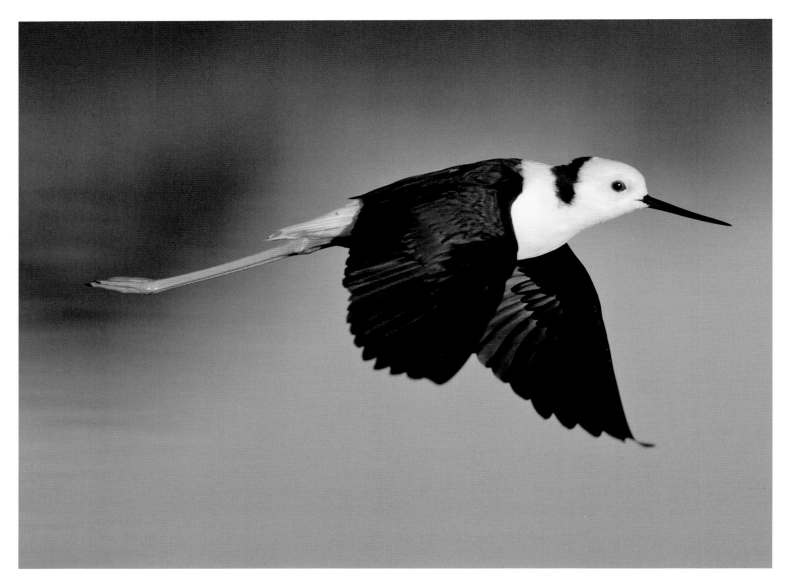

Himantopus himantopus.

HABITAT AND RANGE: Marshes, shallow lakes, and ponds of every continent except Antarctica. Some populations are migratory.

How did the BLACK-WINGED STILT get its name? The long pink-orange trail of legs behind this specimen should be a clue. As might be expected, these birds are waders, subsisting primarily on insects and crustaceans they skim from the sand and water. *Sydney, Australia.*

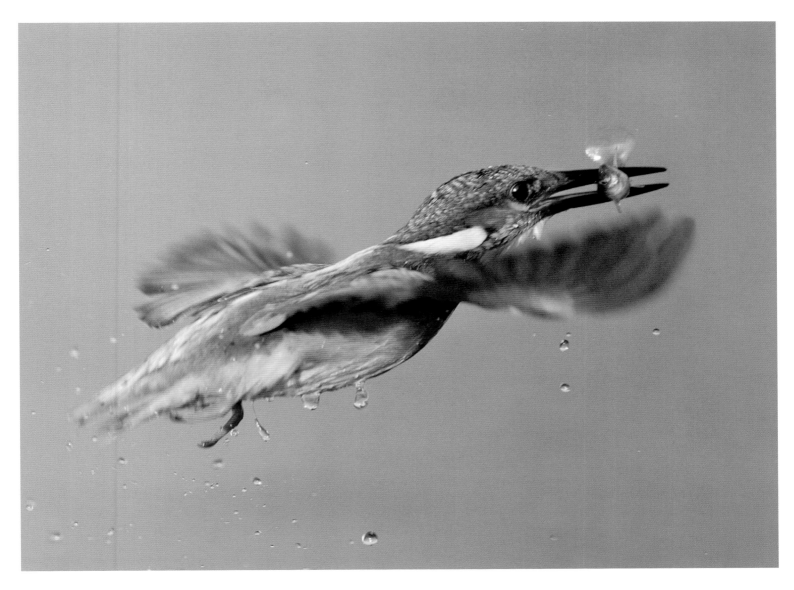

Alcedo atthis.

HABITAT AND RANGE: Waterfronts of Europe, Asia, and Africa. Nonmigratory.

The COMMON (EUROPEAN) KINGFISHER lives entirely on aquatic animals, including small fish, crustaceans, and aquatic insects, which it hunts by dropping suddenly into the water from a nearby perch. This kingfisher has just emerged from the water with its prey gripped by the middle. The fish is relatively small, so it will probably be swallowed—head first—immediately.

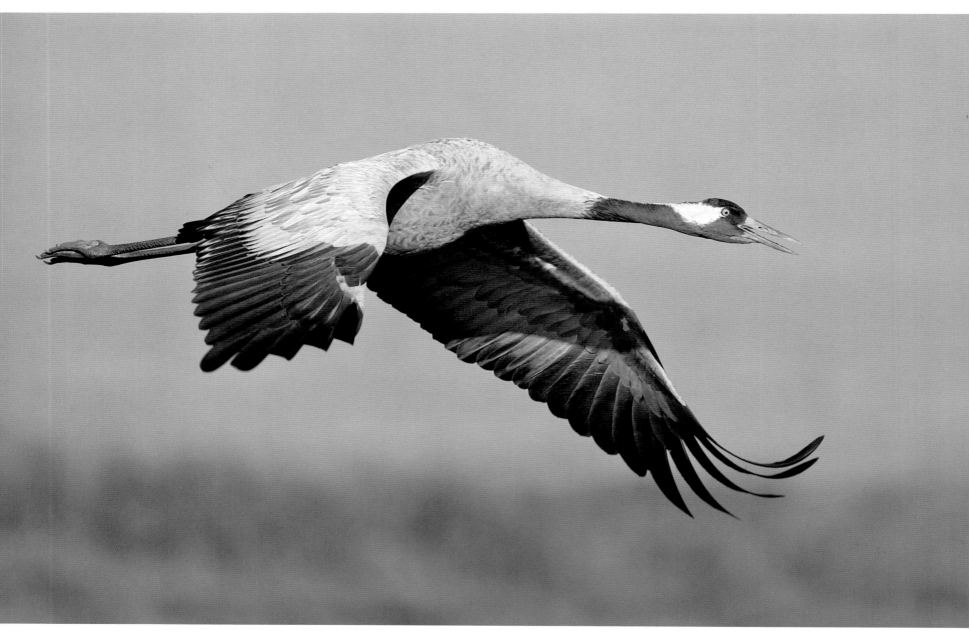

Grus grus.

HABITAT AND RANGE: Forests, grasslands, and wetlands of Europe and Asia, wintering as far south as Africa. Migratory.

With wings that go on forever and a long, graceful neck, the COMMON (EURASIAN) CRANE is sheer poetry in flight. On the crane's left wing, we see the separated primary feathers that reduce drag, making it easier for the crane to soar and expend less energy taking off and gaining altitude. This shot was taken at the Hula Nature Reserve, where thousands of these cranes winter. *Hula Valley, Israel.*

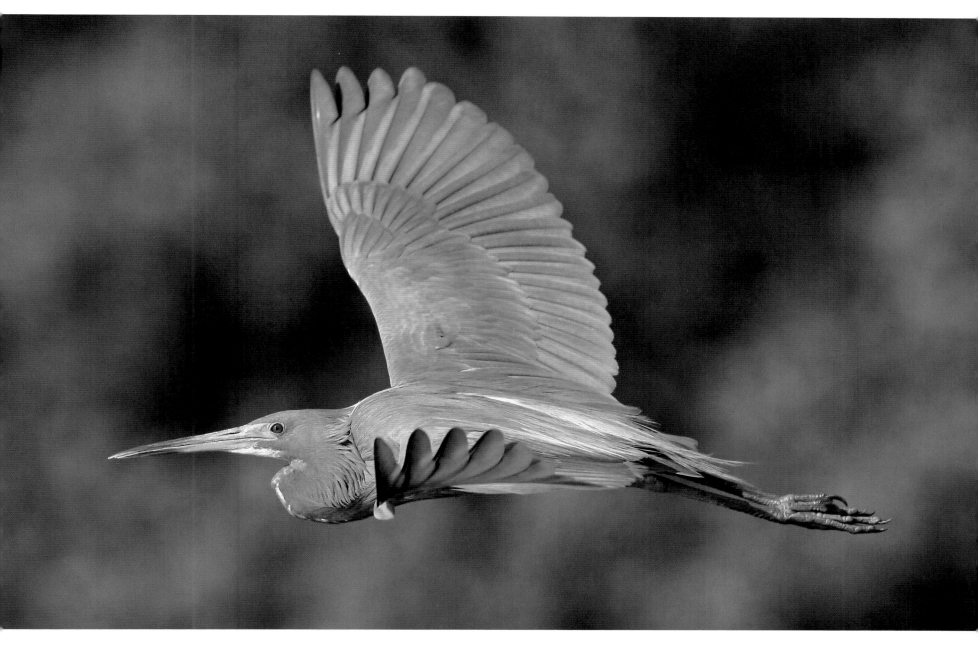

Egretta tricolor.

HABITAT AND RANGE: Forests, wetlands, and coastlines of North, Central, and South America. Migratory.

This gorgeous TRICOLORED HERON is in full breeding plumage, its pastel violet wings outstretched as it flies over the lush forest surrounding a large lake. Formerly known in the United States as the Louisiana heron, this species breeds primarily in subtropical swamps such as those found through the Gulf states. *Osceola County, Florida.*

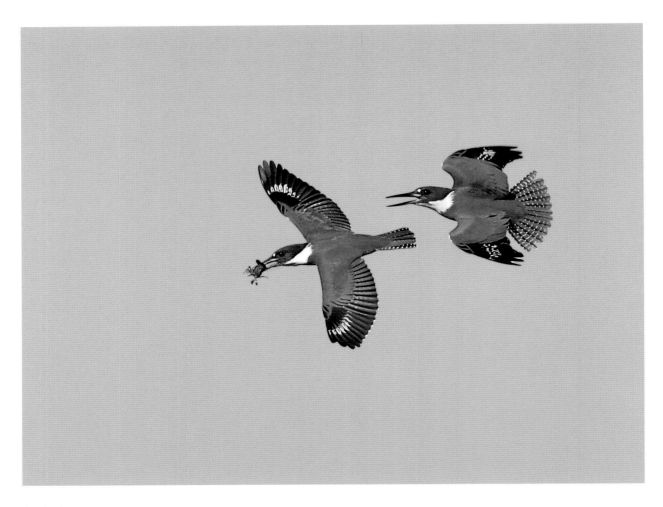

Ceryle alcyon.

HABITAT AND RANGE: Streams, rivers, lakes, and coastlines of North America. Migratory.

A male BELTED KINGFISHER is in hot pursuit of a female with a crawfish in her bill. The crawfish, incidentally, is probably still alive, as a kingfisher must pound this prey on a perch to kill it. *Osceola County, Florida.*

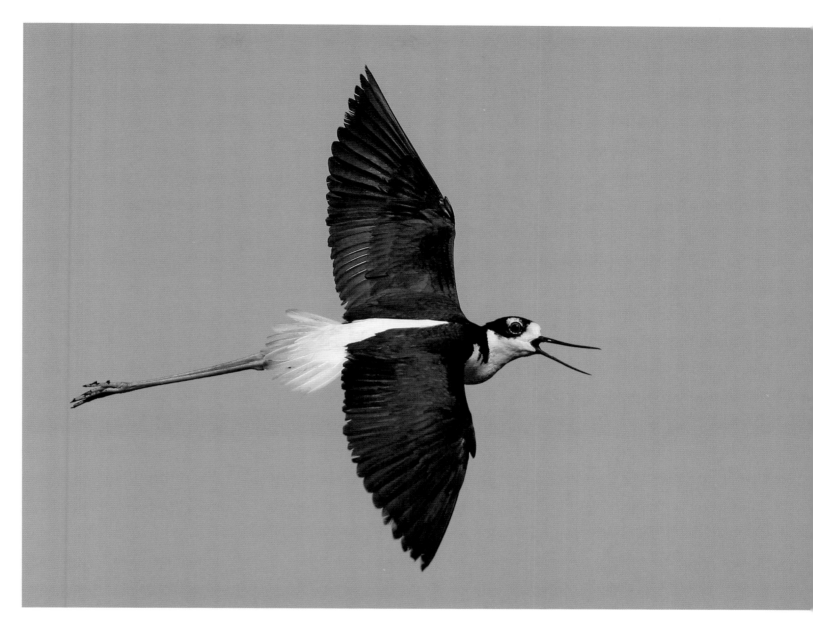

Himantopus mexicanus.

HABITAT AND RANGE: Wetlands and coastlines of North and Central America. Migratory.

Long pink legs trailing out behind it, this BLACK-NECKED STILT almost seems to be looking back over its shoulder in alarm. In fact, it is screaming at (and dive-bombing) a group of fishermen on the shore of a lake.

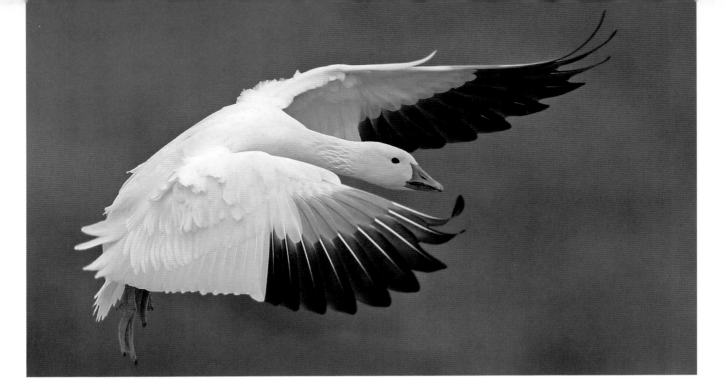

Chen caerulescens.

HABITAT AND RANGE: Wetlands, subarctic tundra, and coastlines of North America. Migratory.

With a dramatic flare of its wings, a SNOW GOOSE comes in for a landing in the cornfields of the Bosque del Apache National Wildlife Refuge. This bird is a white-phase variant, with entirely white plumage except for the black wing tips. Blue-phase variants, which are bluish gray over most of their bodies except the head, neck, and tip of the tail, can and do interbreed with white-phase geese, and the offspring may be of either phenotype. *Socorro County, New Mexico.*

Butorides virescens.

HABITAT AND RANGE: Forests and wetlands of North and South America. Migratory.

In this light, the GREEN HERON doesn't seem to be displaying much of its characteristic color. With its neck pulled far back between its shoulders, much of the green cap on its head, as well as the coloration on its back, is obscured. *Osceola County, Florida.*

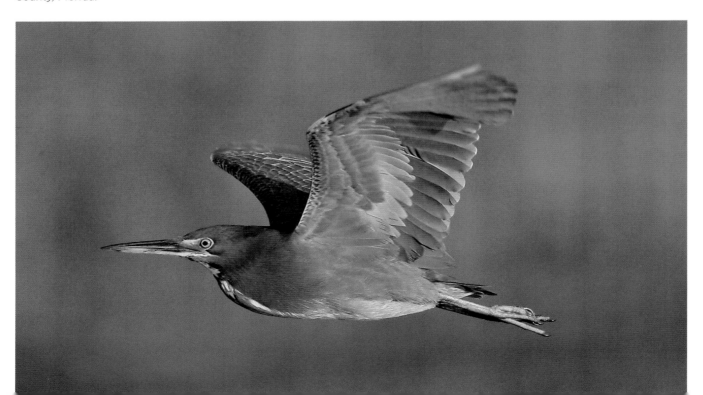

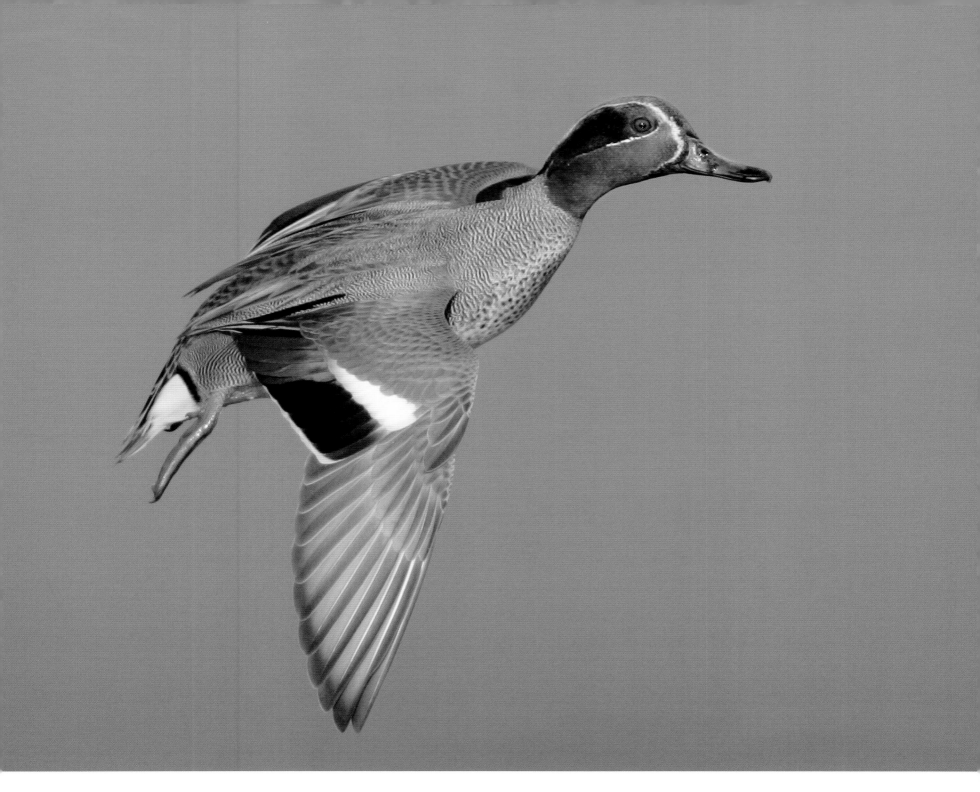

Anas crecca.

HABITAT AND RANGE: Sheltered wetlands of North America, Europe, and Asia. Migratory.

This COMMON TEAL made a sudden and rapid descent to land, showing off its characteristic iridescent green secondary feathers (or speculum). *Hong Kong, China.*

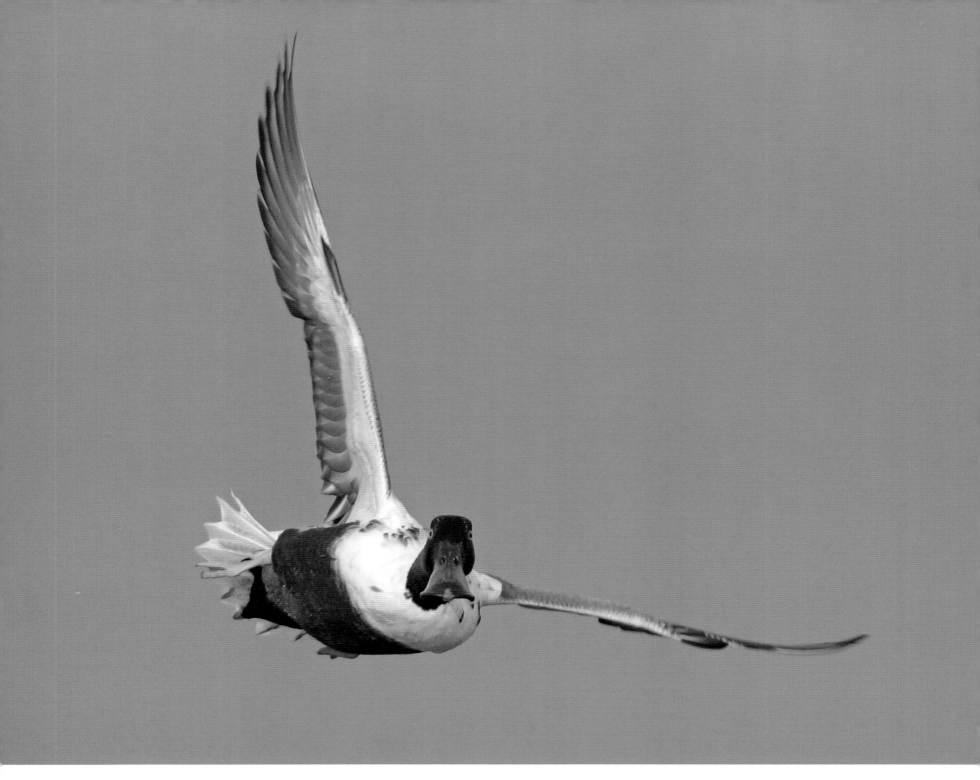

Anas clypeata.

HABITAT AND RANGE: Open wetlands of North America, Europe, and Asia. Migratory.

A head-on approach is rare for a duck in flight, and as soon as this NORTHERN SHOVELER noticed a human presence, it went into a steep bank and turn to get away. From this direct angle, the wide, spatulated beak that gives this duck its common name is quite evident. *Hong Kong, China.*

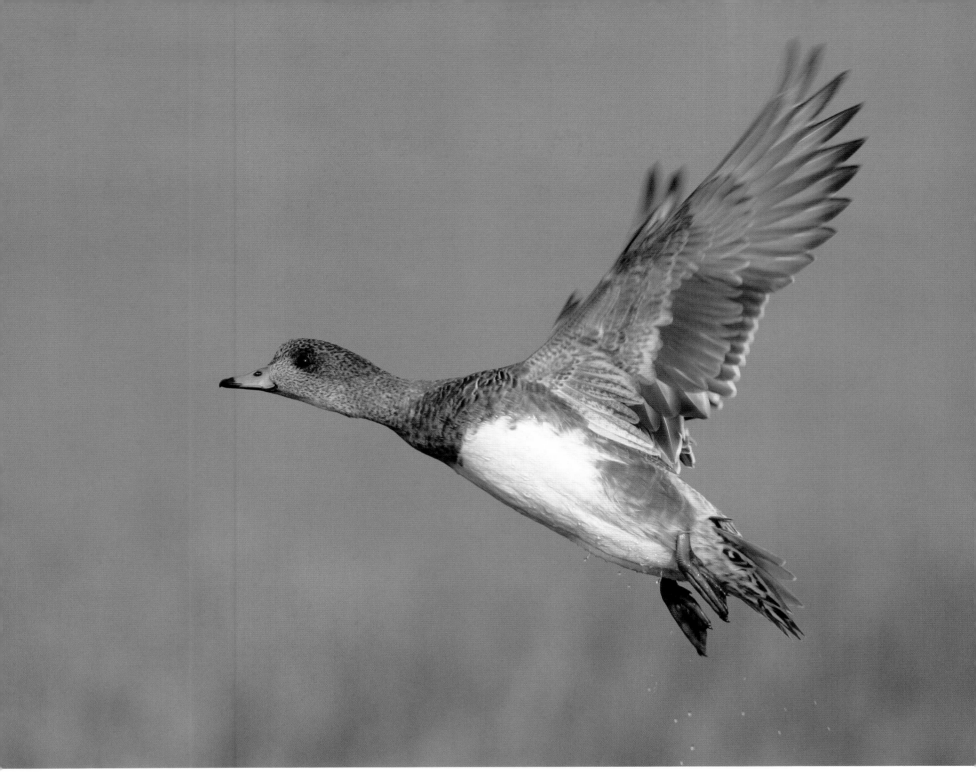

Anas penelope.

HABITAT AND RANGE: Open wetlands of North America, Europe, and Asia. Migratory.

At a pond in the Mai Po Nature Reserve, this female EURASIAN WIGEON leaps out of the water and into the air. The wigeon is often confused with the mallard, as the females of both species have similar coloration, but the chief difference is in the shape of the head and the white of the underbelly. *Hong Kong, China.*

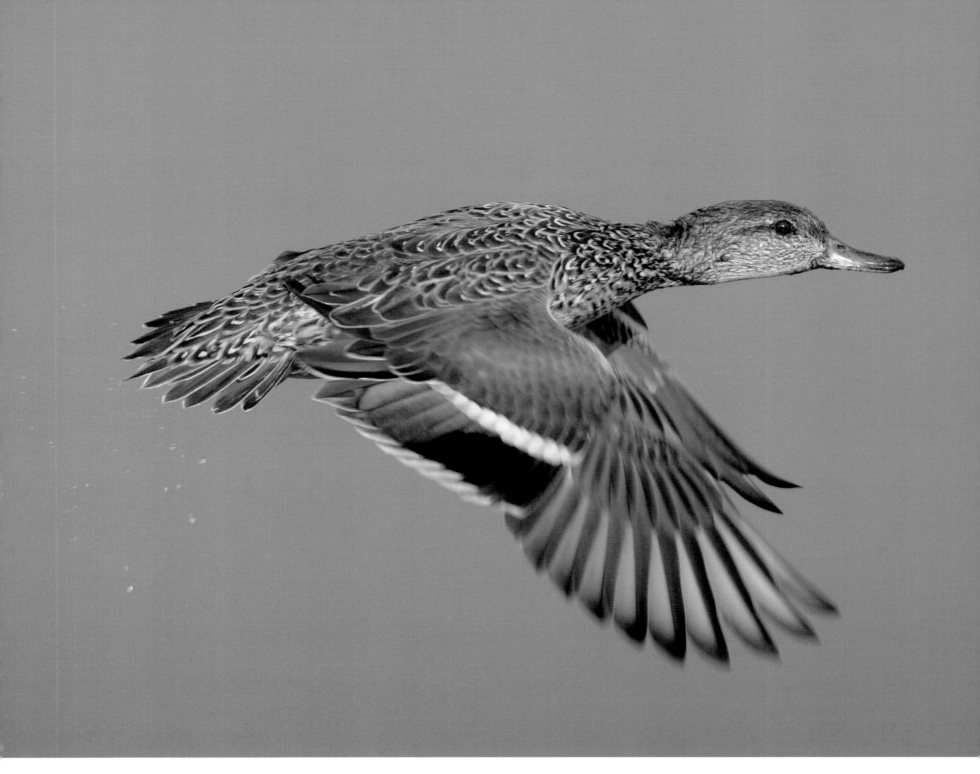

Anas crecca.

HABITAT AND RANGE: Sheltered wetlands of North America, Europe, and Asia. Migratory.

The forward wing stroke and water droplets all denote the speed and energy of this COMMON TEAL. The striking color of the male's speculum matches the coloring around his eyes during mating season; this is the origin of the color we describe as "teal." *Hong Kong, China.*

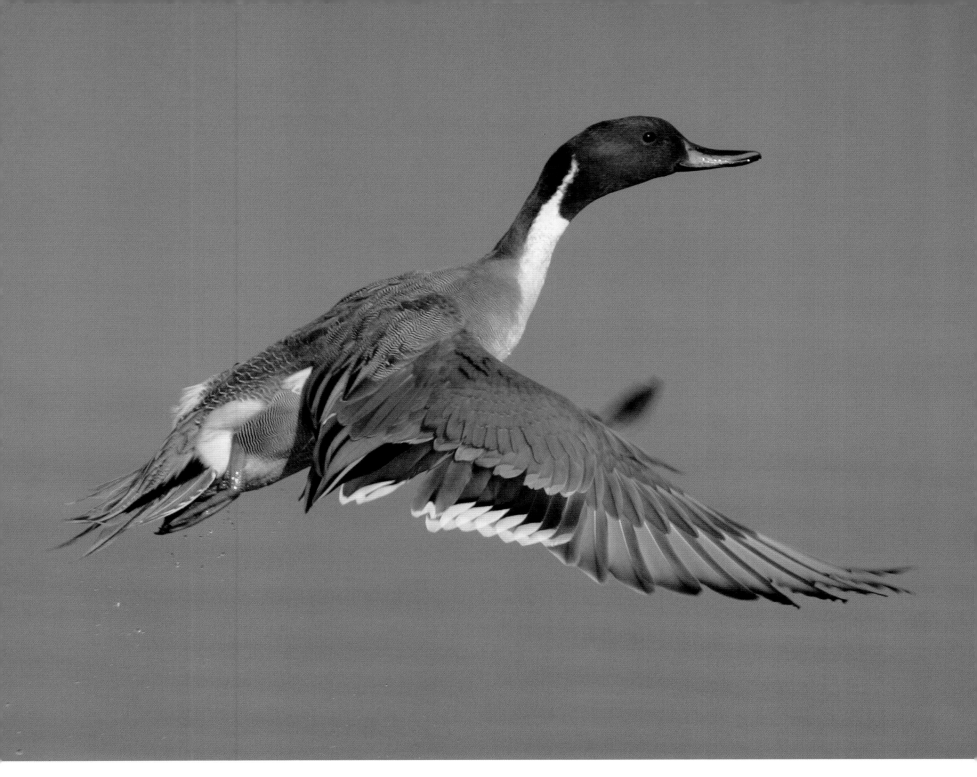

Anas acuta.

HABITAT AND RANGE: Open wetlands and agricultural areas of North and Central America, Europe, Asia, and Africa. Migratory.

The wide-eyed expression on this NORTHERN PINTAIL'S face, coupled with its outstretched neck and ruffled secondary feathers, conveys the flustered urgency with which the duck is fleeing. The bronze-green of the speculum is a muted contrast to the teal's flashy plumage. *Hong Kong, China.*

RIGHT: *Anas clypeata*.

HABITAT AND RANGE: Open wetlands of North America, Europe, and Asia. Migratory.

Her wings apparently pinned back by the wind, a female NORTHERN SHOVELER makes her final approach to land. Her tail feathers are spread out wide to break for landing. *Hong Kong, China.*

BELOW: *Ardea cinerea*.

HABITAT AND RANGE: Shallow freshwater areas of Europe, Asia, and Africa. Migratory.

A winter visitor to Nam Sang Wai, this GRAY HERON is a cornucopia of color seen by the first light of day. The S-shaped curve of its neck in flight distinguishes the heron from its relatives the storks and cranes, and its long, thin chest feathers are pressed against its body by the wind, as the heron is a leisurely flier. *Hong Kong, China.*

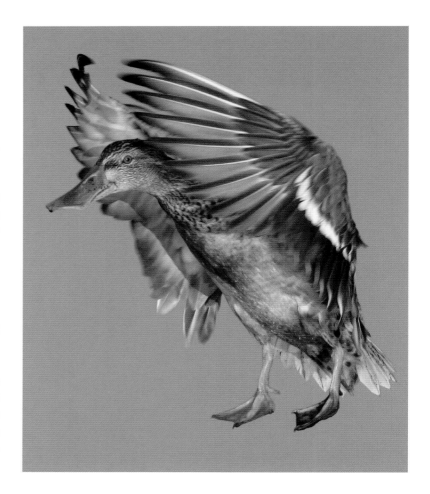

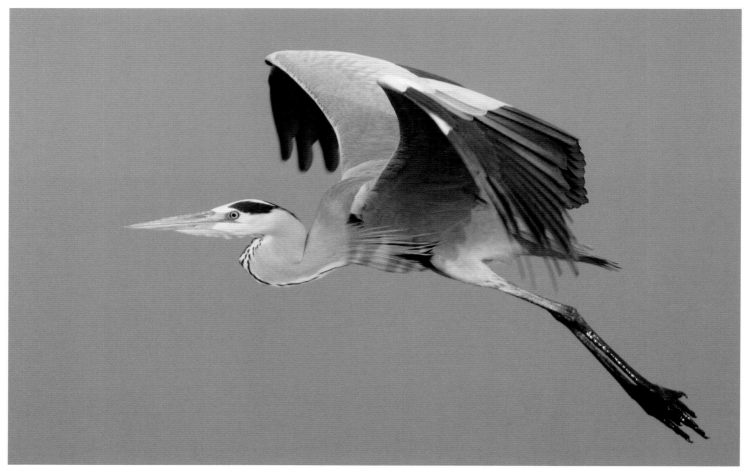

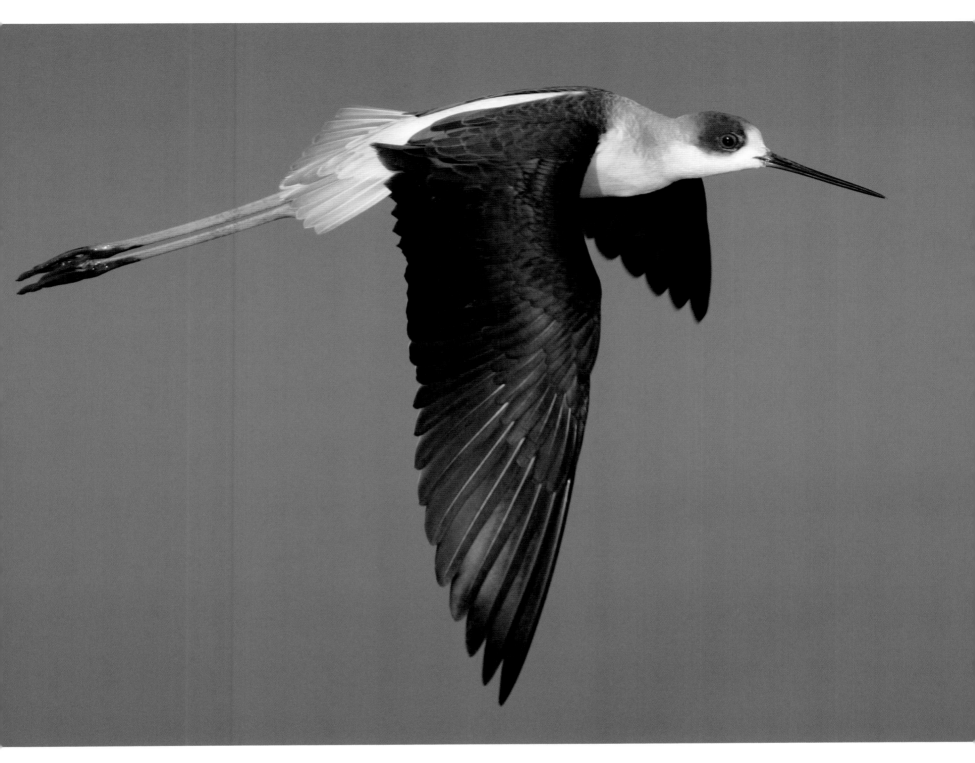

Himantopus himantopus.

HABITAT AND RANGE: Marshes, shallow lakes, and ponds of every continent except Antarctica. Some populations are migratory.

BLACK-WINGED STILTS such as this one, with its extraordinary long pink legs and red glowing eyes, are winter visitors to China. Next to the flamingo, stilts have the longest legs in proportion to their bodies. *Hong Kong, China.*

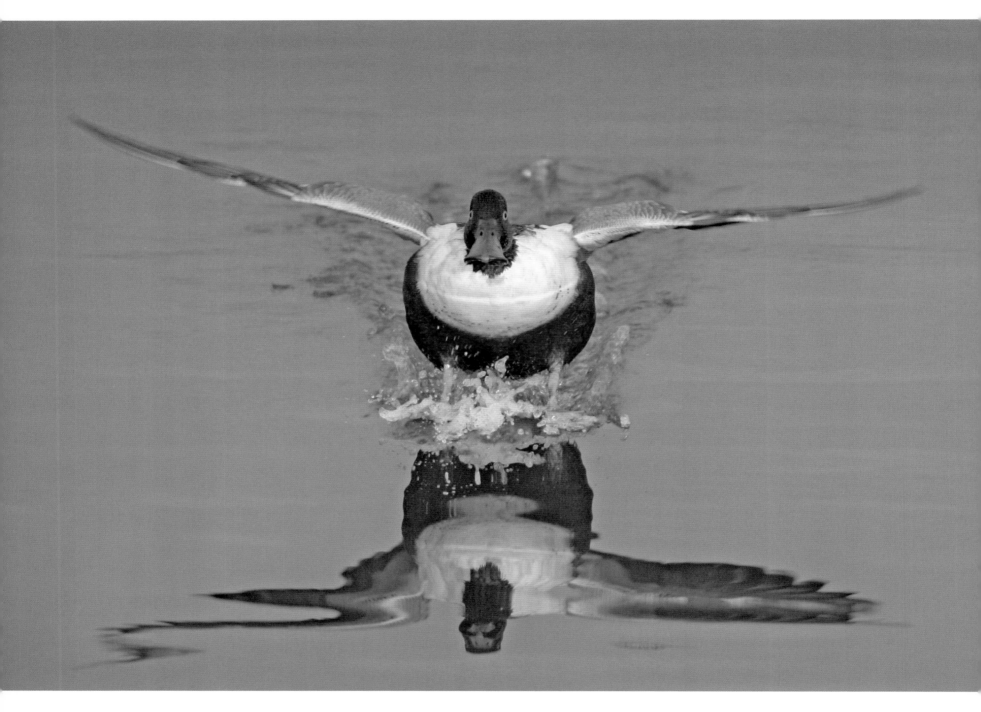

Anas clypeata.

HABITAT AND RANGE: Open wetlands of North America, Europe, and Asia. Migratory.

A male NORTHERN SHOVELER skims the surface of the water, its reflection mirrored in the crystal clear water below. This head-on look reveals the general awkwardness of the duck's body, in comparison with its slender wings, as it skids to a landing. *Hong Kong, China.*

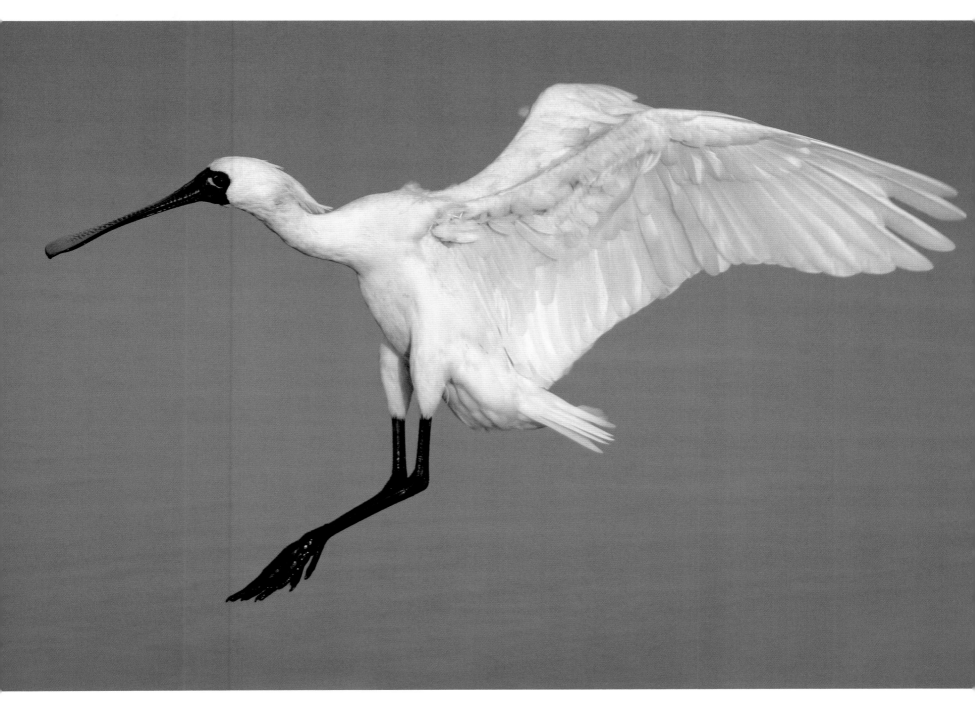

Platalea minor.

HABITAT AND RANGE: Coastal areas of eastern Asia. Migratory.

In this extraordinary shot, a BLACK-FACED SPOONBILL lands at Nam Sang Wai, its stretched wings adding to the tension of the pose. Sadly, sightings of this delightful bird, with its black masked face, long bill, and legs in stark contrast to the rest of its snowy white carriage, have become fewer, as they are the only endangered species of spoonbill. A precious few of them—around three hundred—make the journey from northern China and Korea to Hong Kong each winter. *Hong Kong, China.*

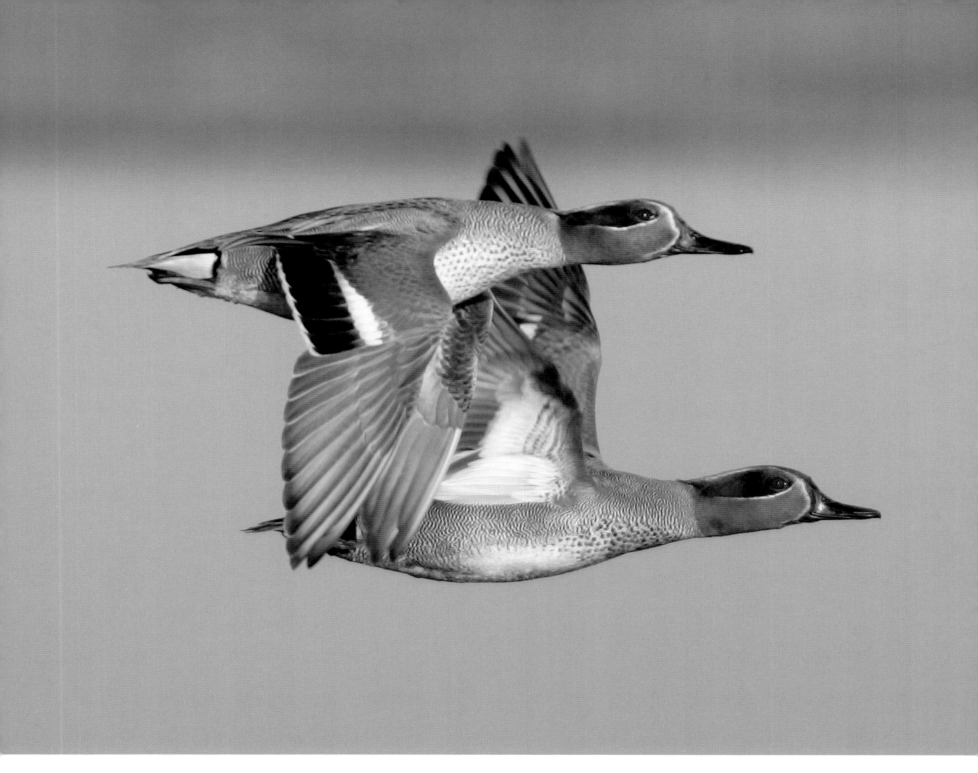

Anas crecca.

HABITAT AND RANGE: Sheltered wetlands of North America, Europe, and Asia. Migratory.

Birds flying in groups display remarkable coordination and teamwork, and this duo of male COMMON TEALS flying in tight formation over Nam Sang Wai are a perfect example. While their bodies are parallel, their wings overlap in complementary positions, one pair on the upstroke, the other on the downstroke. *Hong Kong, China.*

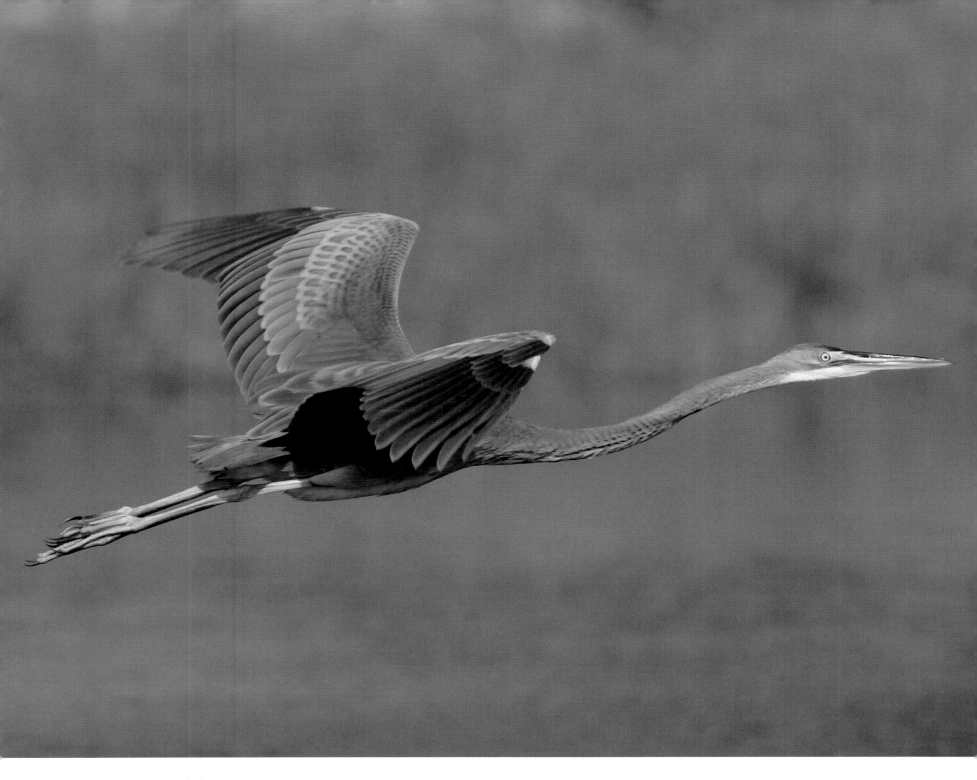

Ardea purpurea.

HABITAT AND RANGE: Forests and wetlands of southern and eastern Asia. Migratory.

Craning its neck forward, a juvenile PURPLE HERON practices its flying technique in the sky over the Mai Po Nature Reserve. It has a long way to go, however; all herons fly with their heads tucked back, in contrast to the extended neck characteristic of their relatives, the cranes. *Hong Kong, China.*

RIGHT: *Anas clypeata.*

HABITAT AND RANGE: Open wetlands of North America, Europe, and Asia. Migratory.

His step light and his reflection gleaming in a quiet, glassine pond, a male NORTHERN SHOVELER is caught on an early morning at Nam Sang Wai. He has barely skimmed the water with his tail, creating just the slightest disturbance in his wake. *Hong Kong, China.*

BELOW: *Anas clypeata.*

HABITAT AND RANGE: Open wetlands of North America, Europe, and Asia. Migratory.

A trio of NORTHERN SHOVELERS touch down at one of the ponds at the Mai Po Nature Reserve. The angle and body position of each shoveler is nearly identical, probably the result of a coordinated approach after a flight in formation. *Hong Kong, China.*

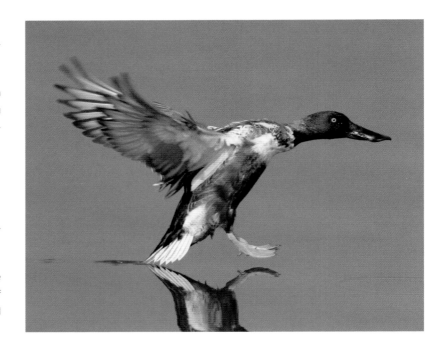

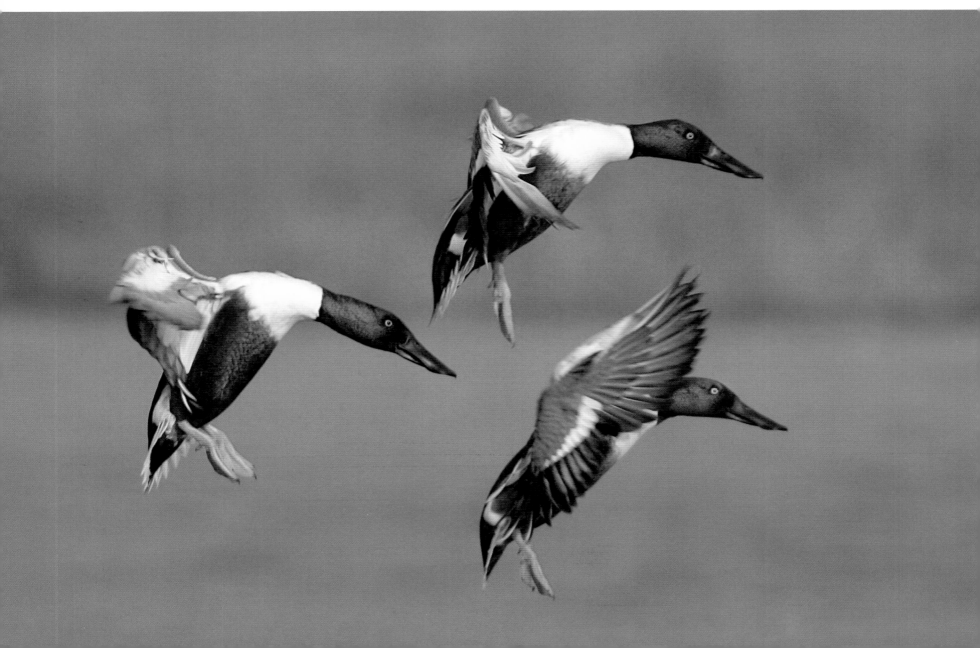

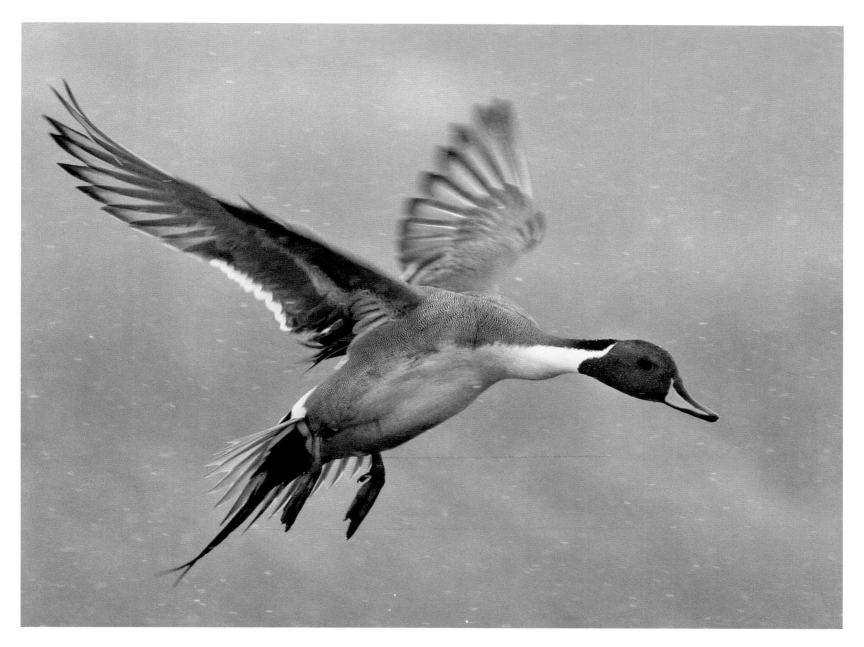

Anas acuta.

HABITAT AND RANGE: Open wetlands and agricultural areas of North and Central America, Europe, Asia, and Africa. Migratory.

This shot of a LONG-NECKED NORTHERN PINTAIL landing during a snowstorm shows exactly why the species was given that name: The two long feathers of its tail come together in a fine point. The pintail is strongly migratory and typically winters as far south as the equator, but this bird seems to have stayed rather far north. *Colorado.*

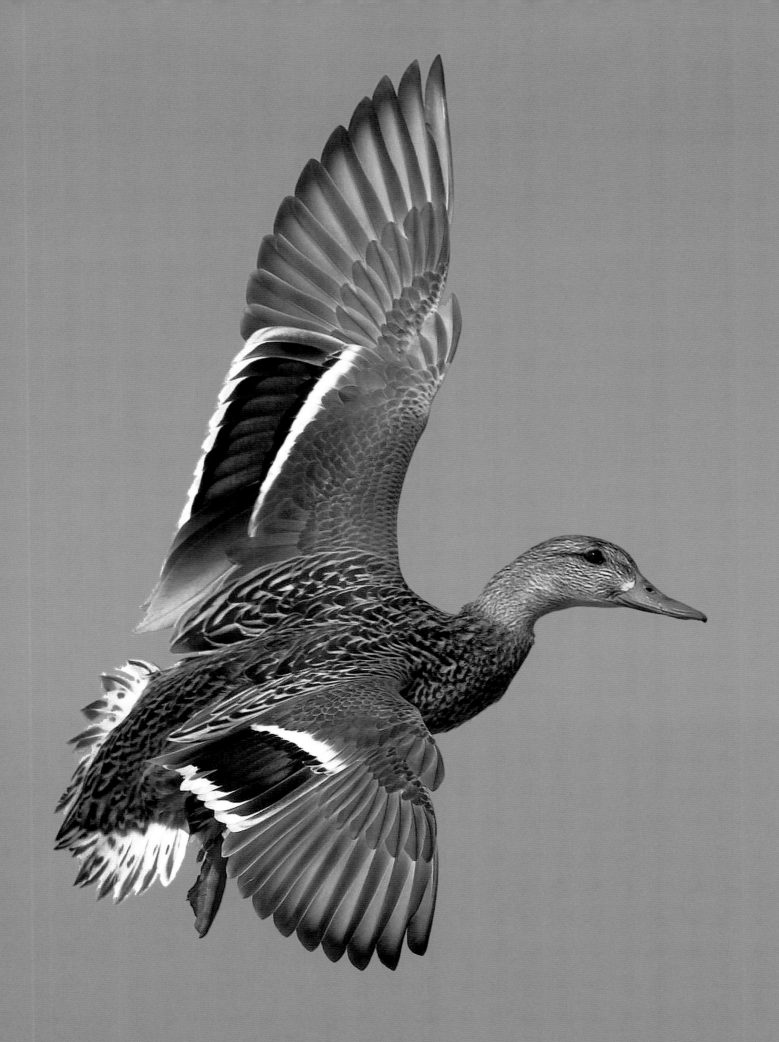

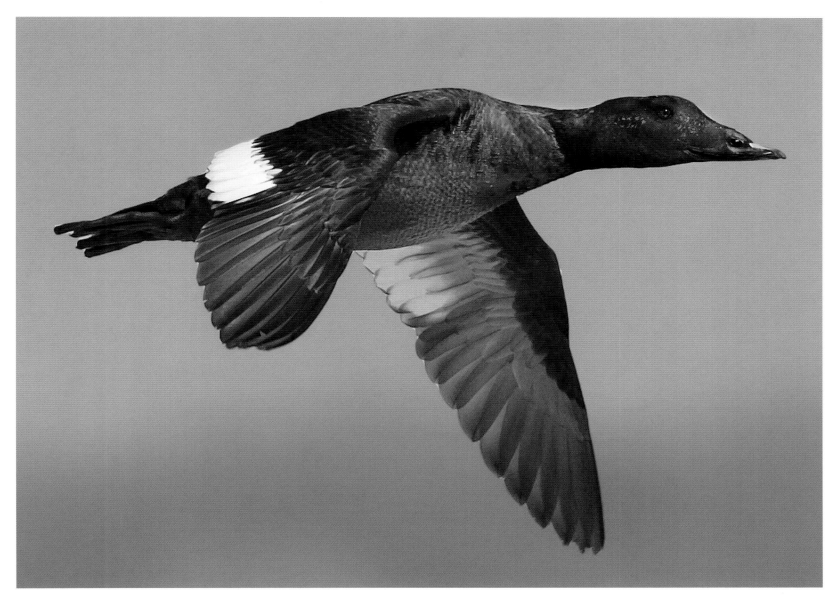

OPPOSITE: *Anas platyrhynchos.*

HABITAT AND RANGE: Wetlands of North America, Europe, Asia, and Australia. Migratory.

The dizzying interwoven wing patterns of this female MAL-LARD DUCK are shown off beautifully as she assumes a prelanding position, one of her blue-and-white bracketed wings up and the other down to negotiate tricky wind currents.

ABOVE: *Melanitta fusca.*

HABITAT AND RANGE: Freshwater lakes, estuaries, and coastlines of northern North America, Europe, and Asia. Migratory.

The male WHITE-WINGED SCOTER has the very distinctive, almost bovine head common to all three scoter species. Shown here in full flight, the bird seems to take on human qualities, such as the cocksure look and even a bit of a grin!

RIGHT: *Bucephala albeola*.

HABITAT AND RANGE: Ponds and lakes of North America. Migratory.

A male BUFFLEHEAD DUCK shows off his complex and illustrious plumage, banking to his right in the wind. Female buffleheads lack the striking contrasts of the body coloration as well as the brilliant prismatic rainbow on the face and throat.

BELOW: *Clangula hyemalis*.

HABITAT AND RANGE: Arctic wetlands of the northern hemisphere. Migratory.

This very fast-flying male LONG-TAILED DUCK, cutting through the air over a frozen pond, is traveling at a speed great enough to flatten out his characteristic tail feathers. When resting on the water, the duck's long tail points up smartly, occasionally even curling slightly. *Nova Scotia, Canada.*

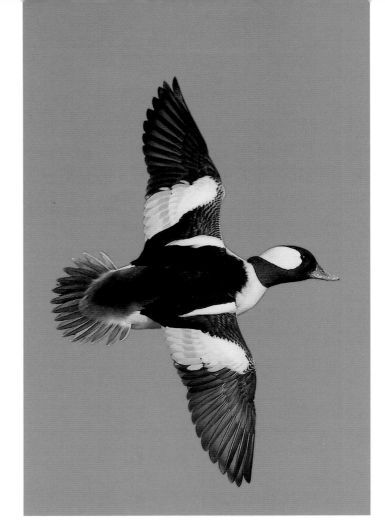

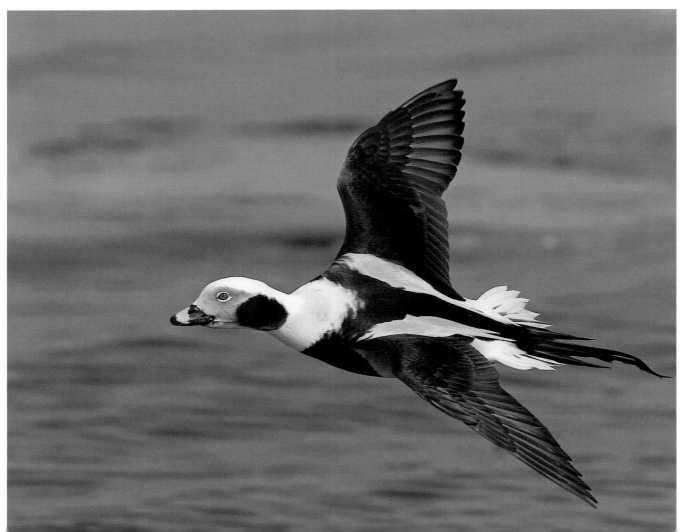

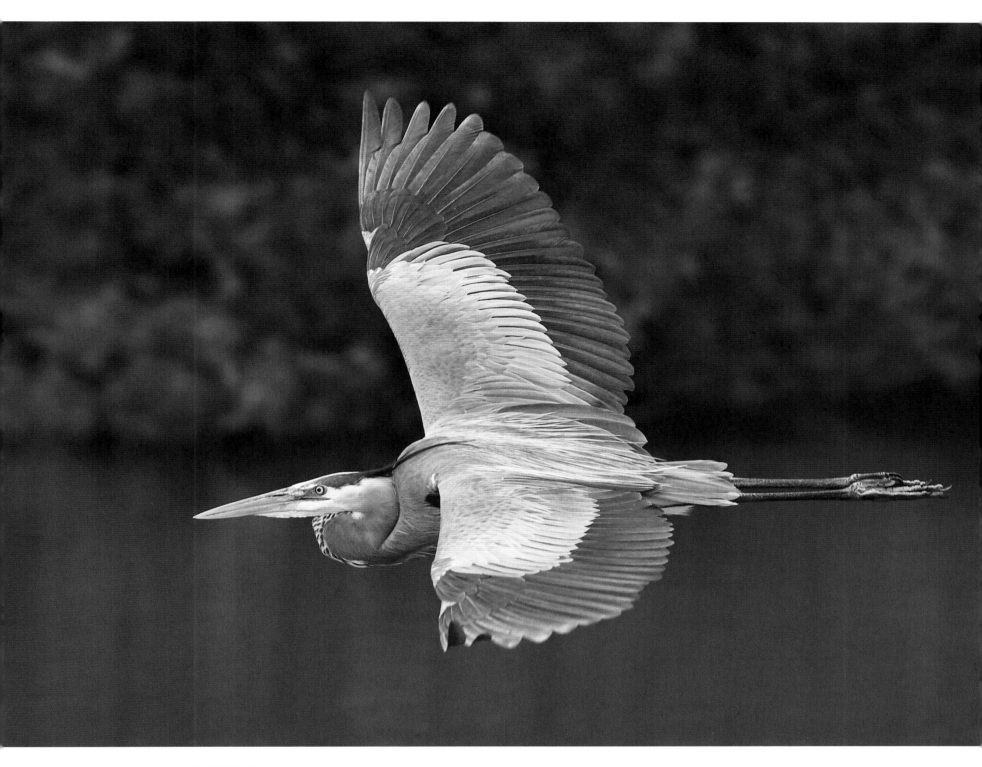

Ardea herodias.

HABITAT AND RANGE: Forests and freshwater wetlands and coastlines of North and Central America. Migratory.

This ramrod-straight GREAT BLUE HERON in flight over a lake has just left the nest to go and gather more building material to bring back to the waiting female. Colonies of nesting herons ("heronries") are not uncommon and range in size from five to five hundred nests in a single heronry. *Venice, Florida.*

Songbirds on the Wing

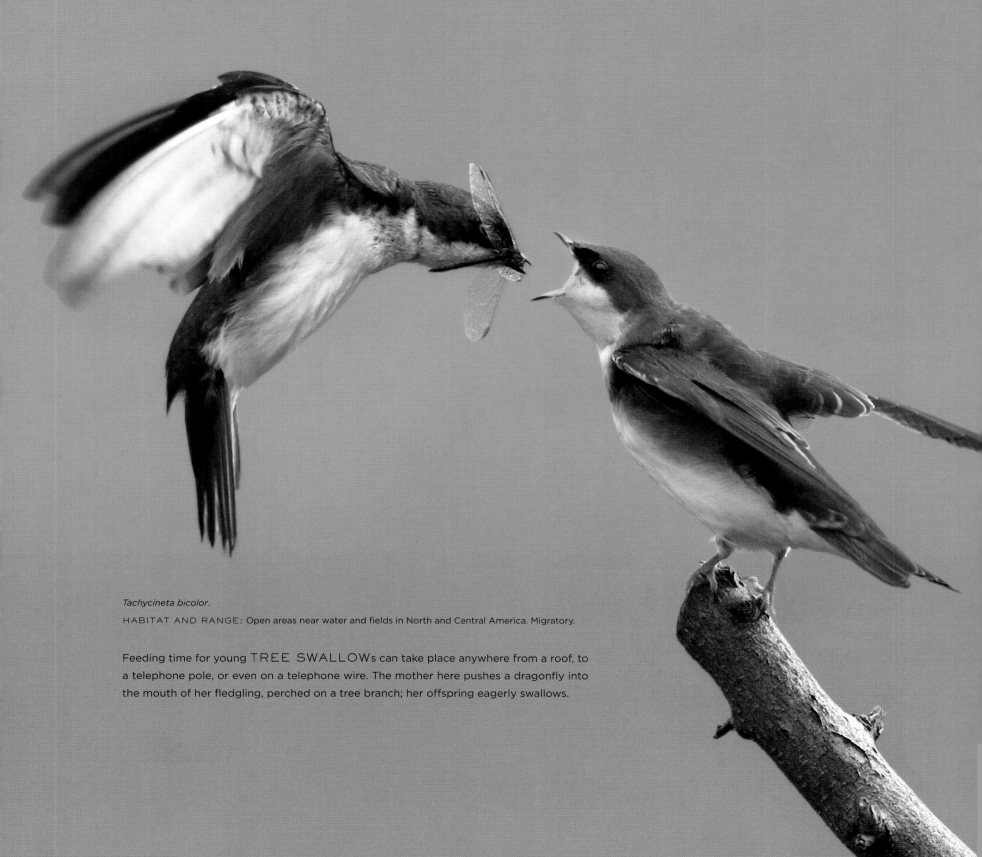

Tachycineta bicolor.

HABITAT AND RANGE: Open areas near water and fields in North and Central America. Migratory.

Feeding time for young TREE SWALLOWs can take place anywhere from a roof, to a telephone pole, or even on a telephone wire. The mother here pushes a dragonfly into the mouth of her fledgling, perched on a tree branch; her offspring eagerly swallows.

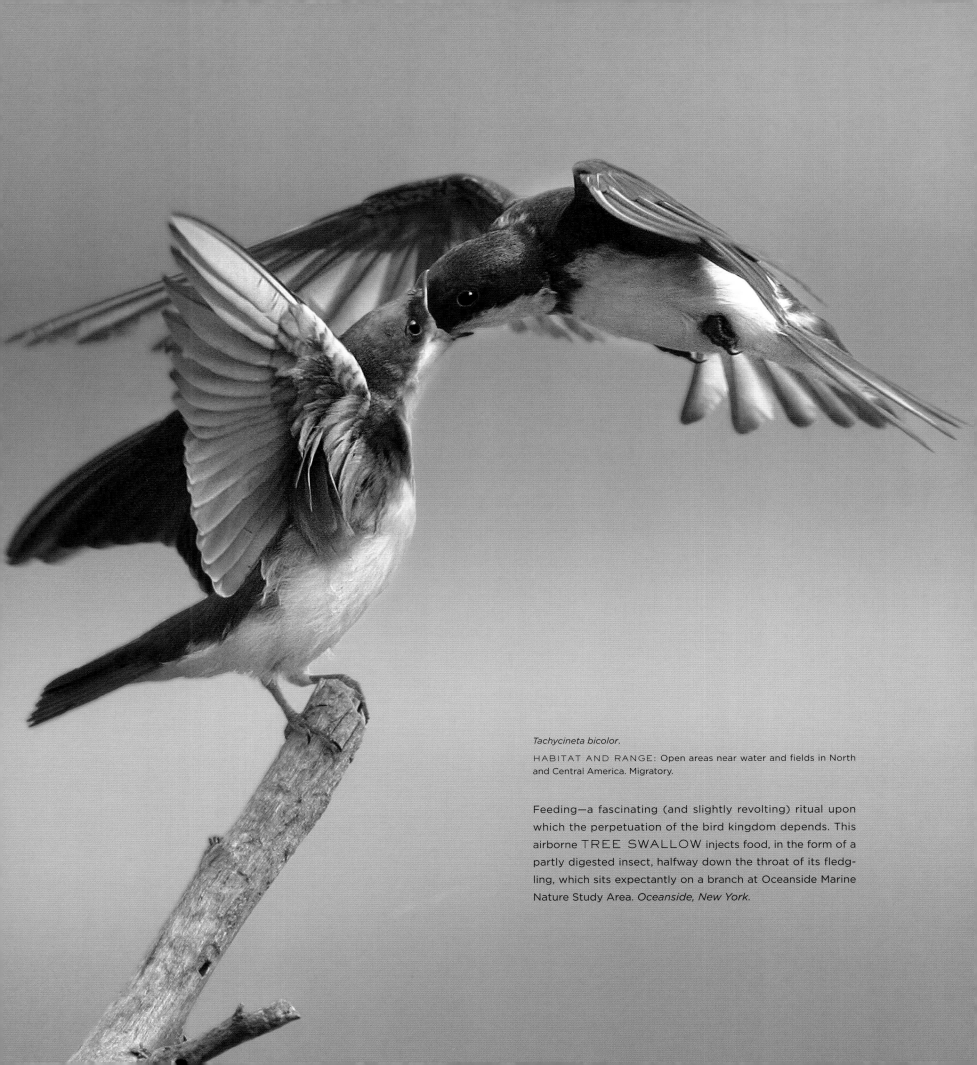

Tachycineta bicolor.

HABITAT AND RANGE: Open areas near water and fields in North and Central America. Migratory.

Feeding—a fascinating (and slightly revolting) ritual upon which the perpetuation of the bird kingdom depends. This airborne TREE SWALLOW injects food, in the form of a partly digested insect, halfway down the throat of its fledg-ling, which sits expectantly on a branch at Oceanside Marine Nature Study Area. *Oceanside, New York.*

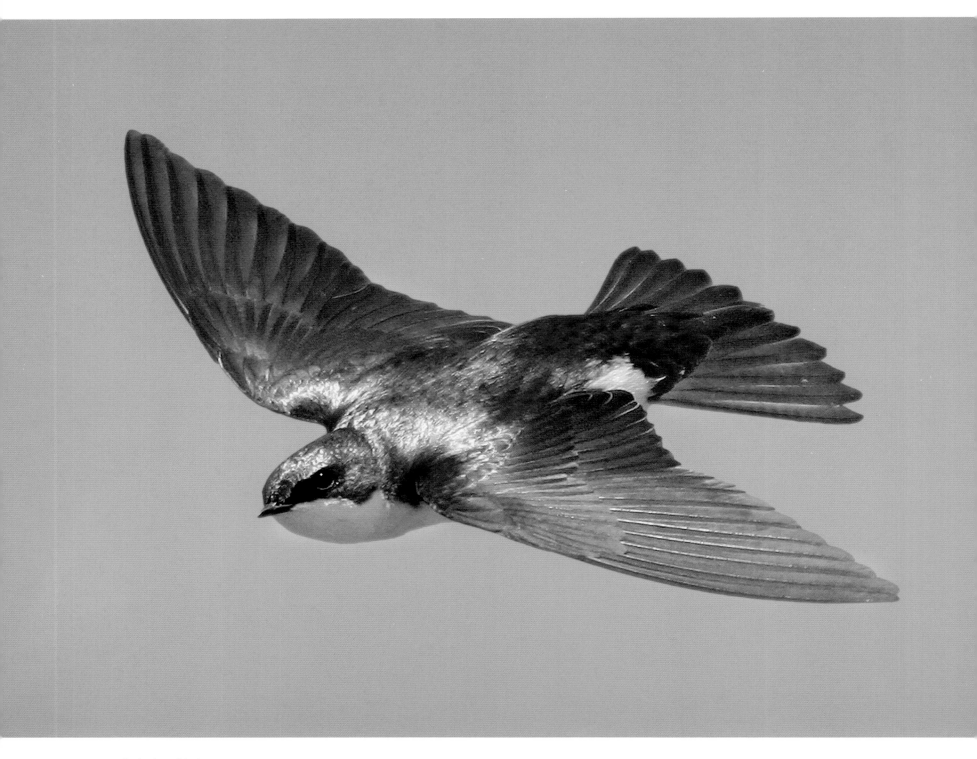

Tachycineta bicolor.

HABITAT AND RANGE: Open areas near water and fields in North and Central America. Migratory.

A gorgeous metallic blue and gray TREE SWALLOW looks fat and sassy as it navigates the skies. *Jamaica Bay, New York.*

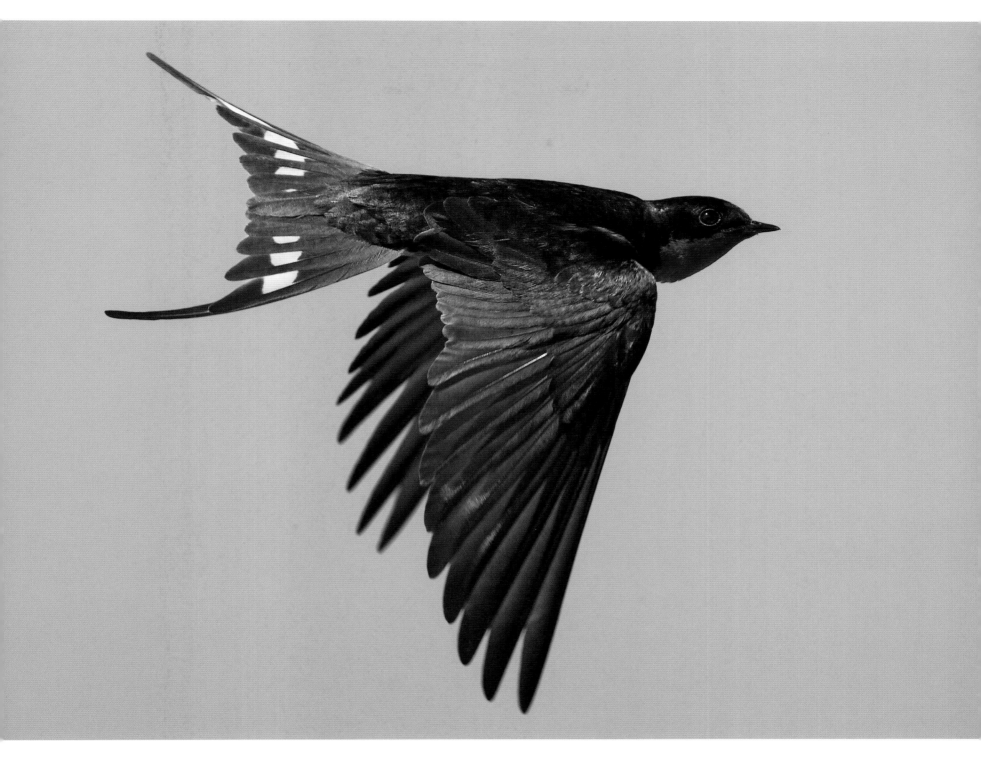

Hirundo rustica.

HABITAT AND RANGE: Grasslands, agricultural areas, and urban and suburban areas throughout the Americas, Europe, Asia, Australia, and Africa. Migratory.

Early in the summer, BARN SWALLOWS like this one are a common sight at Oceanside Marine Nature Study Area, where they can be spotted diving in and out of marsh grass, hunting for flies. *Oceanside, New York.*

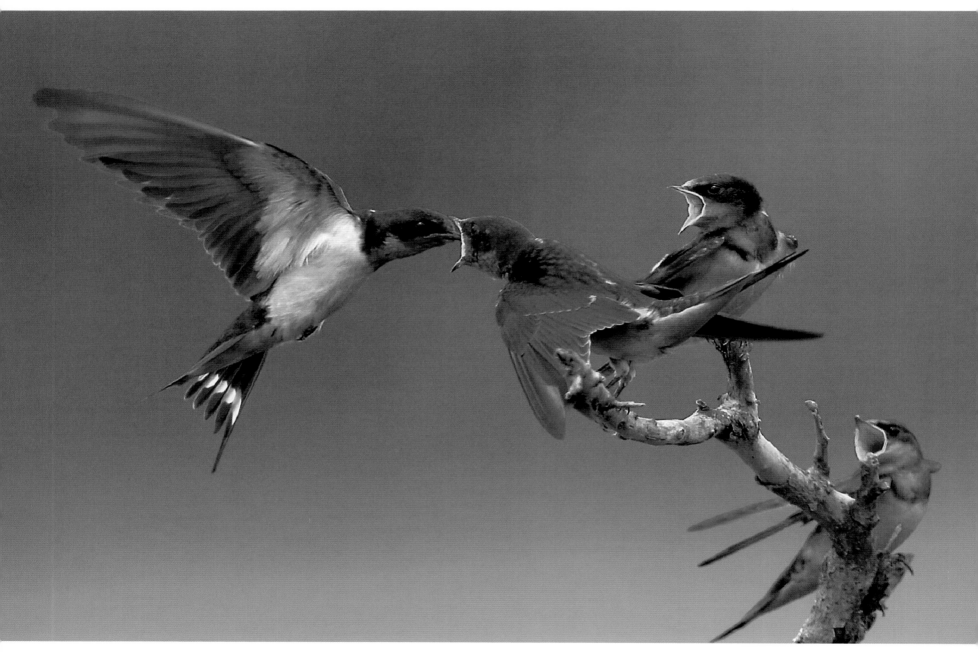

Hirundo rustica.

HABITAT AND RANGE: Grasslands, agricultural areas, and urban and suburban areas throughout the Americas, Europe, Asia, Australia, and Africa. Migratory.

The BARN SWALLOW is the most abundant swallow species in the world, as this busy mother certainly knows. Her clamoring brood perches on a limb, beaks open as wide as possible in expectation of the food she will provide. This midair feat of feeding demonstrates the expert maneuverability on which the barn swallow depends for catching insects.

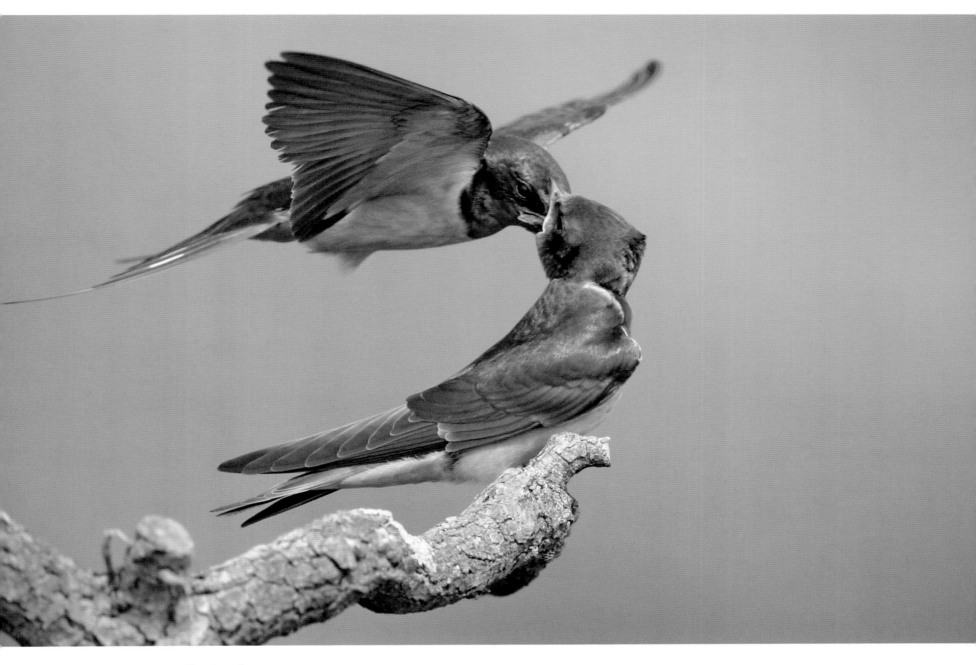

Hirundo rustica.

HABITAT AND RANGE: Grasslands, agricultural areas, and urban and suburban areas throughout the Americas, Europe, Asia, Australia, and Africa. Migratory.

Returning at last with a fly, a female BARN SWALLOW at Oceanside Marine Nature Study Area must now fight against the wind to feed her patient charge. On blustery days, swallows must use all their strength and cunning to catch insects, in this case only to give up the hard-won treat to a smaller mouth. *Oceanside, New York.*

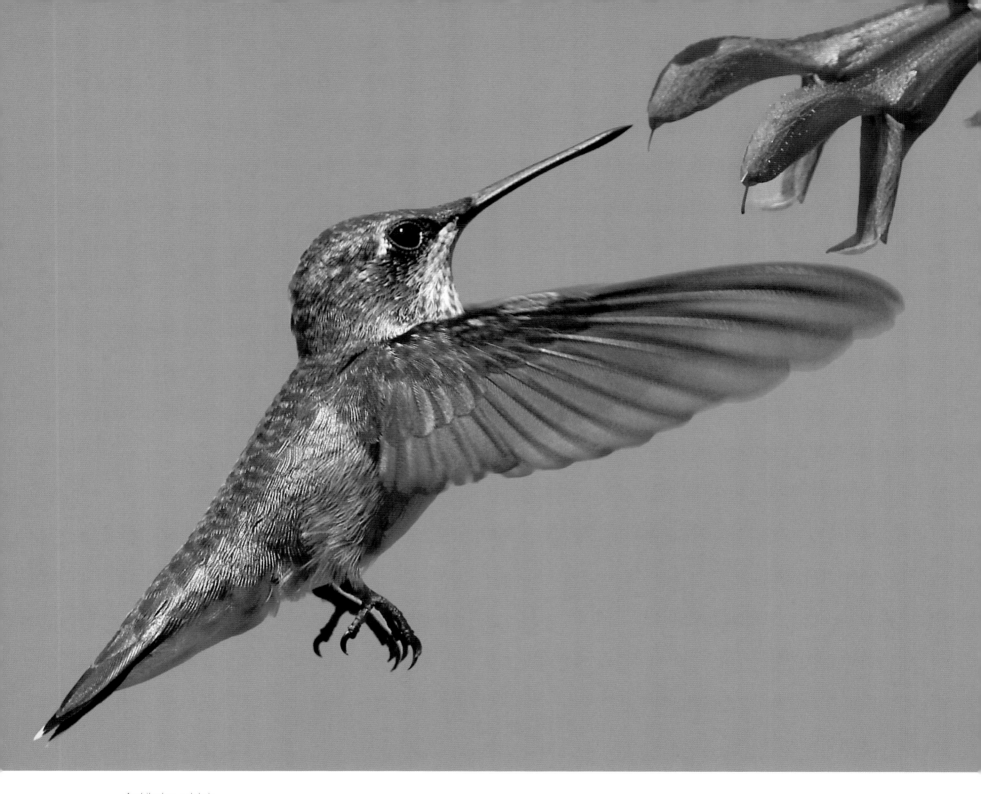

Archilochus colubris.

HABITAT AND RANGE: Forests in North America. Migratory.

In spite of the fact that its wings beat fifty-three times every second, this RUBY-THROATED HUMMINGBIRD has been frozen in time as it feeds on a bright blue flower, the sun producing an almost gold-plated effect on its body plumage. Also extraordinary are the hummingbird's very short legs, which restrict its ground movement to a little shuffle. Even though the legs are nearly useless for locomotion, they come in handy for scratching; a hummingbird can lift its foot up and over its wing to soothe an itch on its head or neck.

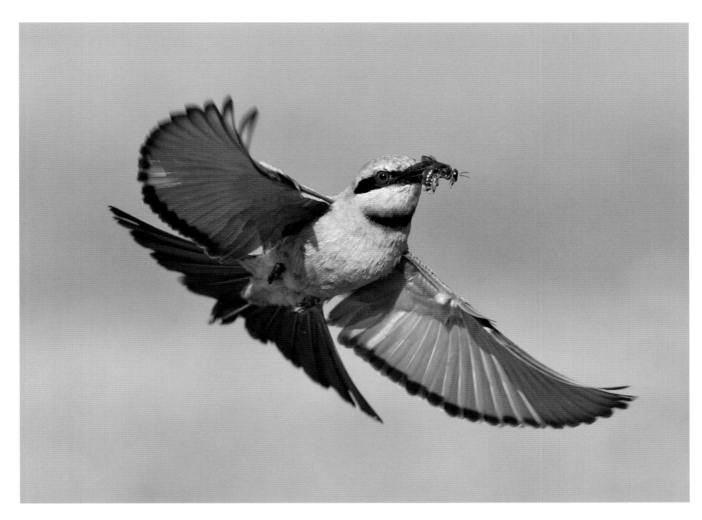

Merops ornatus.

HABITAT AND RANGE: Open country of Australia. Migratory.

Insect securely in its beak, a RAINBOW BEE-EATER'S gorgeous, golden, black-bordered wings stand out as it hurries back to feed its young, which are waiting in a tunnel dug in the ground. The bee-eater mainly lives on flying insects, but as the name implies, this species has a sweet tooth for bees. *Sydney, Australia.*

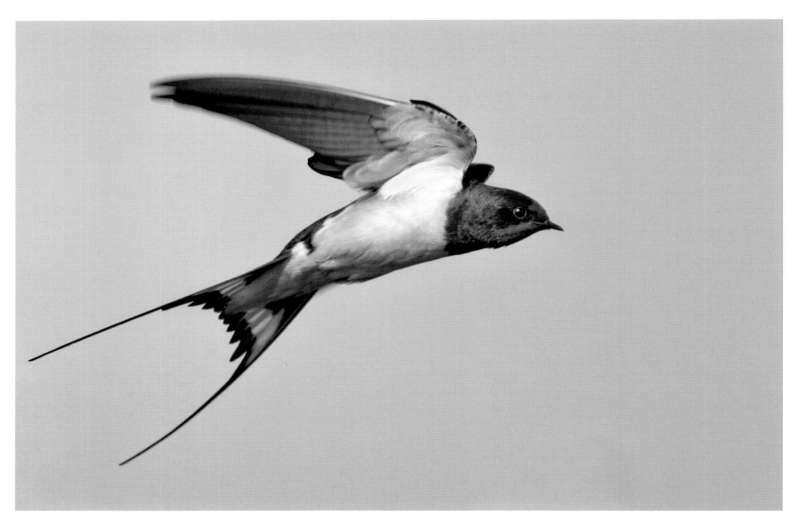

Hirundo rustica.

HABITAT AND RANGE: Grasslands, agricultural areas, and urban and suburban areas throughout the Americas, Europe, Asia, Australia, and Africa. Migratory.

The signature "slingshot" tail feathers of the BARN SWALLOW are a sight to behold. The European subspecies of barn swallow, characterized by a white underbelly and dark blue-black breast band, typically winters in northern Africa, so this bird is rather far afield. *Sydney, Australia.*

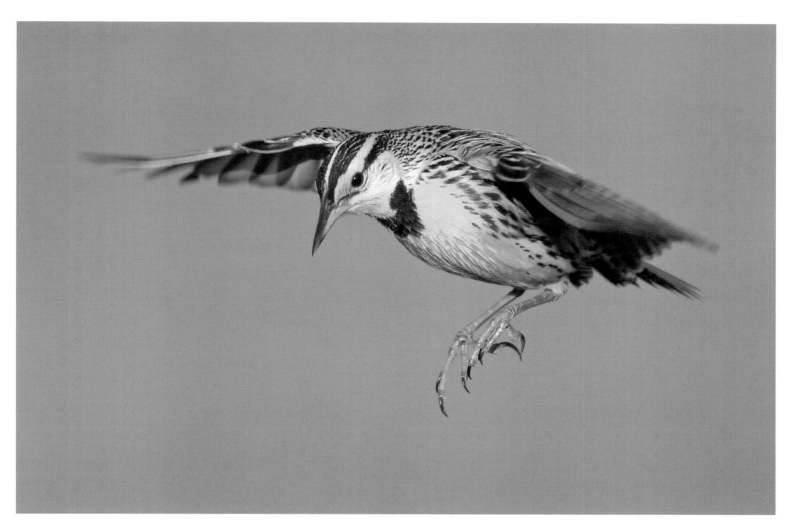

Sturnella magna.

HABITAT AND RANGE: Grasslands and open country of the eastern and central United States and Central America and South America. Migratory.

Because of their small size and fast, erratic aerial maneuvers, photographing an EASTERN MEADOWLARK in flight is fairly challenging. This meadowlark is hovering while it selects a perch on which to land. *Osceola County, Florida.*

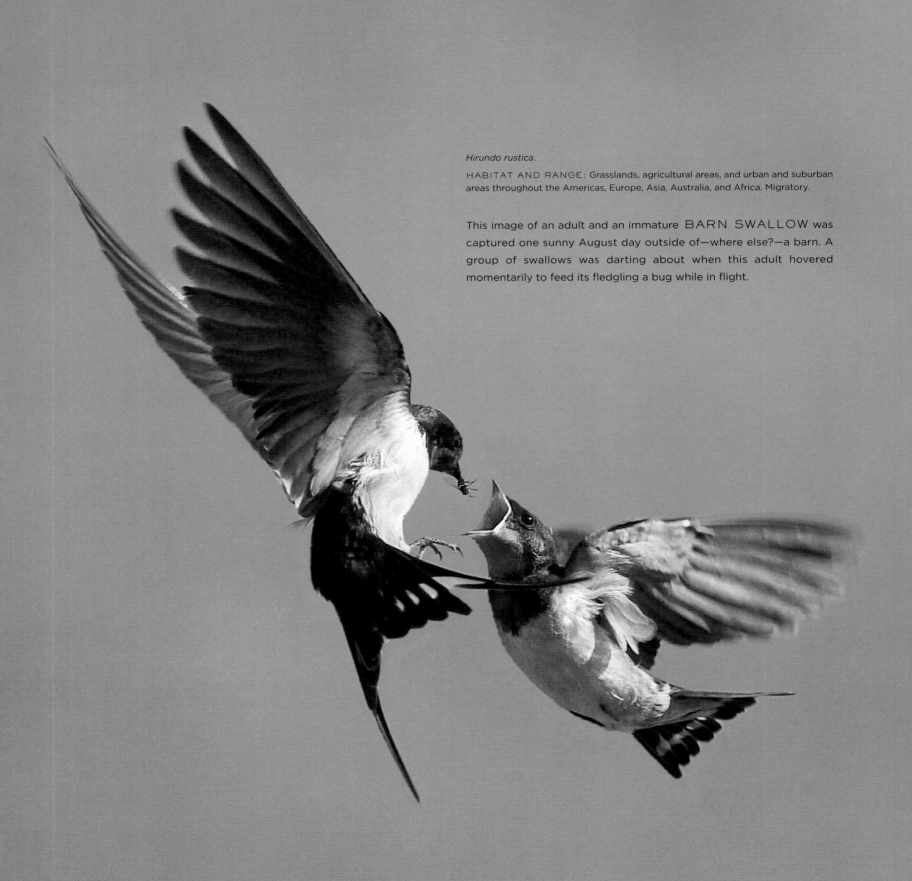

Hirundo rustica.

HABITAT AND RANGE: Grasslands, agricultural areas, and urban and suburban areas throughout the Americas, Europe, Asia, Australia, and Africa. Migratory.

This image of an adult and an immature BARN SWALLOW was captured one sunny August day outside of—where else?—a barn. A group of swallows was darting about when this adult hovered momentarily to feed its fledgling a bug while in flight.

Acknowledgments

A work of this scope and importance could only have been possible through a team effort, and I had a dream team, without whom this project would have fallen short. For their endless supply of support, good advice, expertise, sharp eyes, and a shared love of bird photography that always looked to stretch the limits of what is possible, my sincere and grateful thanks go to editor-in-chief Eric Himmel, whose enthusiasm and encouragement was matched only by his wisdom in seeing this book as I did, as an historical landmark in the genre of wildlife photography; my editor, Aiah Wieder, for her caring and calm; art director Michelle Ishay and designer Kris Tobiassen, for their skill and flair in laying out the photographs with the subtle, nuanced hands of a surgeon; and Mark Ribowsky, for his invaluable assistance in the matter of writing the text and captions.

Of course, as with any team, the most valuable members are its all-stars, my fellow lensmen and true believers: David Hemmings, K.K. Hui, Miguel Lasa, Ofer Levy, Jim Neiger, and Rob Palmer, all of whom are undoubtedly out on a lake or lurking in a blind at this very moment, looking for even better shots. I'd like to express my utmost gratitude to these brilliant and devoted artists. Thanks also to two other photographers, Barbara and Ernie Verdeschi, whose advice and consent throughout the process of bringing this book to fruition was a source of inspiration and pride, and Mike Farina, the lead conservation biologist at the Marine Nature Study Area in Oceanside, New York—his enormous talents as a photographer/artist brought needed perspective from an academic level, as well as some fascinating scholarship on the myriad bird species featured on these pages.

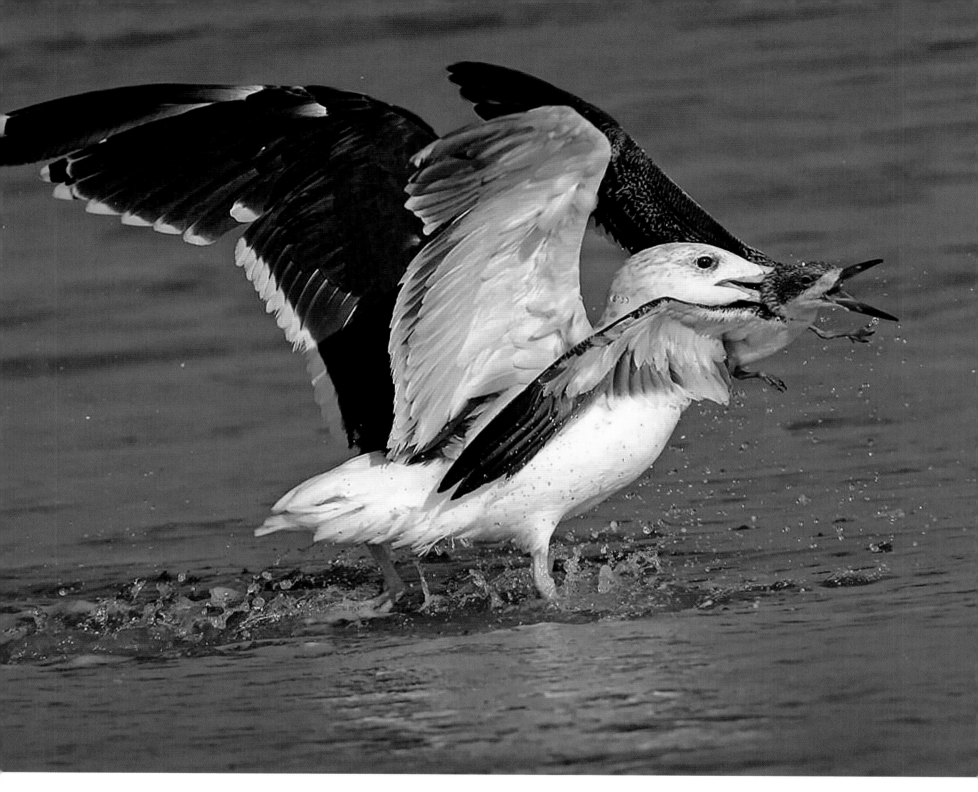

Rynchops niger.

HABITAT AND RANGE: Wetlands and coastlines of North and South America. Migratory.

Larus marinus.

HABITAT AND RANGE: North Atlantic coastlines and islands of North America and Europe. Nonmigratory.

If this BLACK SKIMMER seems upset, he has good cause. Much like his compatriot on page 117, he has fallen victim to a BLACK-BACKED GULL, one of the skimmer's more unlikely predators. *Lido Beach, New York.*

Photo credits

Richard Ettlinger: iii–iv, 2, 5, 7, 13, 18–34, 88, 94, 98, 104, 111–121, 125, 135, 138, 168–174, 182

David G. Hemmings: 6, 15, 100–103, 105–110, 136–137, 164–167, 178

K.K. Hui: 57–60, 126–129, 151–162

Miguel Lasa: 61–78, 130–134

Ofer Levy: 35–40, 122–124, 139–147, 148T, 175–176

Jim Neiger: 9, 41–56, 148B, 149–150, 177

Robert Palmer: ii, 10, 79–87, 89–93, 95–97, 99, 163

Index